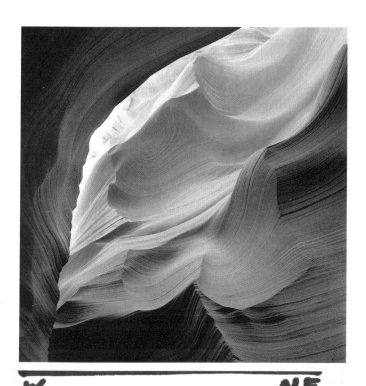

W NE

Q

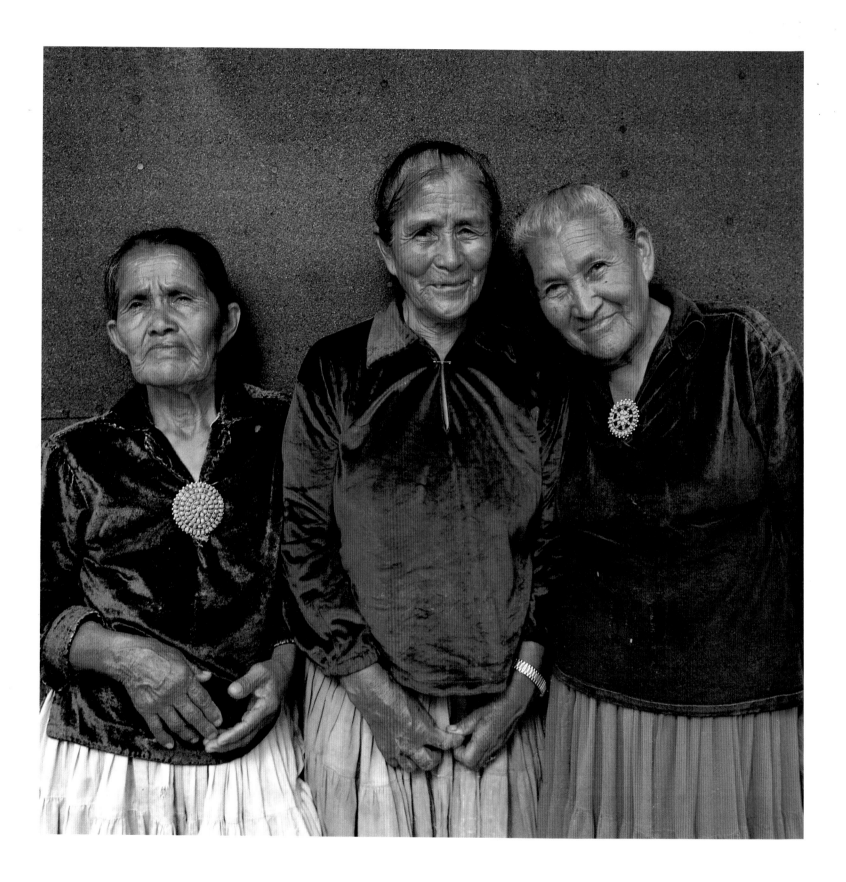

NAVAJO

PORTRAIT OF A NATION

▲▲▲▲

PHOTOGRAPHY BY
JOEL GRIMES

FOREWORD BY STEWART L. UDALL

PUBLISHED BY WESTCLIFFE PUBLISHERS, INC.
ENGLEWOOD, COLORADO

International Standard Book Number: ISBN 1-56579-005-7
Library of Congress Catalogue Card Number: 91-066705
Copyright: Photographs, © 1992, Joel Grimes. All rights reserved.
Copyright: The Two Worlds of the Navajo, © 1992, Betty Reid.
All rights reserved.

Editors: John Fielder, Rich Clarkson
Consultant: Mark M. Trahant
Designer: Nancy Rice, Wilson/Johnson Creative, Inc.
Copy Editor: Margaret Terrell Morse
Production Manager: Mary Jo Lawrence
Printed in Singapore by Tien Wah Press (Pte.), Ltd.
Published by Westcliffe Publishers, Inc.
2650 South Zuni Street, Englewood, Colorado 80110

Navajo Rap song: used by permission and courtesy of Harmon Mason.
All other Navajo songs from *The Indian's Book*, recorded and edited by
Natalie Curtis. New York: Harper and Brothers, Publishers. 1907.
Courtesy of Richard Stark, Santa Fe, New Mexico.

Westcliffe Publishers and Joel Grimes gratefully acknowledge the
support provided toward the publication of this book, in part, by

 THE PROFESSIONAL PHOTOGRAPHY DIVISION
OF EASTMAN KODAK COMPANY

Cover: Rose Tracy and great-grand daughter Amanda, Ganado, Arizona
First Frontispiece: Sandstone formations in Antelope Canyon, near Page, Arizona
Second Frontispiece: Sisters Lutie Wilson (in blue) and Jeanette Lewis
(in purple) and sister-in-law Dorothy Reed (in turquoise), Bodaway near Pillow
Hill, Arizona

To Amy Jo, my wife and best friend,
and to our sons,
Benjamin and Aaron.

And to the faith I have found in my Lord Jesus Christ,
it is for Him that I live.

Sixty years have passed since I first met the Navajo, but my memory of that day remains vivid.

I was 10, a young boy living in a small Mormon farming community in northeastern Arizona. My uncle had asked me to help deliver a truckload of baled hay to a trading post on the Navajo reservation. After a lengthy drive up a rocky slope and along a forested ridgetop, we reached the site. Nearby, a group of Indians was conducting a religious ceremony, or sing.

As we finished unloading the hay and were preparing to leave, something startling occurred. Four Indian men clad in loincloths and fox skins—their half-naked bodies painted with white clay, their heads shrouded with fringed deerskin masks—issued single file from the trees. Chanting and shaking their gourd rattles, the dancers (who hardly seemed human), drew near, performing a ritual that had first been choreographed centuries before.

I was dumbstruck. At that moment, I did not know that this was one of the Navajo tribe's most sacred rites. Nor did I suspect that the pulse of my own life was destined to periodically bring me back into intimate contact with the Navajo. All that I knew—and I knew it instinctively, in my bones—was that I was witnessing something primeval, mysterious and magical. This forest was a church, and these people were communicating with their gods.

In the years since those dancers came filing through the trees, Navajo society has been transformed. In 1930, Navajo subsistence revolved around flocks of sheep, small fields of corn and squash, and the cycle of the seasons. Living in earth-floored, dome-shaped hogans scattered across a reservation larger than West Virginia, the Navajo were a people of the earth, a half-invisible nation within a nation.

Traveling on horseback, in wagons or on foot, bartering wool for essentials at isolated trading posts, hauling their drinking water from the nearest spring, they lived a rugged existence. In winter, when the deep snows came and temperatures plunged far below zero, extended families of three and sometimes four generations huddled together in the hogan, feeding piñon and juniper to the fire, listening to the elders talk of the Long Walk, the exodus forced on the tribe during the early 1860s by white soldiers under Colonel Kit Carson.

The Great Depression, World War II (in which Navajo "code talkers" served with distinction), and the coming of the automobile to the reservation brought a hurricane of change that is still underway. This book, nearly three years in the making, is a contemporary portrait of the Navajo, one that shatters the old stereotypes. In Joel Grimes's exquisite photographs, we see the Navajo in all their current diversity: Navajo in cowboy hats and football uniforms; Navajo in chemistry labs and clinics; Navajo coal miners, sculptors and rodeo hands. Sheep, shepherds and hogans have not vanished, and we see a selection of them here, but the thrust of this book's message is change, and all that it has wrought. A small detail in one photograph may say it best: Ninja Turtles painted on a Navajo child's bedroom door.

This book is being published at a critical moment in Navajo history. Cousins to the Apache, the Navajo have always been brave warriors. But no battle the tribe has ever fought compares with the challenge it now faces. The foe, if indeed it is a foe, is both elusive and seductive: popular culture, the unrelenting bombardment of television, radio, movies and, now, shopping malls. The Navajo are not yet in the American mainstream, but powerful economic and social currents threaten to sweep away their tribal heritage. The Navajo are a proud people, deeply rooted in their land, clans and religious traditions. They are fully aware of their dilemma, as is evident in the dialogue of voices we find in these pages. Wandering between two worlds, recognizing that to some

extent they must swim in the sea that surrounds them, yet hesitant to discard the old ways that have served them so well, the Navajo debate their future.

My hope is that the tribe can discover a middle ground between their culture and ours, a cultural niche as rich and full of nuances as one of the intricately woven rugs for which their weavers are famous. To achieve this goal the tribe must succeed at three difficult tasks: educating their young, protecting their land and natural resources, and preserving the essence of their cultural inheritance.

In 1868, when they returned from the Long Walk, the tribe numbered about 9,000. Today, there are 210,000 Diné, as they call themselves. This population explosion has, in effect, created two tribes: the old (most of whom don't speak English) and the young (nearly all of whom do). The 60 percent of Navajo who are under 24 have lived a different life than the arduous, pastoral existence their grandparents knew. They can't go back, even if they wished to. But housing, jobs and economic opportunity are all in short supply on the reservation. Unemployment hovers around 33 percent. Half of all Navajo homes still lack running water or electricity. Alcoholism and drug abuse claim the lives of too many young people, who feel bewildered, caught between confusing, competing cultures.

A century ago, the Navajo chieftain Manuelito said, "Education is the ladder. Tell my people to take it." These wise words are still germane today. Only if young Navajo are well educated, will they be able to find meaningful work and reconcile the conflicting currents that buffet their lives.

If the tribe's young people are an economic resource, so too are its landholdings. The Navajo reservation contains substantial supplies of coal, oil and natural gas. Judicious development of these resources can provide some of the jobs and capital the tribe so desperately needs. In the long run,

however, one of the tribe's greatest economic assets may prove to be the scenic grandeur of the landscape.

Earlier in this century, the harsh beauty of Navajoland was not always appreciated by those from more verdant climes. One Indian agent termed this region of red sandstone monoliths, hidden canyons, towering mesas and distant horizons "the most worthless country that was ever laid outdoors." Today we know better. Millions of tourists, many of them from overseas, flock to the Four Corners region to revel in the magnificent scale, the subtle patterns, the immensity of this exceptional landscape.

The Navajo homeland is unique. There is only one Monument Valley on earth. Only one Rainbow Bridge. One Canyon de Chelly. We do not find Indian ruins like those at Chaco Canyon or Keet Seel elsewhere. Tourism is fast becoming the world's largest industry, and I believe the Navajo will ultimately profit from this trend.

The tribe will also benefit if it can somehow conserve its cultural inheritance, an invisible resource but one of great value. Like other indigenous peoples, the Navajo have suffered from the cultural imperialism that is deeply embedded in Western civilization.

For more than a century, Anglo-Americans have tried to foist their values on the tribe: requiring Navajo children to speak only English in school, for example, or ridiculing Navajo medicine men and their "pagan" sandpainting rituals (which one expert considers one of the "great healing systems of the world"). When not actively undercutting their religion—"tradition is the enemy of progress" Navajo schoolchildren used to be told—we whites have built ski areas on mountains the Navajo consider sacred, dammed rivers they deem holy, and polluted their skies.

Even our well-intentioned efforts to "help the Navajo" have often been counterproductive. Given

this sorry history, it is truly remarkable how much of the Navajo heritage has survived. This is a tribute to their resilience, good judgment and yes, obstinate adherence to the "old ways." Happily for them and, I believe, ultimately for us, the Navajo have never been in a hurry to adopt Anglo customs.

Even today, the old traditions hold a powerful tug for many Diné, particularly the elderly. (One Navajo woman I know has chosen to move out of her frame house to spend her last years in a hogan.) But many young Navajo, too, seem to realize the folly of trading their ancient inheritance for the meaningless pursuit of consumerism. Young and old, many Navajo are actively striving to preserve the best of their culture, even as they borrow from ours. But why should we care whether the Navajo succumb to the incessant, often vapid drumbeat of Anglo culture?

Although I do not subscribe to the myth of the noble savage, the Navajo do possess sophisticated insights about the natural world and the role of humans in it, insights which can benefit all of us. Perhaps because the Navajo have always lived close to the land, in their belief system there exists no rift between Man and Nature. The Anglo-American view of the landscape as inanimate, a clay to be shaped to our liking, is alien to them. On the contrary, their elders teach that trees and other living things are "manifested gods." The Navajo also understand that the earth should not be injured, for if the earth becomes ill, its sickness will inevitably be transmitted to man.

Contemplating such ideas leaves me wondering if the Navajo don't have as much to teach us as we have to teach them. After all, it is "white men's ways" that have led to ozone depletion, climate change, nuclear weapons, acid rain and toxic waste. To date, the Navajo have survived Western civilization. Now the question is whether Western civilization can survive its mistakes.

The Navajo believe that something is good when it is in accord with nature. By contrast, evil arises from forces or activities that are out of control. As we approach the year 2000, it is clear that most human beings are in conflict with the environment that sustains them. Restoring the harmony between humankind and the environment—the central thrust of Navajo spiritual tradition—may be the most critical task of the coming century. Might not their wisdom guide us in this endeavor?

After six decades of contact with the Navajo, I'm convinced that their rich culture has much to offer. And so I'm proud to champion these dignified, indomitable people, who deserve more respect, consideration and attention than they sometimes have received.

What you hold in your hands is a worthy book. My hope is that it will be widely read, both by Anglo-Americans wishing to gain a better understanding of the Navajo, and by the Diné, the Navajo themselves, as they attempt to hang on to the best parts of their culture. In the words of their prayer, *may they walk in beauty.*

— STEWART L. UDALL
Santa Fe, New Mexico

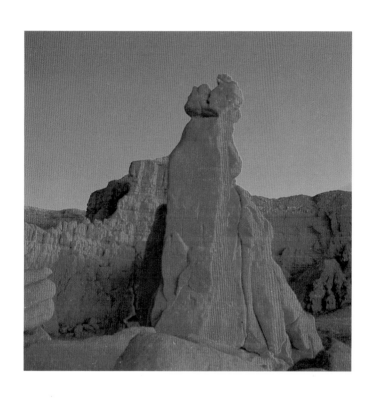

Afterglow light on rock formations

Dinnebeto, Arizona

*Lutie Wilson, mother of nine
and grandmother of 29,
Bodaway near Pillow Hill, Arizona*

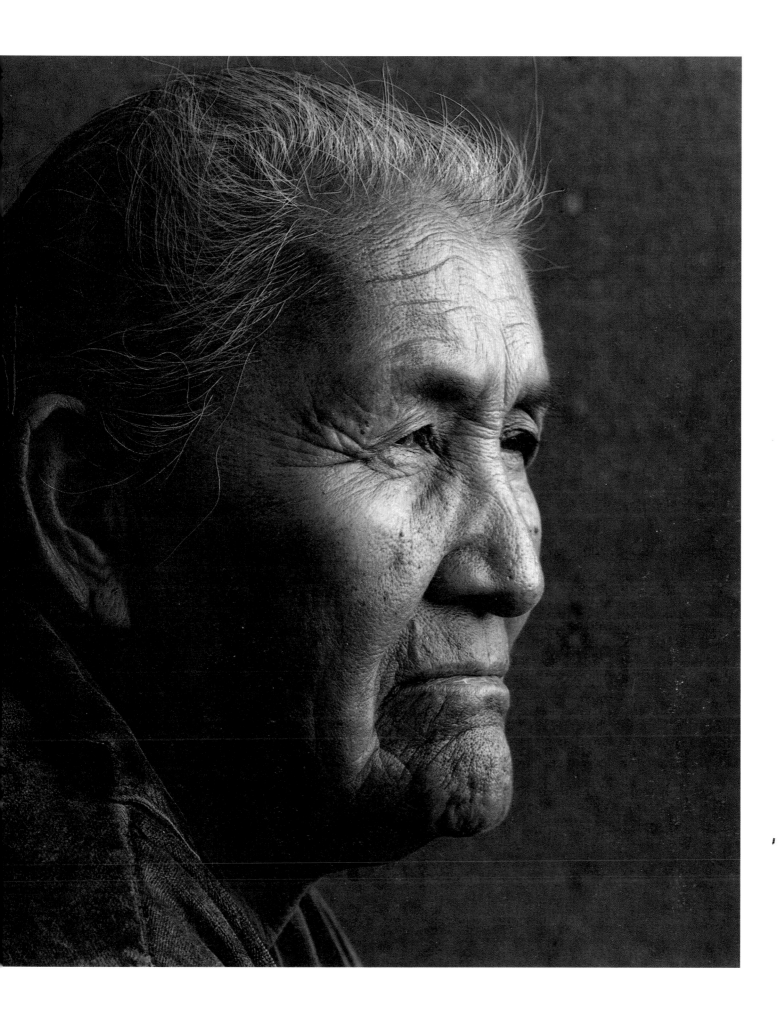

In order to comprehend modern Navajo culture, it is necessary to understand its history. The language of the Navajo, as well as the languages of their Apachean neighbors (the Jicarilla, Mescalero, Chiricahua and Western Apache), is an Athabaskan language. The closest linguistic kin to the Navajo are the hunting and fishing tribes of northwestern Canada and the interior of Alaska: such groups as the Kutchin, Ingalik, Kaska and Slavey.

About a thousand years ago, small bands of these northern hunters started drifting southward. The reason behind their migration and even the route remain unknown. Some archaeologists postulate a passage down the High Plains, along the eastern margins of the Rockies, in search of bison and other game. Other archaeologists argue that they travelled south through the Rocky Mountains or even across the Great Basin. Most believe that these small bands of wandering Athabaskan hunters did not reach the Southwest until the early to mid-1500s, about the same time that Coronado and the first Spanish explorers were entering the region from the south.

The Southwest probably appealed to the nomadic Athabaskans because of its relative emptiness. Between A.D. 1200 and 1300, disease, drought, erosion and other factors had destroyed much of the region's population and brought about the collapse of the period that archaeologists call Classic Pueblo. Mesa Verde, Chaco Canyon and most other areas had been abandoned by Puebloan peoples, and the survivors had moved to the Rio Grande Valley, the Hopi mesas or Zuni.

By the mid-1500s, the Pueblos still had not recovered from the disasters of the 13th century, and much of the heartland of the Southwest remained devoid of any permanent settlements. This empty land with its vast herds of antelope, deer, elk and other game proved a natural magnet for the northern hunters. As they entered the Southwest, the Athabaskan bands dispersed. By the late 1500s they occupied all the vacant lands around and between the Pueblo groups. Regional differences soon appeared among the Athabaskan groups, as some developed close contacts with the Puebloan peoples and adopted Puebloan traits, while others stayed more culturally isolated.

The group of Athabaskans who settled the upper portion of the San Juan Valley in New Mexico developed a close relationship with the Pueblos and even adopted farming to supplement their hunting and gathering. This group farmed on such an extensive scale that the Spanish later called them the *Apache de Navajo*, Navajo meaning "great fields."

In 1598 Juan de Oñate and Spanish colonists from Mexico invaded the Southwest. As settled townspeople, the Pueblos fell easy prey to Spanish guns and horse-mounted soldiers. Within a few years, all of the Pueblos from the Rio Grande to the Hopi mesas came under control of Spanish priests and soldiers.

Although Christianity had to be forced upon them, the Pueblos more willingly accepted other Spanish introductions, in particular sheep, goats, cattle, horses, wheat and metal tools.

In contrast to the Pueblos, the Athabaskan groups proved impossible for the Spanish to dominate and control. Living in small, scattered family groups, they were not as vulnerable to the Spanish military and missions. Attempts to create mission settlements among them failed, and the Athabaskans

1520—1580	1626	1846—1848	1863	1863—1864	1864—1868	1868
Earliest evidence of Navajo	*First mention of Navajo by Spanish explorers*	*Mexican War, which led to U.S. possession of Southwest*	*Navajo population exceeded 10,000*	*Beginning of Long Walk to Bosque Redondo Reservation on eastern New Mexico plains, where U.S. government thought Navajo could be converted into farmers*	*Navajo War, one of the most violent and decisive military campaigns ever waged against a major North American Indian tribe*	*Almost 8,500 once-prosperous Navajo eventually imprisoned in disease-ridden squalor at Bosque Redondo, under close guard of troops stationed at nearby Fort Sumner*

remained outside the orbit of Spanish control. Except for the introduction of the horse and limited trade, the early Spanish had little direct influence on the Athabaskan way of life.

In 1680 the Pueblos rose up in revolt against their Spanish overlords and drove them from the region. Their success was, however, short-lived, as the Spanish returned in force in 1692, and in a bloody four-year war re-established control. Realizing that armed resistance was hopeless, many Pueblos fled their villages along the Rio Grande, and some took refuge among the Apache de Navajo.

Few of the Pueblos who took refuge ever returned home, preferring instead to live free from Spanish control. It was the eventual cultural and biological fusing of the Apache de Navajo and the Pueblo refugees that created the Navajo.

From their Athabaskan ancestors, the Navajo received their language, ghost beliefs, basic social norms and values, as well as their distinctive hogan dwellings. From their Pueblo ancestors, the Navajo acquired blanket weaving and pottery making, the matrilineal clan system, and most of their mythology and religious practices. Navajo sand painting was based upon Pueblo sand painting, while Navajo supernatural beings, the *Yeis*, were derived from the Pueblo *kachinas*. The Pueblos also brought with them many Spanish traits which they had earlier adopted, particularly the herding of sheep, goats and cattle.

By the early 1700s, a distinctive new people—the Navajo—had emerged. At first they lived in the rugged canyon lands of the upper San Juan, an area known as the *Dinetah*, or land of the *Diné* (*Diné* being their word for "people," by which they meant themselves). Their economy combined hunting, herding and farming and proved highly adaptive.

In the mid-1700s, the Navajo began rapidly expanding to the south and to the west. As they expanded geographically, their population also grew rapidly, because of natural increase as well as absorption of other small groups of Athabaskans, Utes, Paiutes and Pueblos. Some small groups willingly merged with the Navajo, but captives also served to swell their numbers.

The Navajo clan system came to reflect the diverse origins of the Navajo people. Navajo children assumed the clan affiliation of their mother, and if their mother was a non-Navajo a new clan was created for them. Thus the 70 Navajo clans include the Ute clan, the Many Hogan clan (Hopi), the Reed clan (Hopi), the Black Stripe clan (Zuni), the Coyote Pass clan (Jemez), the Black Sheep clan (San Felipe pueblo), the Red House clan (San Juan pueblo) and even the Mexican clan, to name only some with non-Navajo origins. More than one-third of the Navajo clans are derived from some other people.

In the late 1700s and early 1800s the Navajo continued to grow in numbers and prosperity. Their herds of sheep were their primary source of wealth, supplying them with their major food source as well as items for trade. Blankets woven by the Navajo were sought-after trade items in the Southwest and were exchanged with neighboring Mexicans, Pueblos, Utes and Apaches.

It was during this period that Navajo began wearing silver jewelry. At first this jewelry was acquired through trade with Hispanic silversmiths along the Rio Grande. In the mid-1800s, however, the Navajo learned silver-smithing and began making their own silver jewelry.

Following the Mexican War of 1846 to 1848, the United States gained possession of the South-

1869	late 1870s	1882	1887	1900	1920s	1930s
First trading post at Fort Defiance	Navajo economy began to regain self-sufficiency	2.4-million-acre reservation established in Arizona for Hopis and other Indians, including Navajo	Passage of compulsory school act	Navajo population exceeded 20,000	Seasonalized wage labor emerged, leading to relative prosperity when integrated with traditional Navajo economy	U.S. government imposed program of mandatory livestock reduction in effort to alleviate over-grazing on reservation lands, thus forcing increasing numbers of Navajo into labor market

west. American officials soon realized that the Navajo were the most prosperous and powerful of the tribes of the region. Now numbering almost 10,000 people, with herds of sheep and goats counted in the hundreds of thousands, the Navajo occupied most of the land from the Jemez Mountains west to the San Francisco Peaks and from Mount Taylor to the La Plata Mountains. The initial goals of federal policy were containment of the Navajo and maintenance of peace between them and their neighbors.

Peace proved difficult to maintain. Local Mexicans and Anglo-American newcomers periodically raided the Navajo herds, and the Navajo responded in kind. Blaming the Navajo for the conflict, the government declared war on them in 1863. In a short but bloody conflict, more than 8,000 Navajo were captured and moved to the Bosque Redondo Reservation on the plains of eastern New Mexico.

For four years, the Navajo were held prisoner as government officials tried in vain to make them into farmers. Admitting failure in 1868 at the end of the Civil War, the government gave the Navajo a small reservation in their old territory and allowed them to return. The motivation for this reversal in policy was economic, not humanitarian. Internment at Bosque Redondo was costing the government too much. The plan was to return the Navajo home and make them economically self-sufficient.

Three main factors have strongly influenced Navajo culture since 1868: (1) an inadequate land base, (2) a lack of adequate government support, and (3) an expanding population. The Navajo reservation in 1868 encompassed fewer acres per capita than almost any other reservation in the United States. Although American officials knew the Navajo were primarily stock raisers and wanted them to be self-sufficient, they deliberately kept them land poor. The rationale was that scarcity of land would force them to shift from livestock to farming. Later extensions to the Navajo reservation were made slowly, reluctantly and grudgingly. Lacking an adequate land base, a high percentage of the population has had to live off-reservation since 1868.

It was not until the 1950s that federal funding for the Navajo was sufficient to meet the obligations of the 1868 treaty. In terms of food rations and other support, the government followed a policy of work or starve: Navajo received less per capita than any other reservation tribe during the 19th century.

At the time the treaty was signed, the Navajo were impoverished. Herds had been destroyed, and fields were overgrown. Government assistance consisted only of 25,000 sheep and goats, some food rations, cheap blankets and farming equipment.

Having to start over did not deter the Navajo, who quickly rebuilt their herds. Within a decade, the Navajo owned more than 500,000 sheep and goats and were again self-sufficient.

During the 1880s the herds continued to expand, until by 1891 the Navajo owned an estimated 1.5 million sheep and goats, as well as tens of thousands of horses and cattle. Their agent reported that the Navajo were the second richest tribe in the United States. The important fact is that they accomplished this feat through their own hard work, with negligible assistance from the government.

The land base, however, could not be expanded to accommodate the herds needed by the ever-growing Navajo population. By the 1880s, Anglo-American and Mexican-American ranchers had occupied

1940s	1941	1950	1955	1950s—1960s	1950s—1970s	1960
World War II and mandatory livestock reduction devastated Navajo relative prosperity and economic self-sufficiency, leading to poverty and bureaucratic domination	Hopi district of 1882 Reservation expanded for first time, forcing first of many Navajo to relocate	Rehabilitation Act gave Navajo Tribal Council power to allocate tribal revenues	Education Scholarship Fund established	Universal education of children in Indian schools exposed students to Anglo-American culture	Cars and trucks replaced wagons as standard mode of transportation	Navajo population about 90,000

all of the available rangeland surrounding the Navajos. No new rangeland was available, while the land within the reservation was already overstocked and overgrazed. New ways had to be found to support the population, which by 1900 exceeded 20,000.

Trading posts had been established on the Navajo reservation in the 1870s. At first, trade was limited to the exchange of hides, pelts and a few blankets for metal tools and other manufactured goods. In the 1880s Navajo began trading surplus wool for flour and other foods. However, it was not until the 1890s that the Navajo trade began to boom. Because they could no longer adequately support their families by subsistence herding, farming and hunting, the Navajo commercialized their herds and their crafts.

Navajos began to market their wool and surplus lambs annually. Navajo weavers stopped weaving blankets and began weaving rugs for the Anglo-American market, while Navajo silversmiths began producing silver jewelry for tourists. As the Navajo trade increased in volume, new trading posts sprang up throughout the reservation. By the 1920s, posts were found in even the most isolated areas.

The Navajo population reached almost 40,000 by 1930, and their economy of herding and farming, supplemented by the marketing of wool, lambs, rugs and jewelry, was no longer adequate to provide for their needs. To make matters worse, severe overgrazing had damaged most of their rangeland, prompting the U.S. government to establish a program of mandatory livestock reduction and stock control.

Wage labor became necessary. At first it was seasonal, with one or more members of the family working off the reservation for the railroad or in agricultural harvests. After 1950, opportunities for permanent jobs increased on the reservation and in nearby off-reservation communities. Seasonal labor was gradually replaced by permanent full-time jobs. These economic developments did not, however, change the basic structure of Navajo life.

Most Navajo still live as part of a large extended family. While wage labor is the main source of income, most families still farm and keep livestock. While they may do most of their shopping at Safeway or Thriftway, most also butcher their stock and grow some of their own food. Most families still market wool and lambs and have one or two individuals who weave or work silver.

In their economic life, as in other aspects of their culture, the Navajo have incorporated new ways and items without surrendering the old. Over the past 400 years the Navajo have added considerably to their culture, but have lost little. With the Navajo the past is still present, and Navajo cultural practices of the 18th century exist side by side with those of the 20th century.

— DR. GARRICK BAILEY AND
ROBERTA GLENN BAILEY
The University of Tulsa, Oklahoma

1960s	1968	1970	early 1970s	1986	1990	1992
Contract schools controlled by local Navajo emerged	*Navajo Community College established*	*College of Ganado established; Northern Arizona University began offering extension courses on reservation, and other state institutions became more accessible*	*Rapid replacement of hogans by western-style houses*	*Deadline passed for Navajo to vacate entire 1882 Reservation, including former non-Hopi district; many Navajos have yet to obey this government order to abandon their ancestral lands*	*U.S. Census reported Navajo population exceeding 165,000 on now-almost-18-million-acre reservation*	*Tribal sources reported Navajo population exceeding 200,000 on and off reservation*

NAVAJO

PORTRAIT OF A NATION

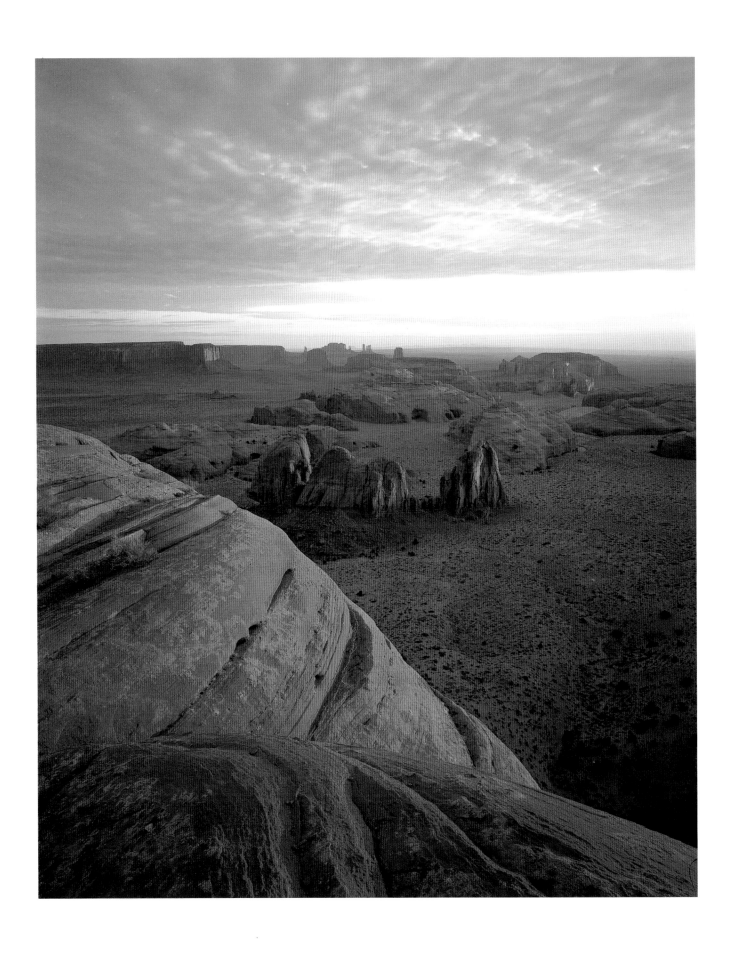

The fire hums in the half-bellied oil barrel wood stove. It shoots smoke through its pipes, which project through the square opening in the hogan's dome-shaped ceiling. Specks of stars peek through the smoke hole. Navajo elders say that *Ma'ii*, the trickster coyote, hastily tossed the stars into the heavens.

The kerosene lamp placed by the wood stove offers limited lighting in the dark hogan, occasionally flickering shadows of guests on the hogan walls. Women sit in the north of the hogan, and men to the south.

Jecal Bedonie, a 95-year-old Navajo medicine man, sits in the west of the Cottonwood Springs hogan with a headband wrapped around his silver hair. His patient sits to his left. Bedonie's eyes are closed. He follows an unwritten script exactly as it has been done for generations. In an ancient, falsetto, nasal language Bedonie begins to sing the Wind Way Chant. He sings of the spiritual wonders of an adventure by the hero of a Navajo legend.

Earlier in the day, the patient's family from Piñon, Arizona, drove their dark blue Ford pickup truck some 140 miles to Sanders, seeking the help of the medicine man. Health problems afflicted a grandson. A hand trembler, or diagnostician, had recommended a Wind Way Chant. Someone over by Cottonwood Springs had spoken highly of Bedonie.

A family representative negotiated a fee for the medicine man after Bedonie heard the exact nature of the illness. An agreement was reached. The patient's family carried Bedonie's buckskin medicine bundle to their pickup. A medicine man always follows his bundle. Bedonie rested comfortably in a choice seat in the truck. Although other medicine men drive to and from their patients' homes, Bedonie has never driven a chidi; he has never learned how to drive.

Navajo, the *Diné* or the People, are a spiritual tribe whose religious ties are heavily rooted to Mother Earth and the Holy People, deities the Navajo believe created them and placed them on this earth. Some Navajo are also members of Christian churches and the Native American Church.

The traditional belief system says the Navajo emerged through a reed from four colorful underworlds to *Dinetah*—the Place of Emergence—in northwestern New Mexico. The People started in the Black World, journeyed to the Blue World, the Yellow World, the White World and finally emerged into the present world.

Navajo chantway myths tell different stories about Navajo history and culture. The Holy People, Navajo elders say, serve the role of disciples to Mother Earth by taking the form of wind, rain, thunder, lightning and snow. In the beginning, the Holy People defined the Navajo homeland by designating the Four Sacred Mountains—Blanca Peak to the east (present-day Colorado), Mount Taylor to the south (New Mexico), San Francisco Peaks to the west (Arizona) and the La Platas to the north (Colorado). *Shii'kayah*, "my land or my home," is what Navajo call this land-

Lucy Sage

Kaibito, Arizona

Opposite: Monument Valley

Navajo Tribal Park

from Hunt's Mesa, Arizona

scape of valleys, plains, mesas, high plateaus and mountain areas with altitudes ranging from about 4,500 feet to slightly over 10,000 feet.

Until 124 years ago, Navajo were protected from the outside world by these distant plateaus and deep canyons. When the great Navajo chieftain Manuelito saw this unique lifestyle coming to an end, he told his children to get an education. His children did. Through the help of missionaries, the federal government and three states, school systems multiplied on the Navajo reservation.

Abiding half-heartedly to a provision in the treaty of 1868, thousands of young Navajo girls and boys were sent by agency officials to be educated in reservation boarding schools where, for a time, the practice was to ban any use of the Navajo language or discussion of Navajo culture. The idea was to remove the "Navajoness" from the individual and convert him or her into an Anglicized Indian ready to cope with modern society.

This practice changed in the 1950s. More and more schools were built across the Navajo reservation. The Navajo went from being one of the most unschooled Indian tribes in America to one of the most educated. In three decades a path was established that added Navajo teachers, doctors, lawyers and other professionals to the tribe's traditional callings.

By 1980, the schools were promoting the idea of using Navajo knowledge, culture and traditions, as well as American culture, to contribute to the well-rounded person in Navajo ceremony. More than 200,000 Navajo now live either on- or off-reservation. Some are professionals: Dr. Beulah Allen from Crystal, New Mexico; educator William LongReed from Tuba City, Arizona; artist Bessie Jackson from Navajo Mountain, Arizona, and 13-year-old weaver Celesly Shabi from Wide Ruins, Arizona. Some work the land: farmer Woody Ben from Chinle, Arizona, and sheepherder Mary Ann Nockiadeneh from Bodaway, Arizona. Others are the Navajo future: students Dwight Witherspoon of Tempe, Arizona, and Delores Wilson of Albuquerque, New Mexico.

Navajo society nowadays is a world that is neither white nor Navajo in the traditional sense. It is a world where values are shifting. Most of the changes can be attributed to education and more recently to the influx of television. Traditionalism survives mainly in the remote areas of the reservation, primarily because those Navajo have not been touched as much by the ways of the modern world.

Back in the Cottonwood Springs hogan, Jecal Bedonie sings stories of Navajo heroes. He carries within him the songs and prayers of well-known healers, such as the late Hosteen Nez over by Wildcat Peak or Hosteen Edgewater over by Hosteen Goldtooth's camp. In the Wind Way Chant, he sings about people a long time ago who overcame great obstacles caused by the powers of the supernatural: a hero turned into a snake by Snake People, a man fooled by a beautiful woman who was more than she appeared to be.

The patient, guided by Bedonie, follows the same journey as the mythical hero. At the end, the patient is restored—as is the Navajo hero. For more than 60 years, the elderly Navajo has served in the capacity of *hataalii*, a singer or chanter who guides his people on this journey and restores them to wellness and balance here on earth.

Bedonie is a singer of the Bead Way, the Evil Way, the Blessing Way and the Blackening Way. His elderly wife accompanies him to the various ceremonies, serving as an assistant in creating sand paintings or gathering wild plants for medicine. Like most medicine men, Bedonie is careful not to disclose too much about his songs and prayers. He believes in a philosophy common among singers that revealing details about the chants means an end to their life here on earth. "I'm alive because of my songs and prayers," Bedonie says. "The prayers and songs are who I am." Growing up in the 1920s on the reservation wasn't that simple for the elder. His parents died when he was very young and he was often shunted from hogan to hogan, raised by a large extended family in the harsh, rugged terrain of Dinnebeto and

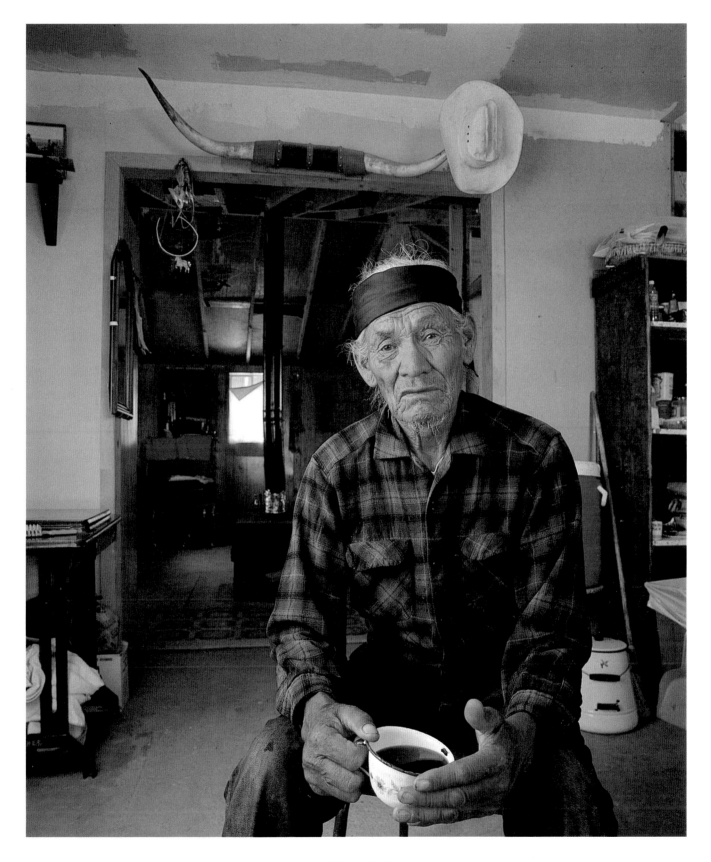

Slim Biakeddy

Tuba City, Arizona

Howell Mesa. This was when Navajo men wore slacks made out of Bluebird flour sack fabric and horse and wagons were a source of transportation.

For 20 years the singer followed and helped reputable and respected Navajo medicine men. Late one warm summer afternoon while resting in the shade of a ceremonial hogan near Tuba City, the young apprentice was overcome by a powerful feeling of knowledge.

"All the songs, prayers came to order in my mind. It entered my soul, my thoughts," Bedonie recalls. "People say that's when a young man knows the power to heal is within him. Throughout my life, I have never abused my profession. Never, during the time I was training or singing, did I drink or become involved in a physical fight. I ensure that songs and prayers are delivered correctly. Caution and care are aspects of my profession because I answer to the Holy People, who I believe blessed me with a medicine bundle. My work is sacred to me."

Mother Earth, in Bedonie's mind, is etched out and held together by prayers and songs. Each component of the universe—the moon, the sun, the darkness, the wind, the thunder—has its own song and prayer. "When the prayers and songs are gone," Bedonie warns, "that is the end of life here in this world for Navajos, the great singers told me."

Bedonie observes daily changes among his people caused by the modern ways. A transformation has not spared even his own family: recently his daughter gave him a picture of Jesus, which remains on a wall.

These changes create a gap, and often a distrust, between elderly people and the young. The gap worries some medicine men, including Bedonie, and prohibits the singer from passing his knowledge to a younger person.

"If I were training, I don't want someone to ridicule or disbelieve a song or a prayer which is sacred and precious to me as individual," Bedonie says. "There is also constant fear of how young people might perceive us and our beliefs. Some singers are afraid they'll be accused of witchcraft. I'm charged with restoring people to health, protecting my songs and prayers, which hold the earth intact."

It's rare to find a Navajo youth willing to train for 20 years as a medicine man, Bedonie believes. "Training to become a medicine man is more intense than, say, modern medicine. Navajo youth portray themselves as sluggish and many don't care about Navajo ceremonies. They appear to be more interested in living in the city where life is much easier. Plus, there is the gift which the Holy People bless you with; that's extremely important. If you don't have that blessing, no matter how much you train, it doesn't work.

"I've lived a long, peaceful life of hard work," Bedonie says. "To be a Navajo, one must have self-respect, self-discipline, respect for the earth and other people. It's hard, but bad words often create conflict. I've limited those in my life. If there aren't any bad words behind me, then everything is OK, everything is beautiful ahead of me. That is the way the earth, the world is. If there are no bad words around me, then life is beautiful behind, above and all around me."

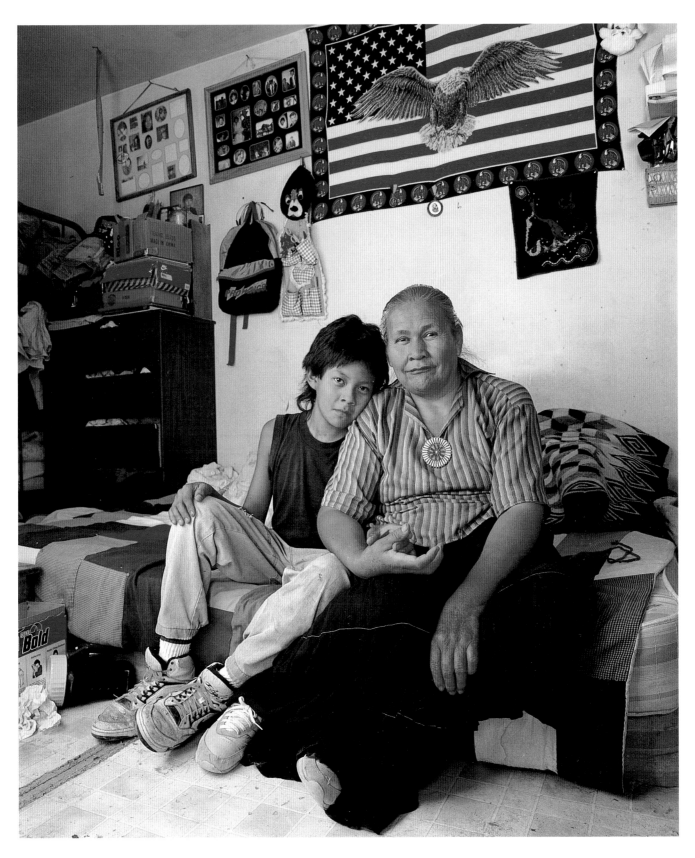

Fannie Goy and son Jonathan

Big Mountain, Arizona

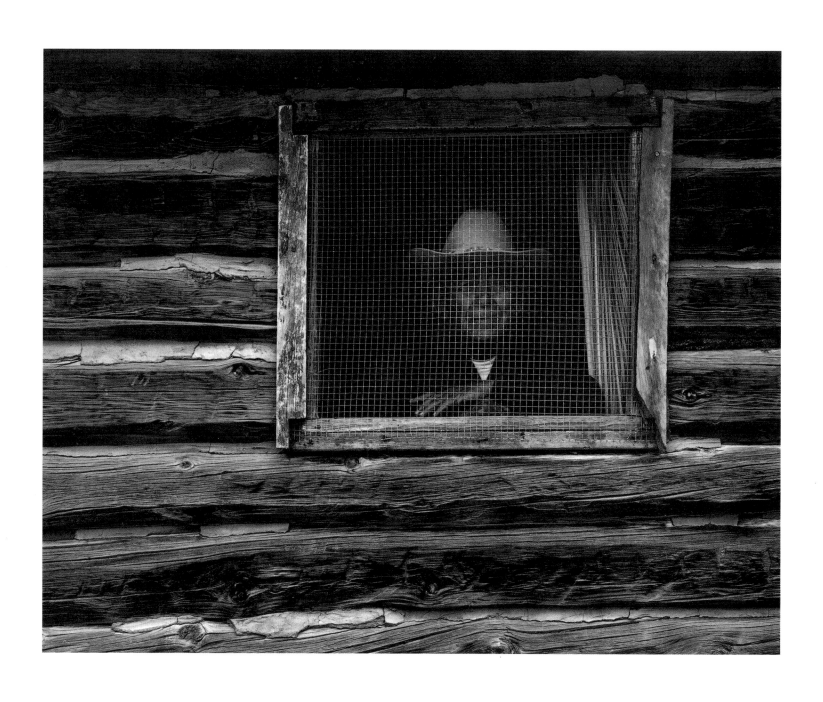

Rancher and farmer Chauncey M. Neboyia

Canyon de Chelly National Monument, Arizona

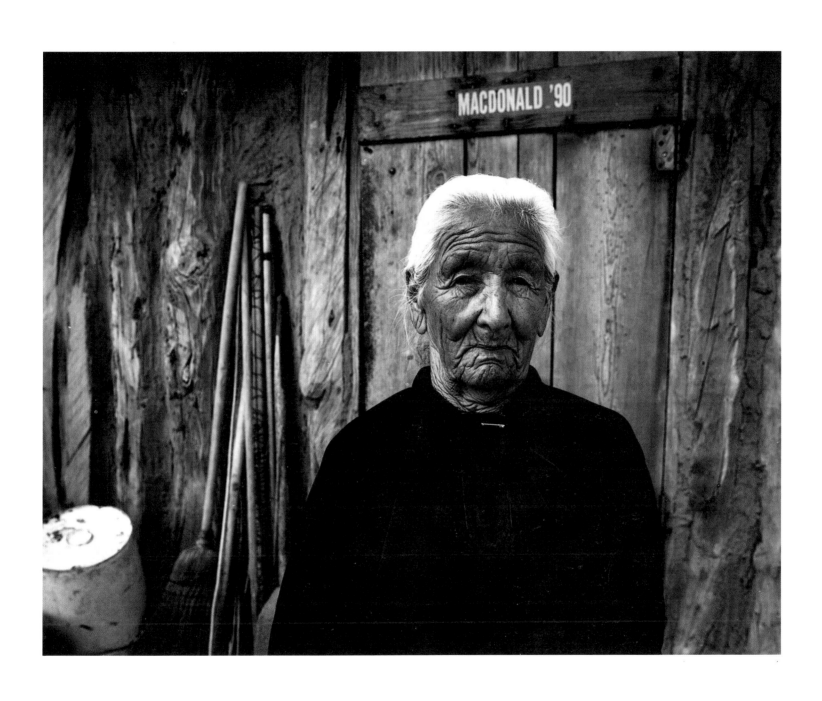

Sheepherder Manygoats Daughter

Big Mountain, Arizona

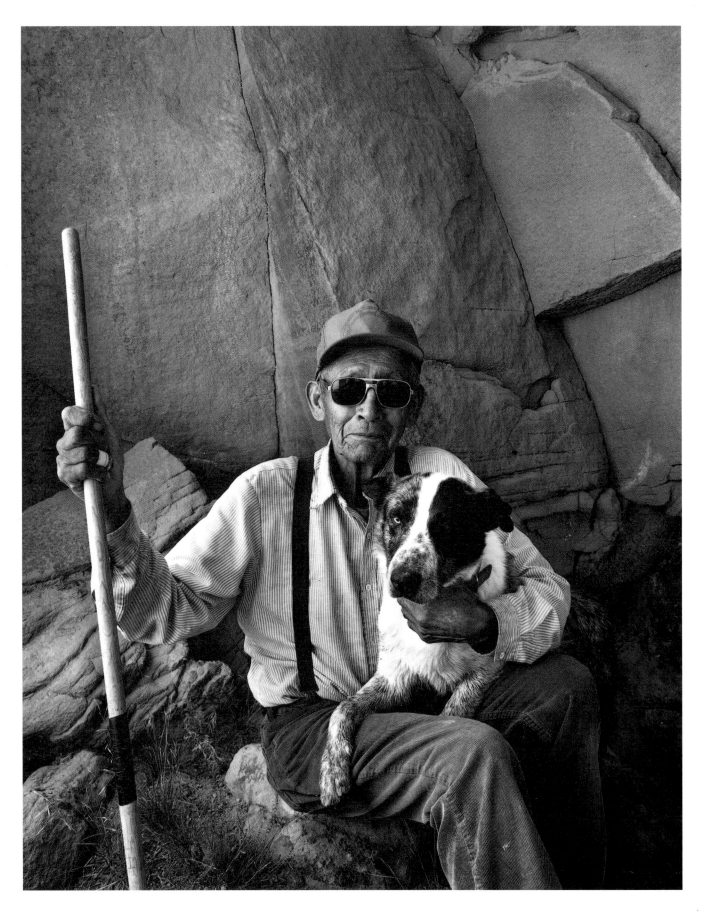

Sheepherder Leonard Haven, age 87

Twin Lakes, New Mexico

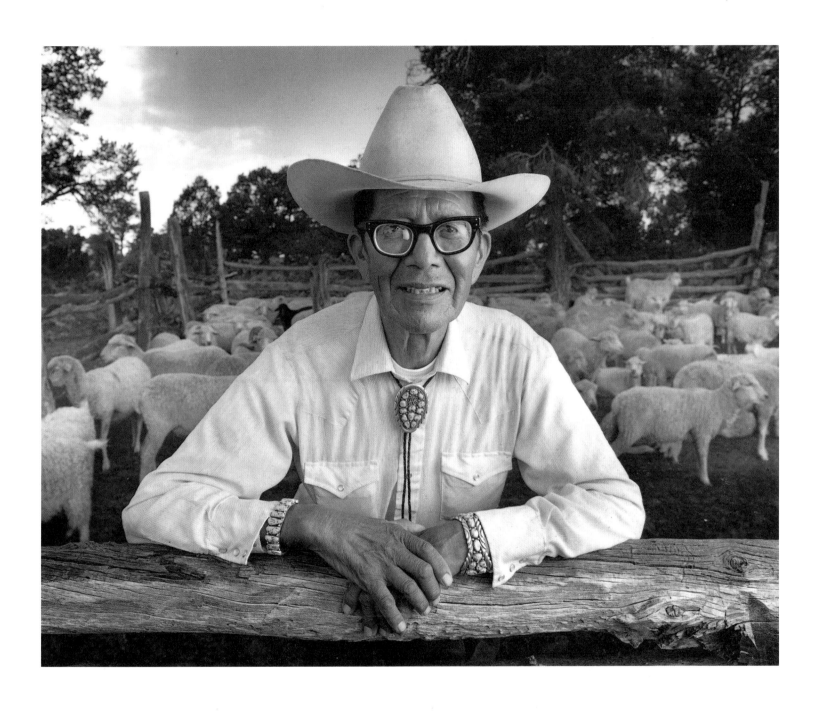

Sheepherder Jimmy Curley

Ganado, Arizona

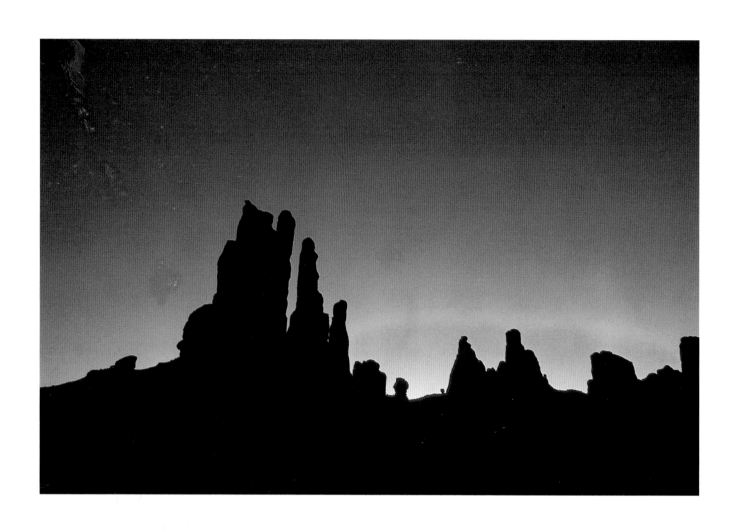

Yeibichei Rocks at Monument Valley Navajo Tribal Park

Arizona/Utah border

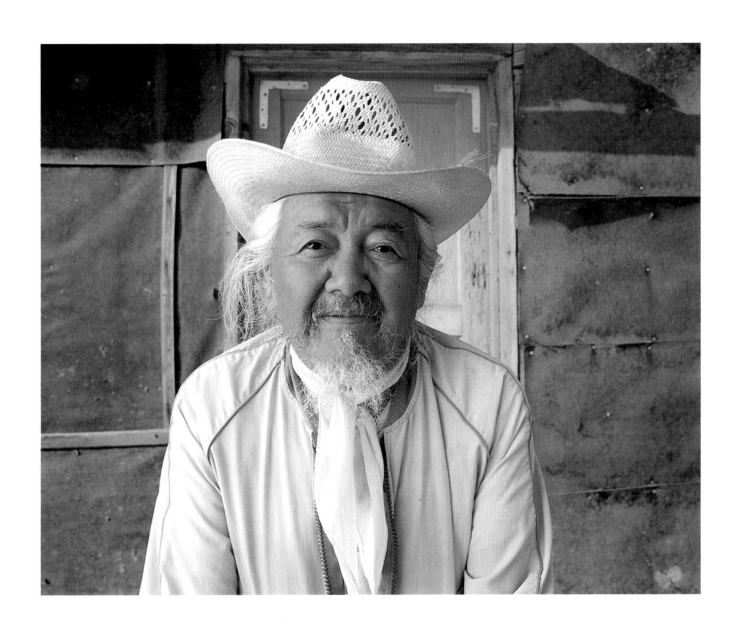

Silversmith Clarence Cleveland, age 82

Gallup, New Mexico

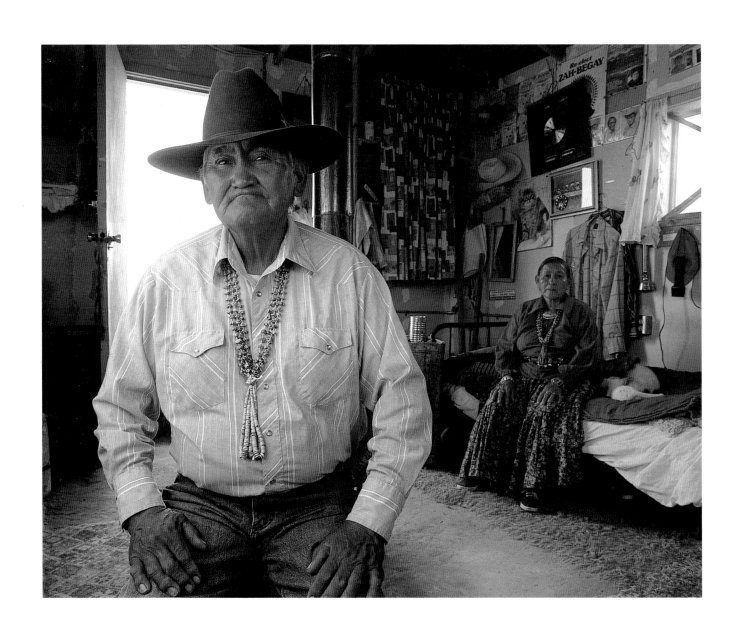

Ranchers Ned and Anita Keyonnie

Brimhall, New Mexico

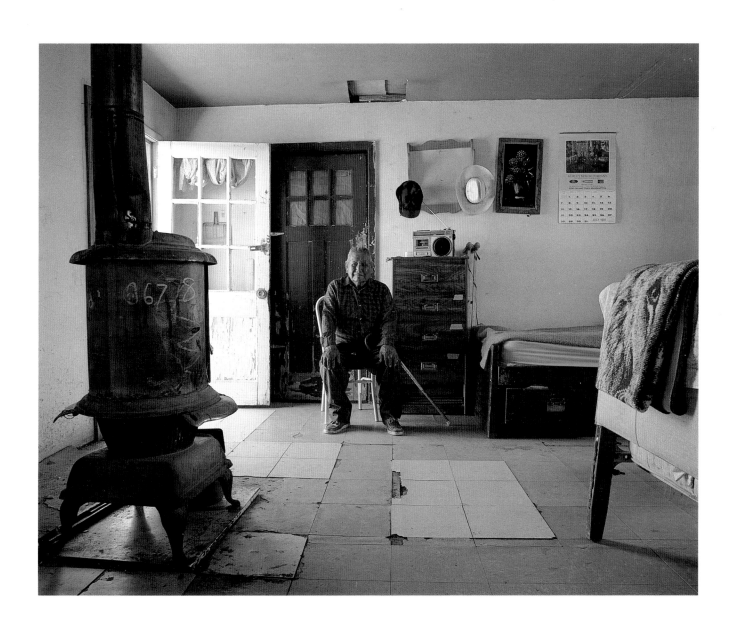

Rancher and former coal miner Mike Yazzie

Brimhall, New Mexico

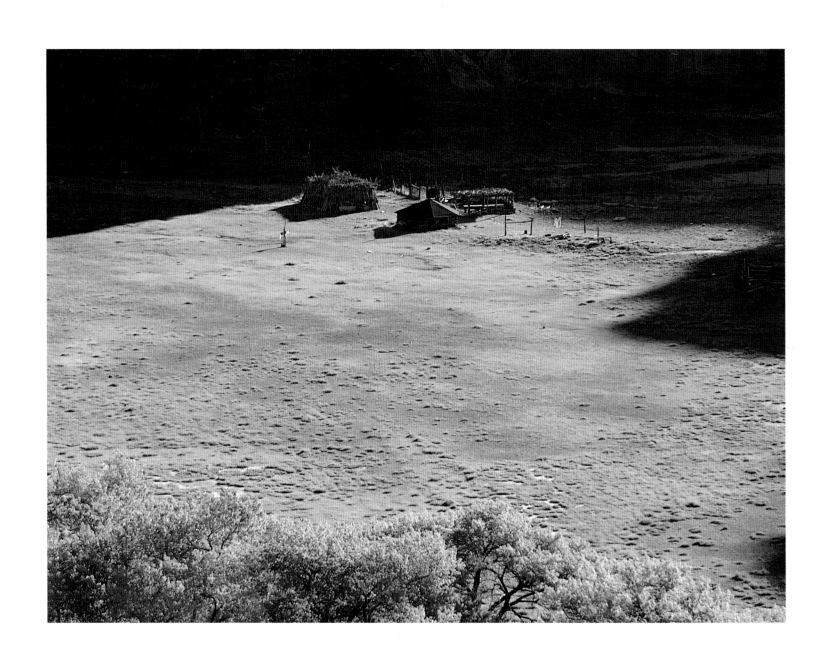

Early morning light on hogan

Canyon de Chelly National Monument, Arizona

Tɛanti hogani-la, / Hozhon hogan-e.

 Lo, yonder the hogan / The hogan blessed!

Hayiash-iye beashòje / Hogani-la, / Hozhon hogan-e,

 There beneath the sunrise / Standeth the hogan, / The hogan blessed.

Ka' Hastyeyalti-ye bi / Hogani-la, / Hozhon hogan-e;

 Of Hastyeyalti-ye / The hogan, / The hogan blessed.

Hayolkatli-ye be bi / Hogani-la, / Hozhon hogan-e;

 Built of dawn's first light / Standeth his hogan, / The hogan blessed.

Tan-alchaï-ye be bi / Hogani-la, / Hozhon hogan-e;

 Built of fair white corn / Standeth his hogan, / The hogan blessed.

Yotti-iltraɛɛaï-ye be bi / Hogani-la, / Hozhon hogan-e;

 Built of broidered robes and hides / Standeth his hogan, / The hogan blessed.

Tro-altlanastshini-ye be bi / Hogani-la, / Hozhon hogan-e;

 Built of mixed All-Waters pure / Standeth his hogan, / The hogan blessed.

Tradetin-iye be bi / Hogani-la, / Hozhon hogan-e;

 Built of holy pollen / Standeth his hogan, / The hogan blessed.

Ka'ɛa-a naraï,

 Evermore enduring,

Ka' bike hozhoni bi / Hogani-la, / Hozhon hogan-e.

 Happy evermore / His hogan, / The hogan blessed.

Tɛanti hogani-la, / Hozhon hogan-e.

 Lo, yonder the hogan, / The hogan blessed!

I-iash-iye beashòje / Hogani-la, / Hozhon hogan-e;

 There beneath the sunset / Standeth the hogan, / The hogan blessed.

Ka' Hastyehogan-i bi / Hogani-la, / Hozhon hogan-e;

 Of Hastyehogan-i / The hogan, / The hogan blessed.

Nahotɛoï-ye be bi / Hogani-la, / Hozhon hogan-e;

 Built of afterglow / Standeth his hogan, / The hogan blessed.

Tan-alchtɛoï-ye be bi / Hogani-la, / Hozhon hogan-e;

 Built of yellow corn / Standeth his hogan, / The hogan blessed.

Nekliz iltraɛɛaï-ye be bi / Hogani-la, / Hozhon hogan-e;

 Built of gems and shining shells / Standeth his hogan, / The hogan blessed.

Tro-piyash-iye be bi / Hogani-la, / Hozhon hogan-e;

 Built of Little-Waters / Standeth his hogan, / The hogan blessed.

Tradetin-iye be bi / Hogani-la, / Hozhon hogan-e;

 Built of holy pollen / Standeth his hogan, / The hogan blessed.

Ka'ɛa-a naraï,

 Evermore enduring,

Ka' bike hozhoni bi / Hogani-la, / Hozhon hogan-e.

 Happy evermore, / His hogan, / The hogan blessed.

Tɛanti hogani-la / Hozhon hogan-e.

 Lo, yonder the hogan, / The hogan blessed!

HOGAN BIYIN
*Song of the Hogans
(Hozhonji Song)*

▲

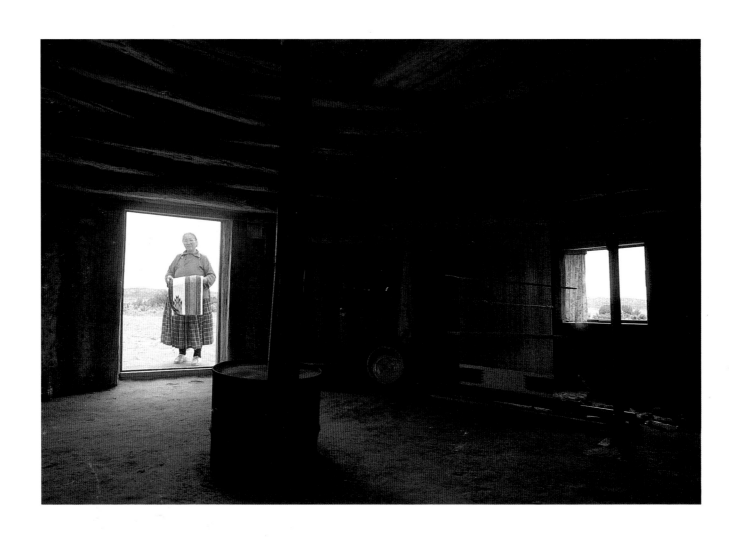

Weaver Mae Chee

Big Mountain, Arizona

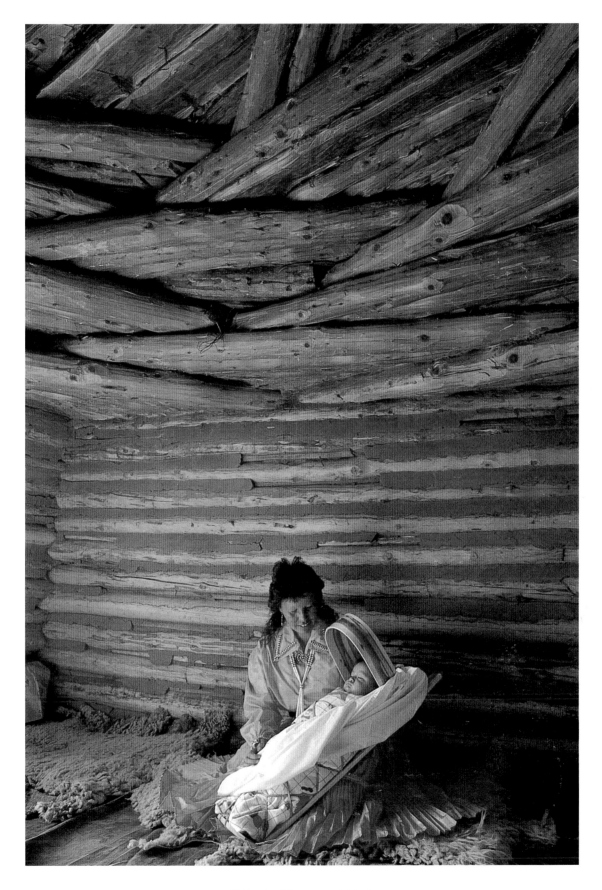

Shikanita Thompson with baby

Chinle, Arizona

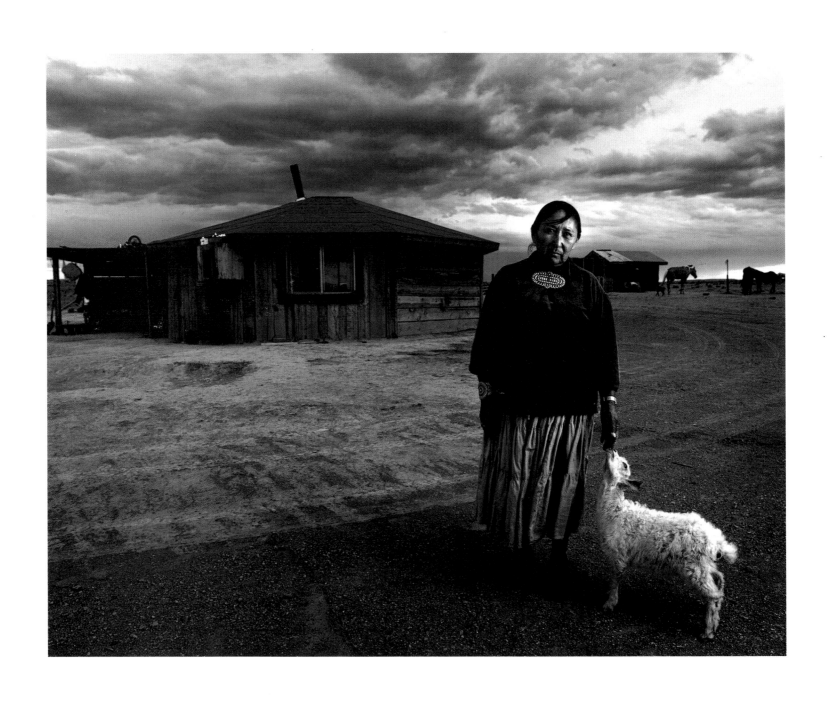

Sheepherder Mary Ann Nockiadeneh with goat

near Pillow Hill, Arizona

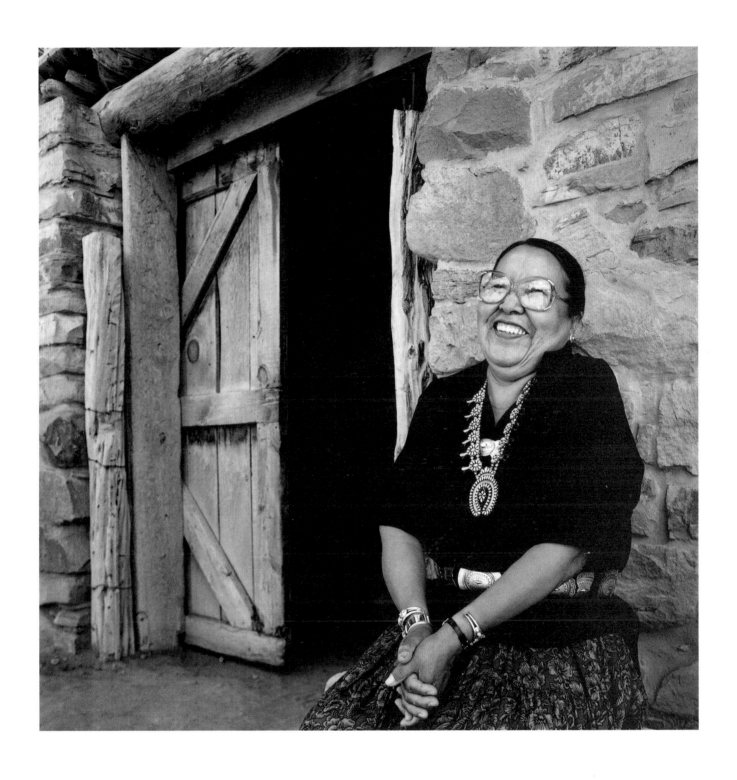

Weaver Helen Kirk at Hubbell Trading Post

Ganado, Arizona

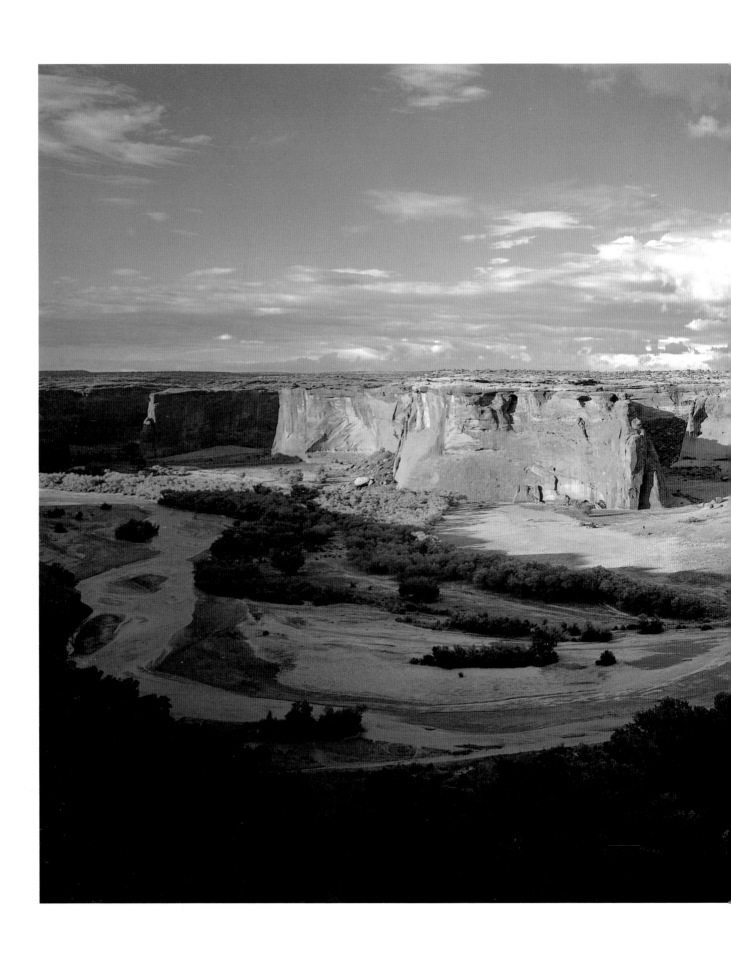

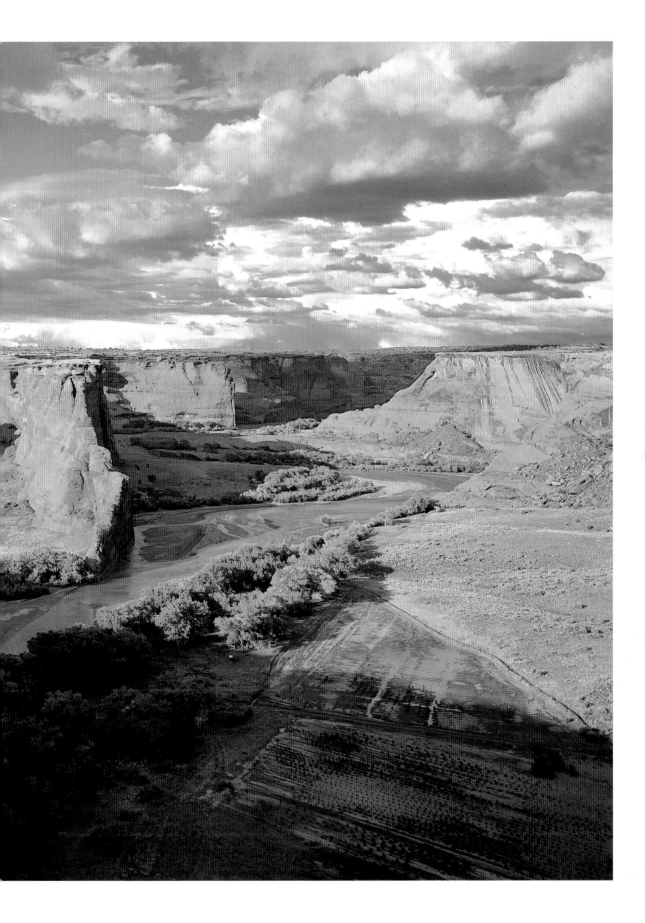

Canyon de Chelly National Monument

from Tsegi Overlook, Arizona

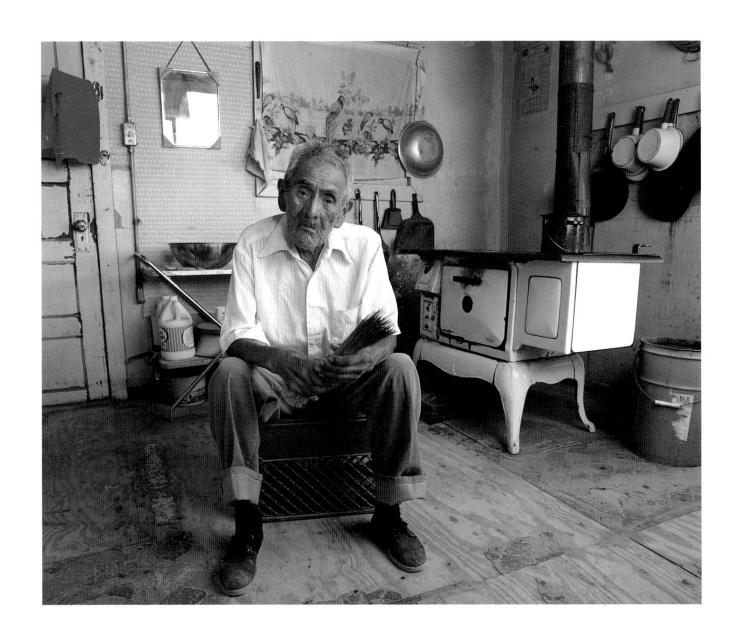

Rancher Billy Arviso, age 87

Crownpoint, New Mexico

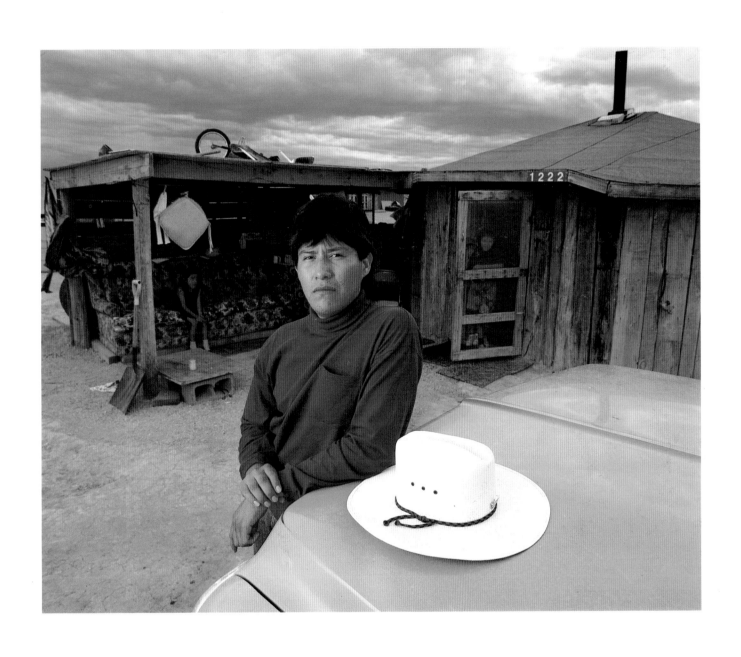

Franklin Nockiadeneh

near Pillow Hill, Arizona

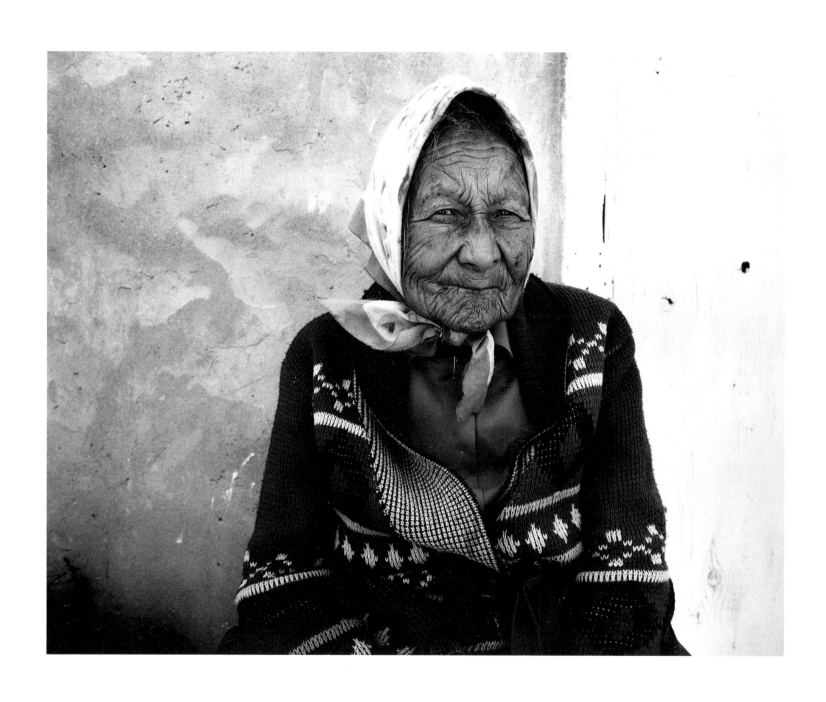

Lucy Peshlakai, age 70

Naschitti, New Mexico

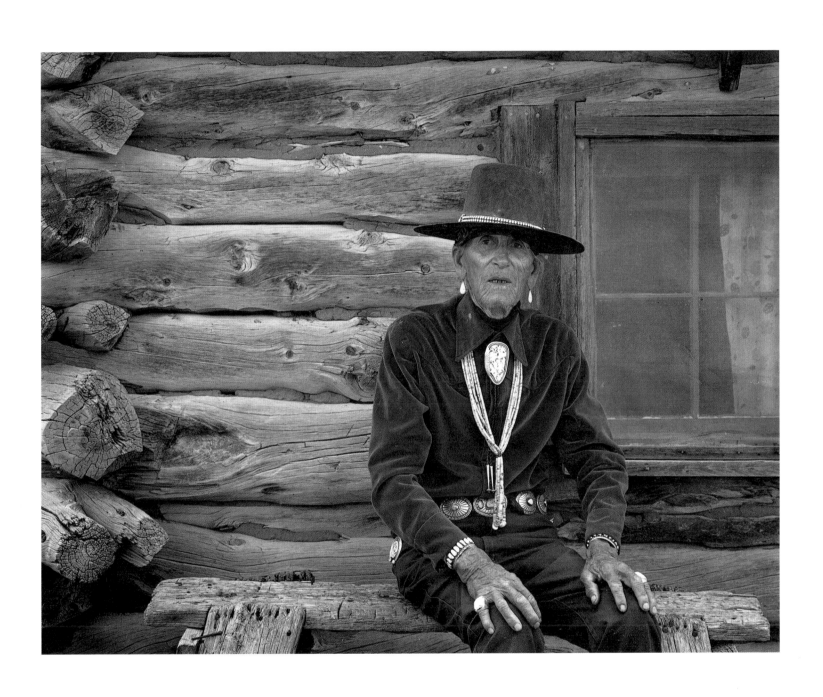

Retired mason and medicine man, Descheeney Nez Tracy

Ganado, Arizona

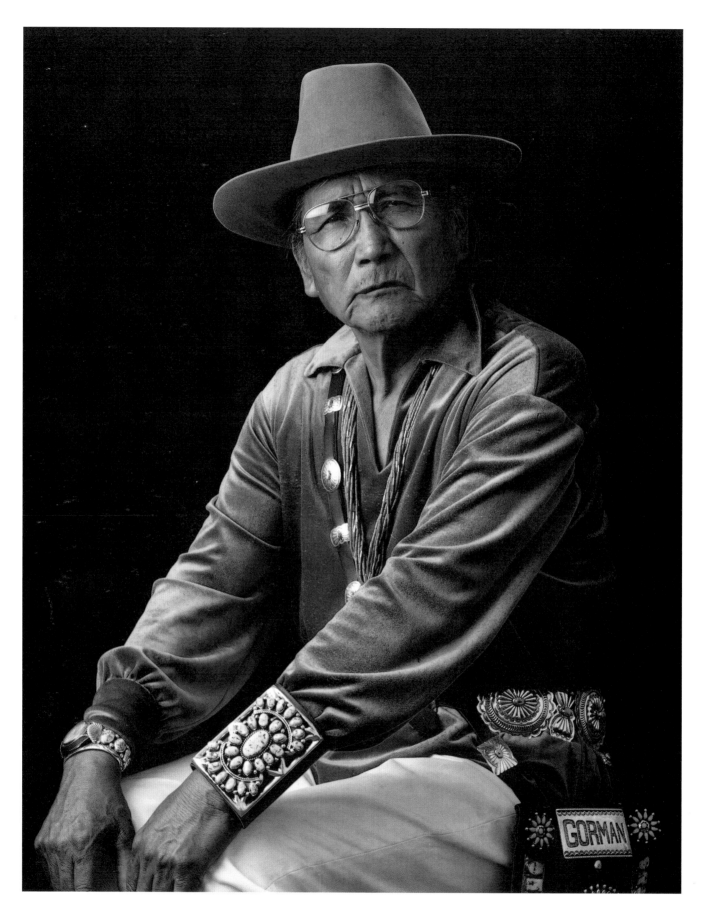

Dr. Guy Gorman, Sr., age 72, a founder of Navajo Community College

Tsaile, Arizona

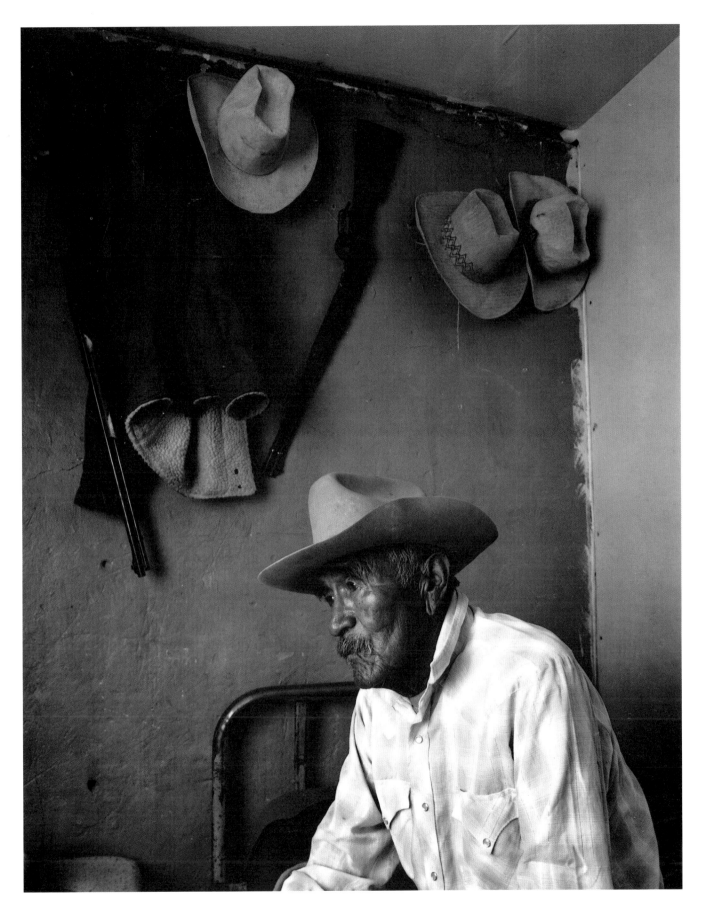

Sheepherder Oscar Whitehair

Cactus Valley, Arizona

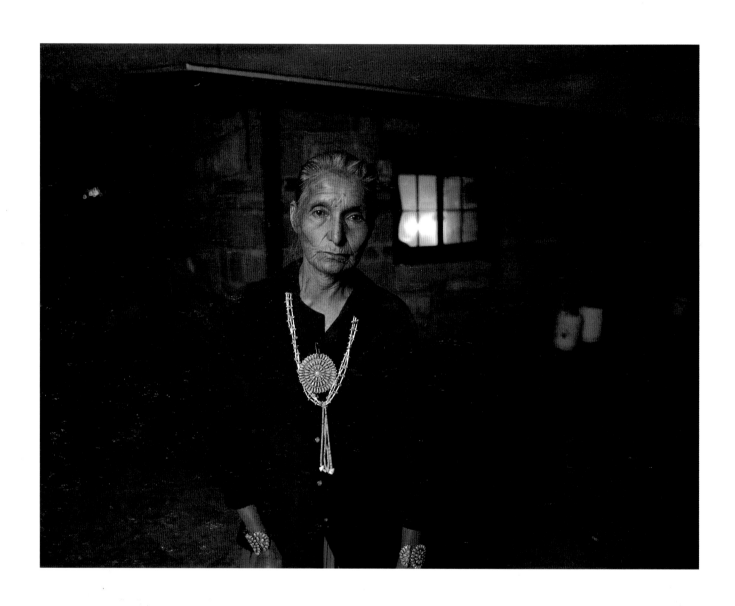

Rancher Mae Kateney Begay

Cactus Valley, Arizona

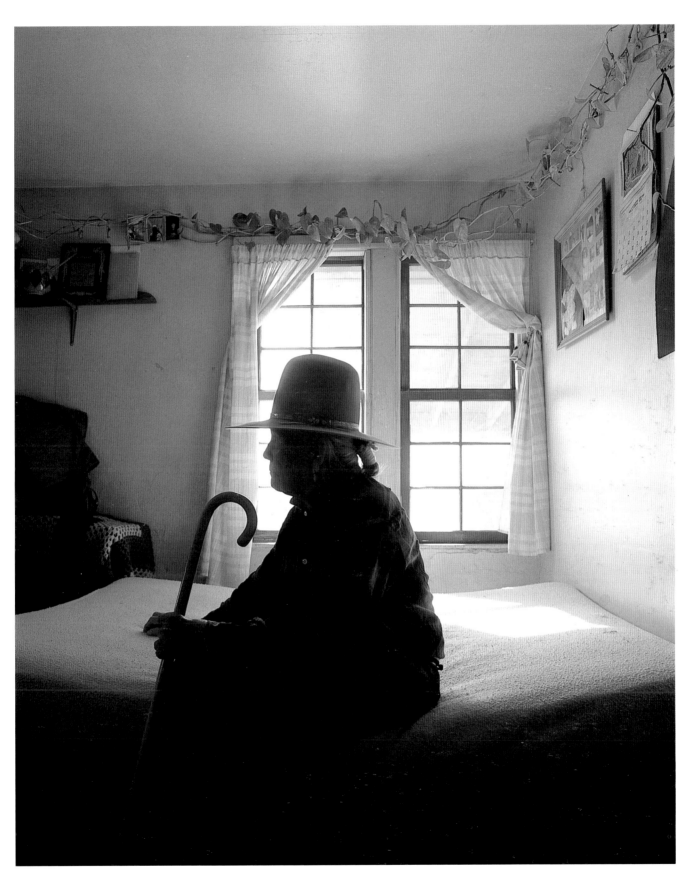

Retired medicine man Andilthdoney Begay, age 94

Indian Wells, Arizona

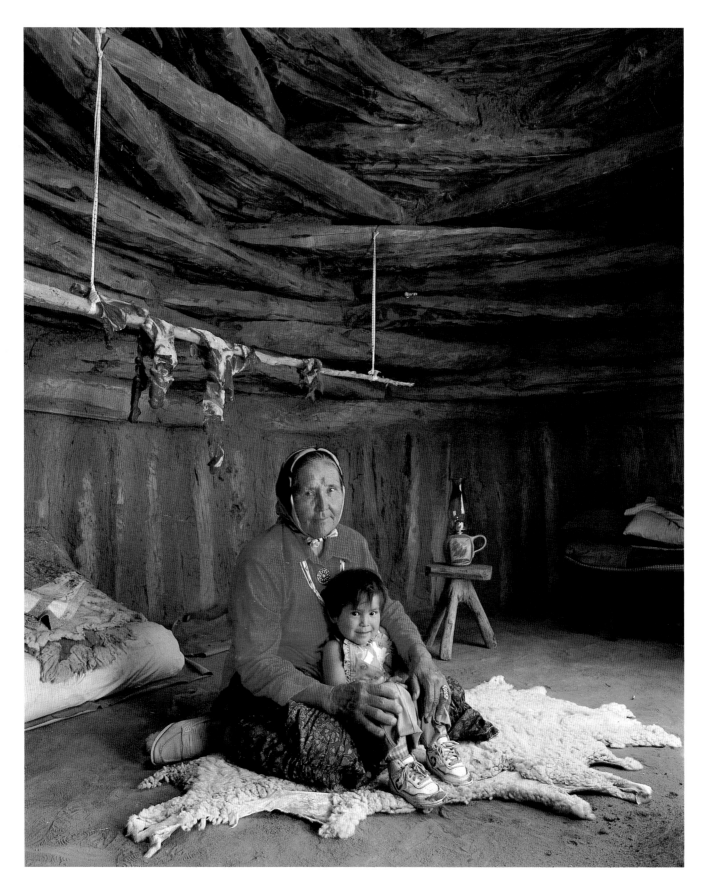

Relocation resister Pauline White Singer with granddaughter

Big Mountain, Arizona

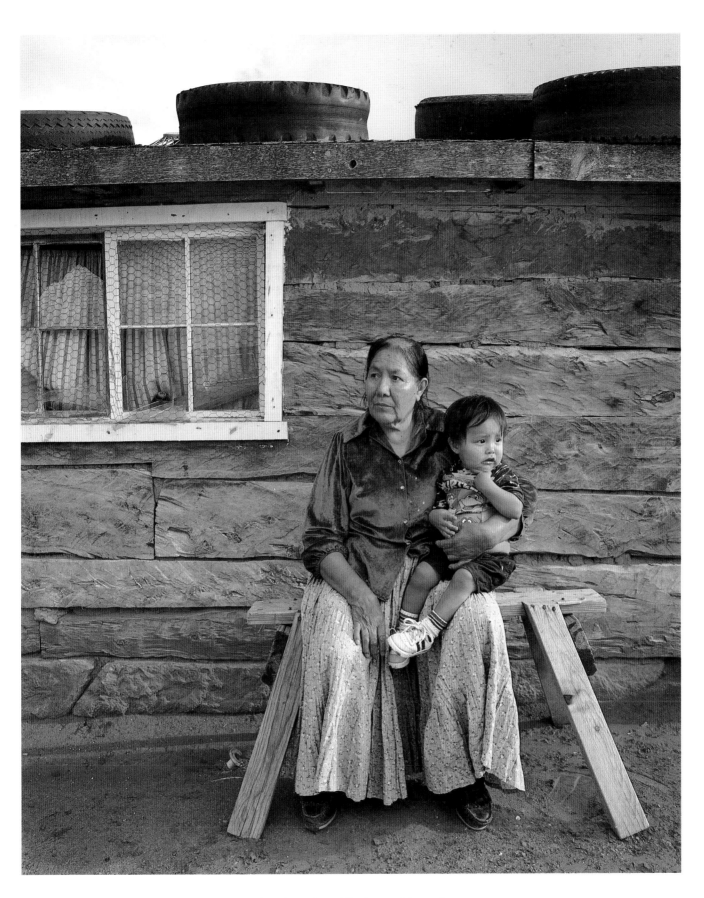

Relocation resister Alice Begay with grandson

Big Mountain, Arizona

John Whitehorse

Red Mesa, Arizona

Dance participant Bruce Williams

Tuba City, Arizona

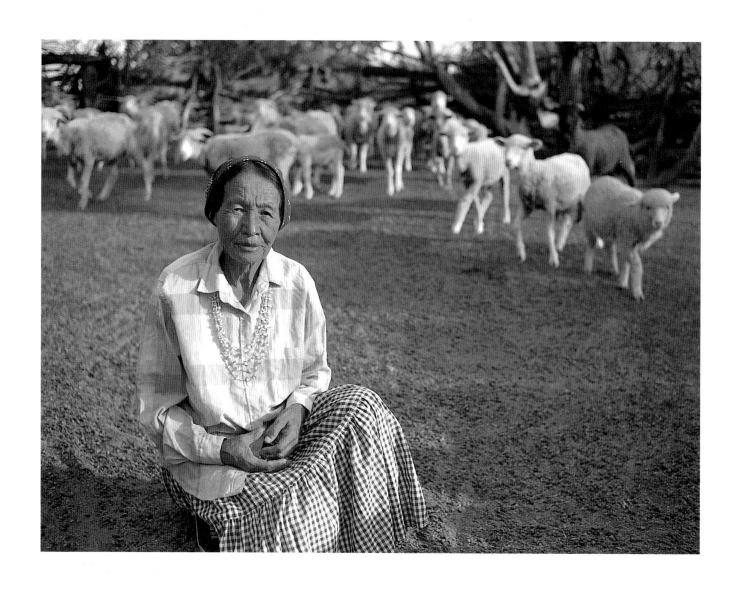

Sheepherder Mary Johnson

Wide Ruins, Arizona

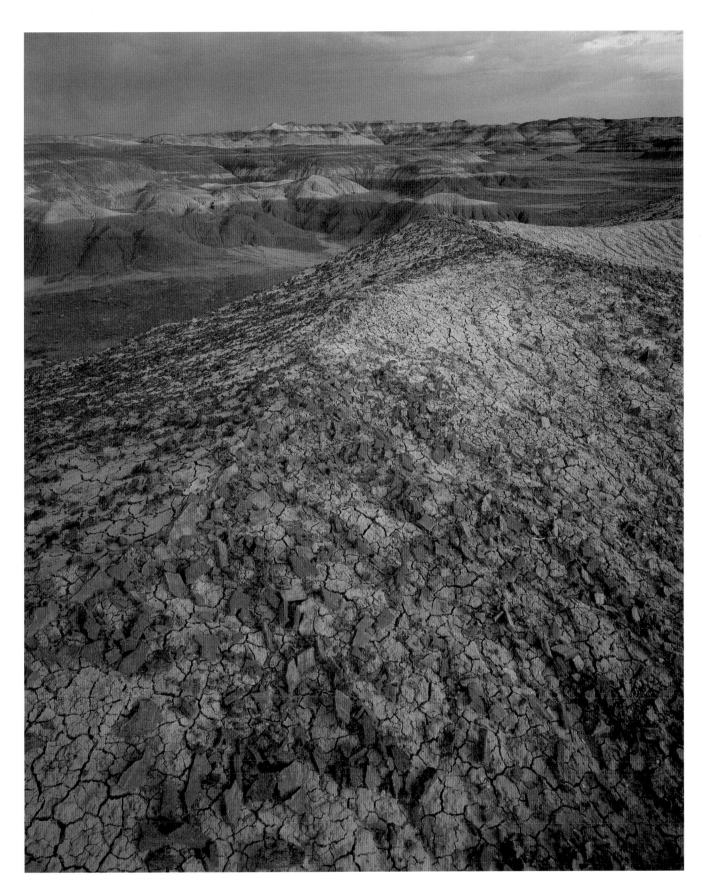

Bentonite deposits near Nazlini,

between Chinle and Ganado, Arizona

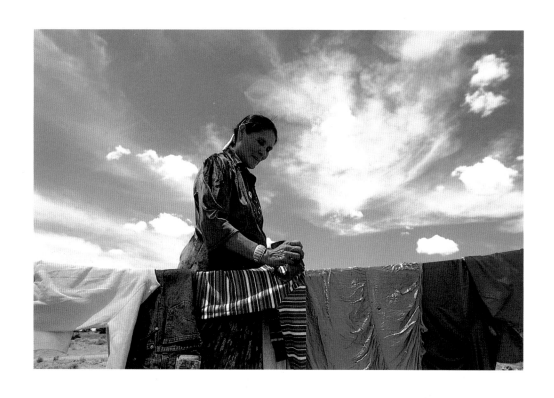

Jane Biakeddy hanging laundry

Big Mountain, Arizona

Traditional Navajo dancing during Fourth of July Fair

Window Rock, Arizona

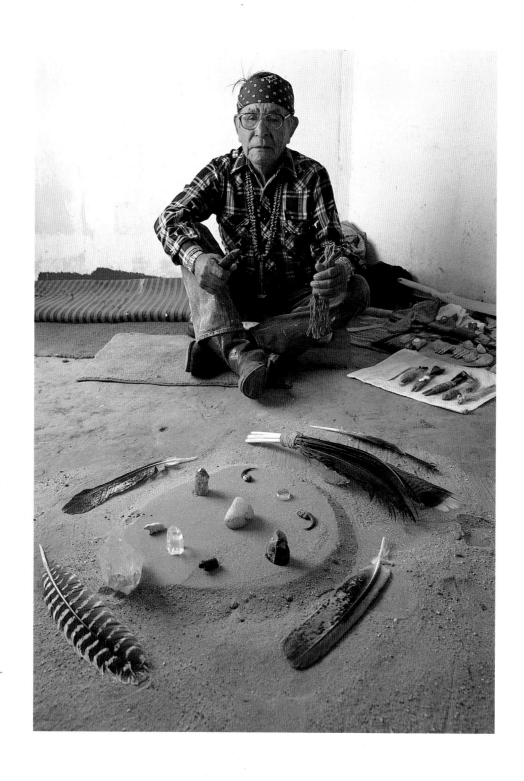

Rancher and medicine man Kee Williams

Steamboat, Arizona

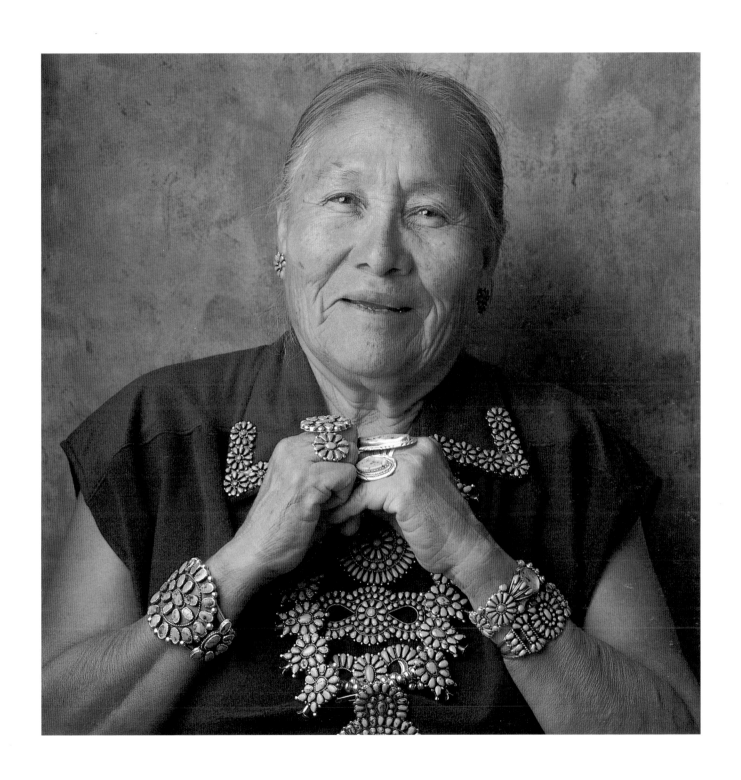

Dance participant Emily R. Williams

Tuba City, Arizona

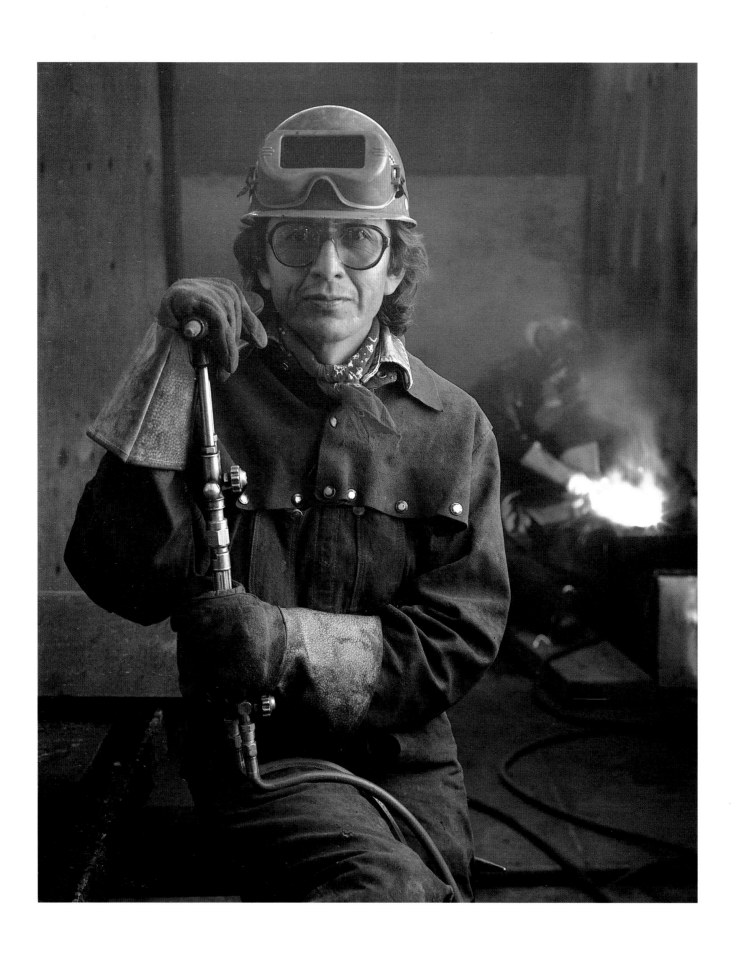

More than 100 miles northeast of the medicine man, Beulah Allen turns the dial on her truck radio and hears the sounds of Navajo. "Sugar in the morning, sugar in the evening, sugar at suppertime ... be my little honey," blares over the radio waves. Next comes a Navajo help wanted ad about a shepherd near Oak Springs needing help with his flock of sheep. The station is KTNN, whose bilingual programming switches back and forth from English to Navajo and from country music to Navajo songs. KTNN also airs events such as the Yeibichei dances in the winter and the Enemy Way ceremonies in the summer.

Arriving at the Indian Health Service hospital located at the mouth of Blue Canyon, Allen enters a red stone building constructed in the 1930s by the federal government. Donning a lab coat, she begins her day at a profession shared by few Navajo. Unlike the Navajo medicine man—who uses faith, the Holy People and Mother Earth to heal the ill—Dr. Allen cures using modern medicine. Most of her colleagues are non-Navajo.

Hundreds of Navajo come to the hospital daily for health care. At times, the hospital serves as a social gathering for Navajo, for it provides an opportunity to see friends and family in one place. As patient Navajo wait long hours in the lobby for treatment, they quietly converse about topics ranging from how much Hubbell Trading Post is offering for wool to the number of children they have.

Heavy equipment at work in Pittsburg & Midway Coal Mine, near Window Rock, Arizona

Opposite: Welder Jim C. Oldman at Pittsburg & Midway Coal Mine, near Window Rock, Arizona

"Desbah Manygoats!" the chart woman hollers. A shy young woman with an infant wrapped snug in a cradleboard responds to the place where family charts are kept. She is sent to Dr. Allen.

While Jecal Bedonie's education to heal required learning hundreds of Navajo songs and prayers and following other singers across Navajoland, Allen's schooling took her away from her Fort Defiance home to high school in Northern California, college in New York and travel in Europe. Later she worked on her medical degree at the universities of Florida and Arizona. Allen returned home in 1984 as a physician. She lives in a remote part of the Navajo reservation in Crystal, New Mexico, a place her ancestors called Where-The-Star-Is-Located.

Around Allen's non-Navajo colleagues, conversation centers on medical issues, plans for the hospital and world events such as the freeing of the American hostages in the Middle East or the Persian Gulf War. With the Navajo staff, topics sway toward ceremonies, squaw dances, personal lives and a keen interest in who visited the hospital the other day and how that individual is related to someone else.

Dr. Allen changes her conversations as swiftly as KTNN shifts from country to Navajo songs. "I kind of enjoy it because it's like having a secret life," she says with a laugh. "What happens with the Navajo people is something the rest of the non-Navajo staff don't participate in. They are ignorant of what goes on."

Up to the age of 12, she attended the Fort Defiance Day School. It wasn't unusual for young Allen and her friends to watch Yeibicheis—ceremonial

dancers—from the roofs of federal buildings as the dancers searched for bad children or gifts.

Allen's mother insisted on a strong education for her daughter. That education pushed her to leave the reservation, and for a time, to break her ties with the Navajo language and people. She married twice outside of the tribe and raised children with a non-traditional, modern upbringing.

Allen learned to be assertive and aggressive in the "white people's sense," a characteristic often shunned in traditional Navajo society. Public demeanor of most Navajo leans toward patience and reserve. In the Navajo way, one doesn't hurry time. An individual is taught to not speak rapidly and unthoughtfully, but to be considerate of others.

"And that's awfully hard," remarks Allen. "I've learned that if I want something done, I have to go after it myself. Often that means I run into a brick wall because people just won't let you hurry."

Growing to maturity as a Navajo didn't happen for Allen. Yet, during her years away from the reservation, her heart remained in Navajoland. "I always felt like I needed to come back to educate myself or become educated as a Navajo woman in the traditional culture, stories and values," Allen says, adding that she is learning the language. "I feel that's necessary to become a complete human being."

Developing as a Navajo in middle age is difficult, Allen admits. Yet her determination to one day learn to speak Navajo fluently is strong. If an invitation arrives for a ceremony in the community, she hangs up her doctor's garb and replaces it with the traditional attire of velveteen shirt and calico skirt. She participates as a guest, gets involved in the cooking and enjoys the banter and humor that surface at these social gatherings.

"I feel so jealous of those young people who know exactly where they are from and feel such a strength of pride in that beautiful Nightway Chant," Allen says. "They understand each other, they speak the same language, they joke the same jokes and they are going to grow up and marry Navajos and they are going to raise their children in this society."

But the modern world also beckons Allen.

"There is always a sense that your roots are somewhere else. I'm familiar with American society and white people's culture and their historical origins," she says. "The advantage of that is I can go anywhere in the world and feel comfortable. I can go any place where English is spoken and feel perfectly part of the background because you are never a stranger in American society. But I never really felt that I belonged to them. I've always felt that my roots were with Navajo culture and I needed to come back and make a place for myself here."

While the Western medicine Dr. Allen was trained to practice uses sophisticated scientific techniques to treat diseases and injuries, Navajo medicine approaches a patient as one complete person. "People who come to the hospital for surgery, very often go to the medicine man first because they want to be assured that things are going to go well," Allen says. "Navajo medicine doesn't separate the body from the mind or spirit. The treatment is for that individual as a unified creature, a unified entity. The emphasis is on bringing harmonic balance to that individual so that that person can live in a healthy way. When the prayers are said, a patient regenerates from the toes all the way to the head. You become a newer, stronger, healthy individual, and it gives you a tremendous sense of well-being and joy."

Across the reservation in Tuba City, Jecal Bedonie often travels to the hospital to conduct religious ceremonies. He, too, believes there is more opportunity nowadays for Navajo ways and modern medicine to work together to restore patients to health.

Just as customs are changing quickly on the reservation, so are religious beliefs.

The churches of Christendom are found in large and small Navajo communities. They range from the sleek, modern buildings of the Church of Jesus Christ of Latter-day Saints to the hundred-year-old stone and stained-glass Catholic churches. Far from the towns, in isolated mesas, Pentecostal religions worship in large white tents that move from camp to camp. Out there among the junipers, these camp

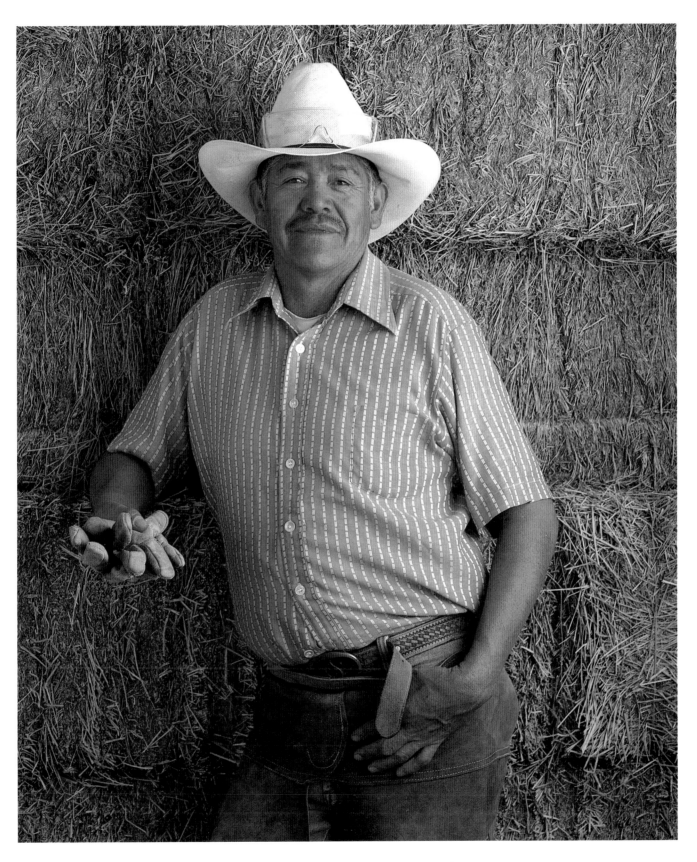

Navajo Agricultural Products Industry-employed farmer Robert B. Augustine

Farmington, New Mexico

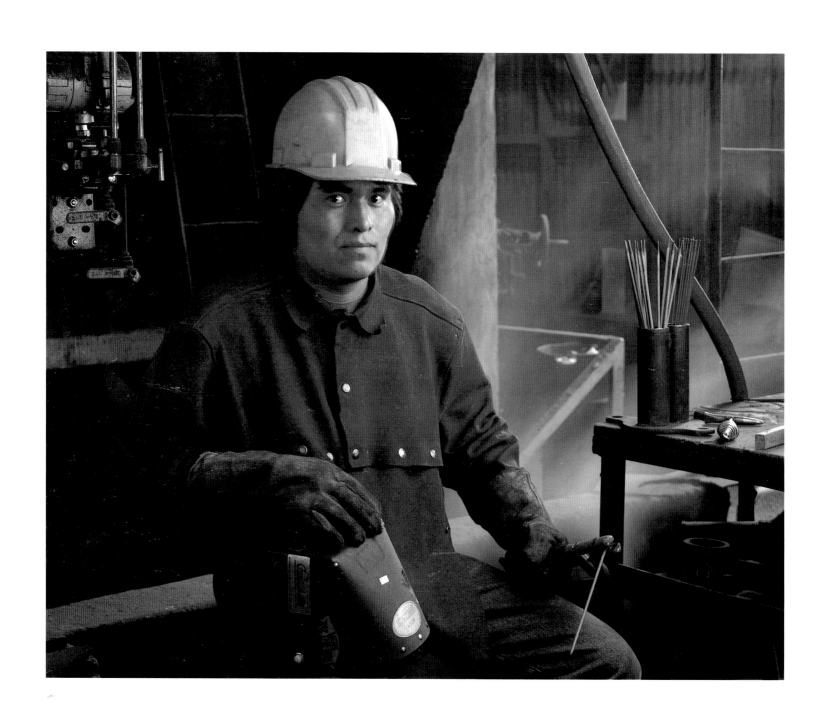

Welder Alvin Tso at Navajo Forest Products Industries sawmill,

north of Fort Defiance, Arizona

religions profess to be "God's holy warriors." Nearly every denomination of mainstream America has some sort of root in Navajoland.

Traditional elders often blame this diversity of religion on the federal boarding school education acquired by their children and grandchildren. At these schools, young students were forced to join Christian churches of various denominations. They passed on these teachings to their children.

A tepee erected next to a Navajo home usually means the family is active in another kind of religion: the Native American Church, which the Navajo adopted in the early 1900s.

For traditional people such as Bedonie, no shades of gray exist when it comes to belief in the Holy People and Mother Earth. His children may believe otherwise. For them, two sets of beliefs — traditional and Christian — are often meshed. One day, for instance, Bedonie performed a Blessing Way ceremony for his grandchild; a day later the child was baptized in a Christian sect.

Another illustration occurs often at public gatherings when a person recites a Navajo Blessing Way prayer and ends it with, "In the name of Jesus Christ, amen." Or a family attends church on a Sunday and later participates in a Blackening Way or Native American Church ceremony. It isn't uncommon to see a rosary, Bible, cross or framed portrait of Jesus in the most traditional of Navajo homes.

"I believe in the Catholic Church and the Navajo religion," says Jonas John, a 39-year-old professional Navajo photographer from Shiprock, New Mexico. "I don't go deep into the Catholic religion, but I'm comfortable with it. I can juggle the two beliefs in my mind. I keep my Navajo beliefs flexible and accurate in my mind."

For other Navajo, such as elderly Ida Johnson, Christianity turned into a way of life when her faith in the Holy People was tested. Ida lives west of Fort Defiance on the rim of Canyon de Chelly. Her family's history is rich with stories dating back to the 1800s, when the U.S. Cavalry fought with Navajo for territory, livestock and slaves.

The elderly woman's lineage is full of singers. One day, an illness afflicted her daughter. Numerous Navajo singers failed to cure her. As a last resort, Johnson admitted her daughter to the hospital, where a Navajo Christian minister prayed for the child. The girl lived. Seeing no need for her old cures, Johnson destroyed her sacred mountain soil and burned her pollen because "their magical powers failed and Christianity proved stronger."

Christianity is also important to 38-year-old Jerry Yazzie from Black Mesa, Arizona. "Christianity is a way of life, not a religion," Yazzie explains. "The belief is, Jesus is the savior of mankind. Only Jesus knows where heaven is. For 33 years, he lived here on earth. The main purpose was, he was to die for mankind because they separated themselves from God. He accomplished that purpose by dying on the cross. We carry on that message."

Yazzie believes that Navajo choose to carry that message because Christianity relieves long-held superstition and taboos. Navajo religion is too restrictive, he says, even dictating the season when you can tell stories about coyote.

"Many people who join my church tell me, 'I quit my old beliefs because with Christianity you are set free in your mind and life.' There is a lot of fear associated with Navajo religion," the preacher says. "It's all based on fear. They control you by fear. In Christianity, you are free from those fears. You live a life according to the Bible." Just because a Navajo abandons an old belief and chooses Christ, doesn't mean he becomes less of a tribal member, Yazzie says.

To communicate with non-English-speaking Navajo, biblical words are frequently translated into the Navajo language, a task that often requires mention of the Holy People to help people understand who Jesus is. "Culturally, we don't try to change things," Yazzie says. "We still do the kneel-down bread, the sheepherding. Only where beliefs come in do we differ. The two beliefs are like oil and water. They can't be mixed."

During his work, Yazzie has come to realize that the two religions sometimes benefit each other —

for instance, when a non-member of the Christian church dies. Traditional Navajo believe the dead become *chindees*, or ghosts, who later haunt the living. "They usually want somebody else to deal with the funeral or the body," Yazzie says. "So they give the body to the church. From their point of view, they are letting the church do their dirty body work for them. With Navajo religion, a belief that the spirit returns to haunt the living is quickly adopted, and no one wants to have anything to do with a dead body. Even the clothes and home of the deceased are feared. To us, it is considered a body because the spirit has left. There is no fear of death."

Robert Billy Whitehorse follows a different preachers' path. The affable 51-year-old Navajo from Aneth, Utah, is a community leader, a businessman and the main "roadman" of his local Native American Church. A roadman conducts the rites associated with the Peyote Road. As president of the 25,000-member Native American Church of Navajoland, Whitehorse has been busy seeking a reversal of a U.S. Supreme Court decision that failed to protect peyote as a religious sacrament.

Navajo adopted the peyote cult, as it sometimes is termed, from the Utes, their neighbors (and enemies) to the north. Historians note its membership flourished during the 1930s when the federal government imposed its livestock reduction program on the Navajo. The trauma of stock reduction provided a reason for many Navajo to look to a new way of coping with their changed circumstances.

The Native American Church is no stranger to controversy. Its presence in Navajoland has received much criticism from many traditional Navajo and Christians because of its use of hallucinogenic drugs during ceremonies. As these leaders have become more sensitive to the Native American Church, however, they have repealed restrictions on the use of peyote. Today, NAC leaders often unite with traditional Navajo medicine men to champion similar goals. Teachings include brotherly love, care for the family, self-reliance and abstinence from alcohol.

Just as Jecal Bedonie is asked to perform traditional Navajo ceremonies for individual patients, people approach Robert Billy Whitehorse to conduct NAC ceremonies. In the Native American Church, God is equated with the Great Spirit as the supreme being. The Great Spirit is the ultimate source of power, therefore controlling the destiny of everything in the universe, including man. To help the Indians, the Great Spirit made the peyote cactus and put some of his power into it. When peyote is used as a sacrament, the user absorbs its power.

Native American Church services are called "meetings." The altar is a fireplace, located in the center of a hogan or tepee. Songs are prayed throughout the night, accompanied by the sound of a water drum. There is a patient in need of a cure, and often the services mirror traditional Navajo rites. Both religions, for instance, have Blessing Way ceremonies. The NAC ceremonies are easier for Navajo who don't speak Navajo, however, because they are not required to recite long prayers.

"Our belief is simple," says Whitehorse. "The traditional Navajo belief is deeper and much more complex. It takes 20 to 30 years to become a respected medicine man with the power to heal. A trainee, I understand, has to learn 300 songs and prayers, which are all different.

"Today's people, the youth, don't have time for that. In the NAC religion, you don't have to learn many songs related to Mother Earth or the fire. The service or ceremony is pretty much the same. We don't have a nine-day Nightway Chant or the four-day Blessing Way. Our ceremonies require one night. We can say, 'A person can get cured in one night.'"

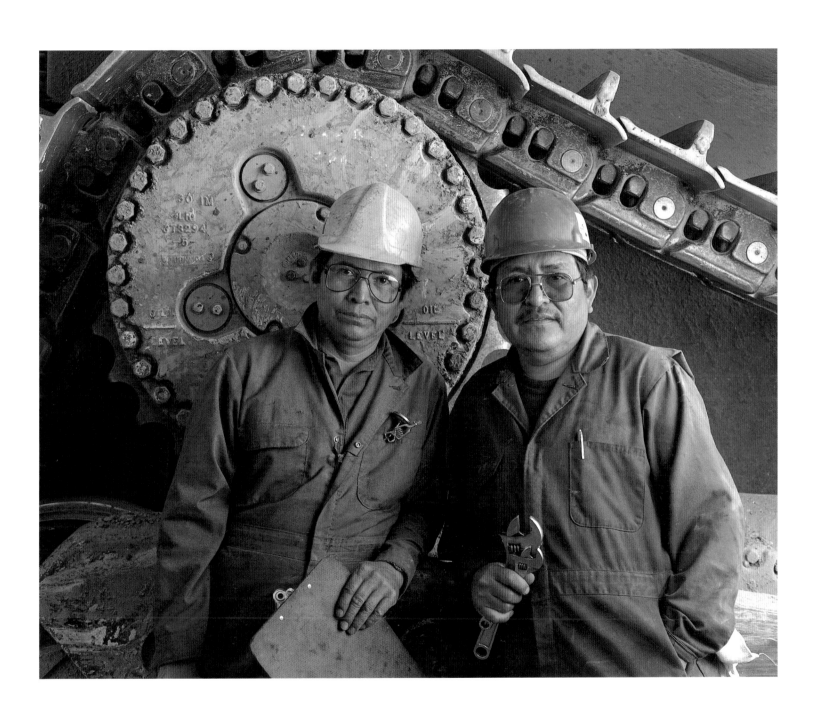

Mechanics Phil Calvin (with clipboard) and Jimmie R. Yazzie

at Pittsburg & Midway Coal Mine near Window Rock, Arizona

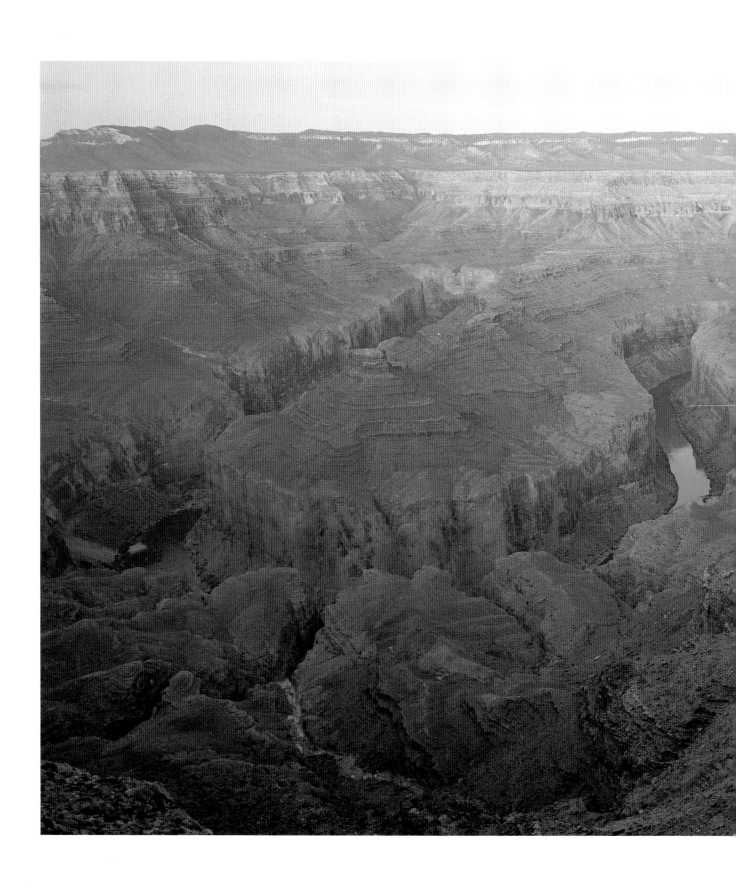

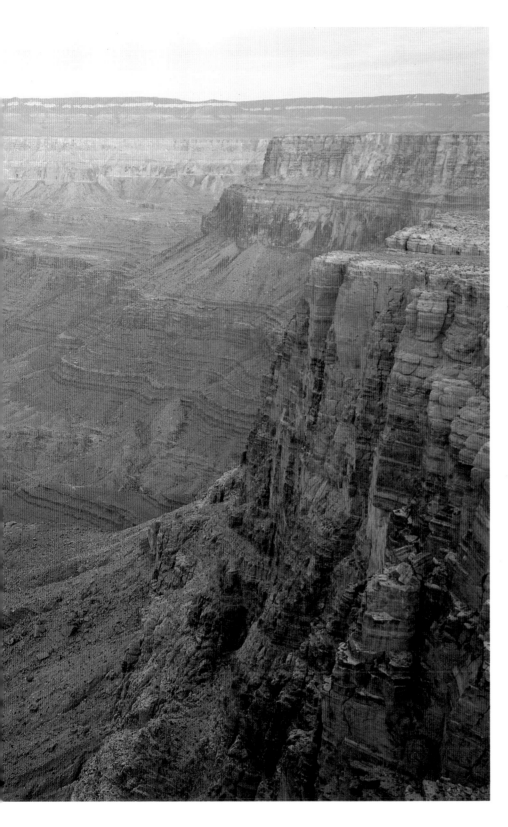

Marble Canyon from overlook

near Cedar Ridge, Arizona

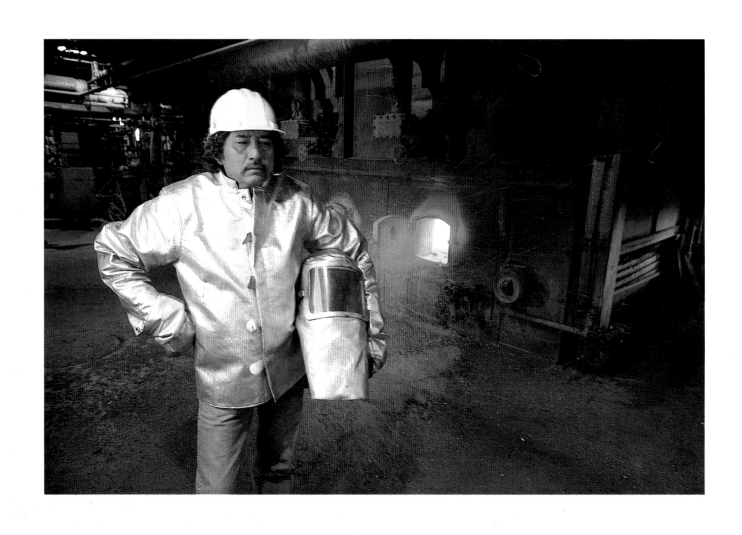

Welder David Wilson at Navajo Forest Products Industries sawmill,

north of Fort Defiance, Arizona

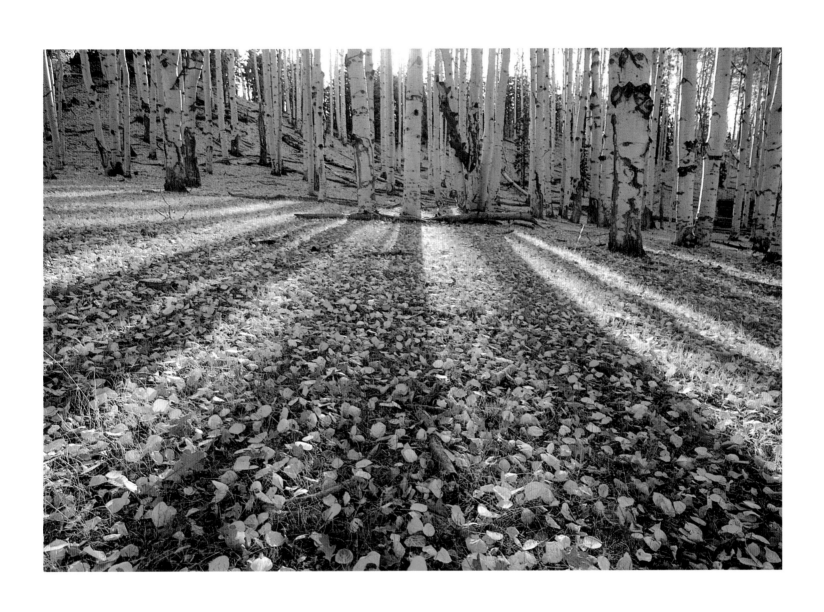

Aspen grove in Chuska Mountains, New Mexico

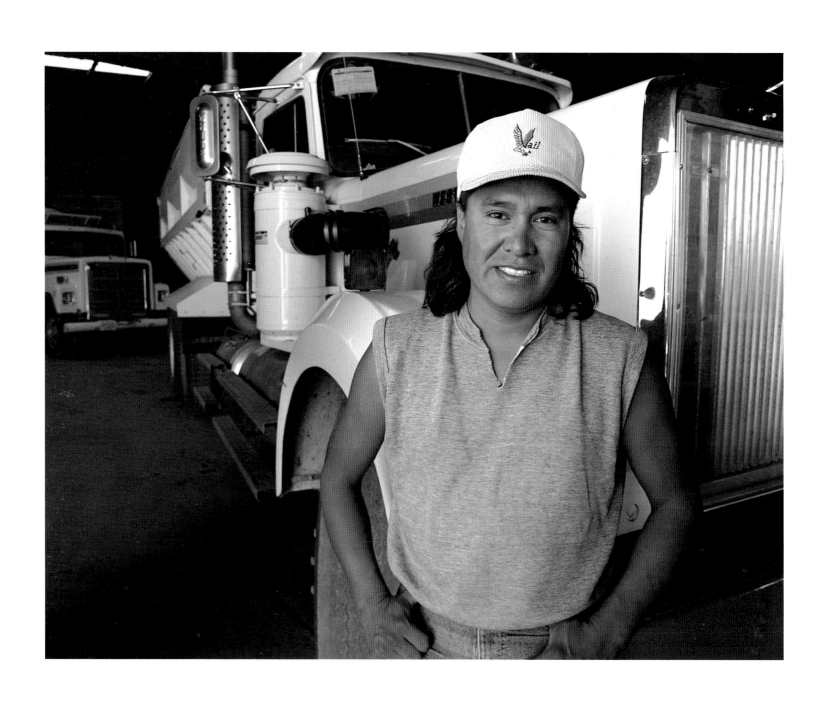

Navajo Agricultural Products Industry truck driver Jared Bennie

outside of Farmington, New Mexico

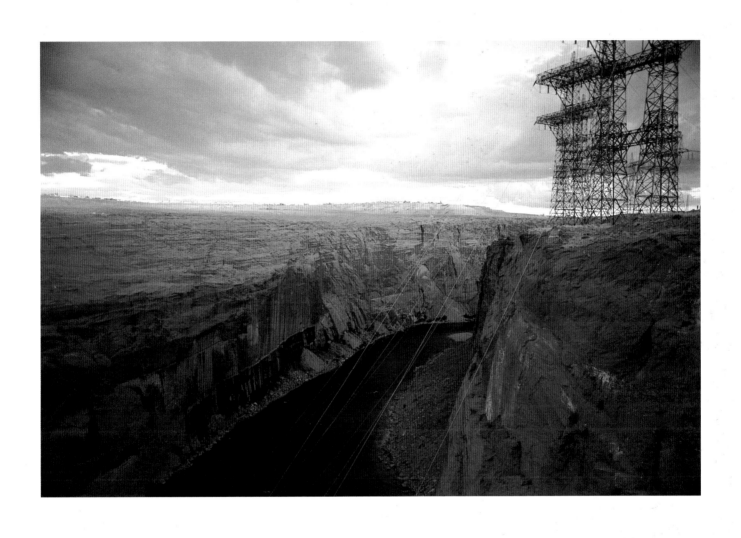

Marble Canyon from Glen Canyon Dam, Glen Canyon

National Recreation Area, Arizona

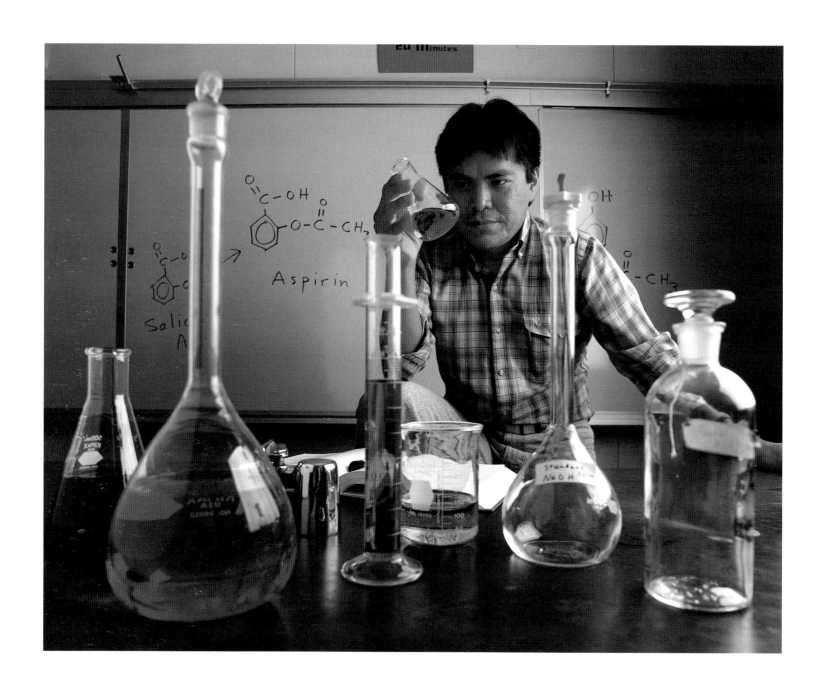

Biology and chemistry teacher William LongReed

Tuba City High School, Tuba City, Arizona

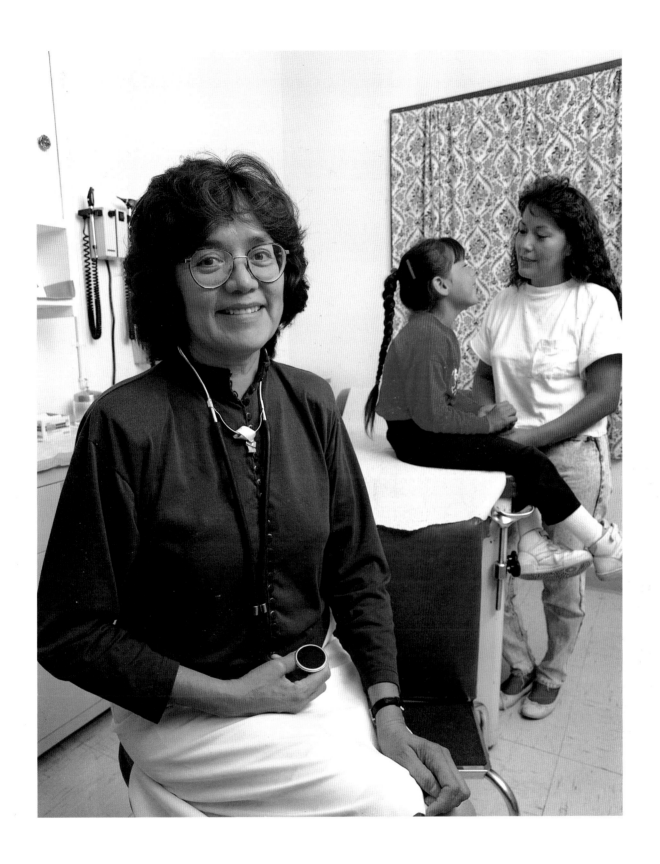

Ganado-based nurse Ruth Tracy with Ernestine Benally and daughter Tamara Rose Higdon

Wide Ruins, Arizona

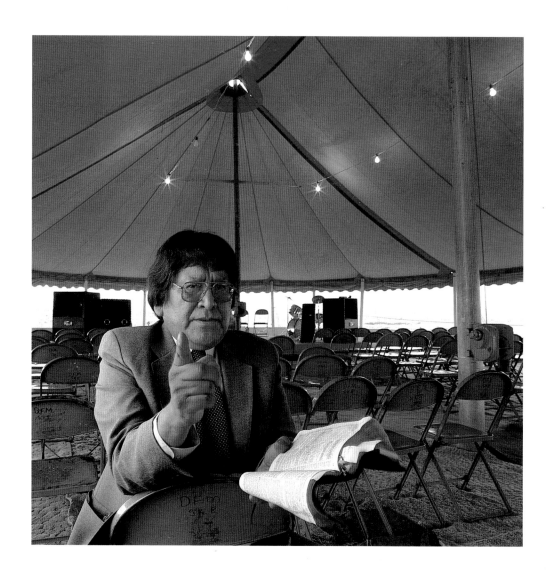

Kirtland-based tent evangelist Scott K. Redhouse at Rattlesnake,

near Shiprock, New Mexico

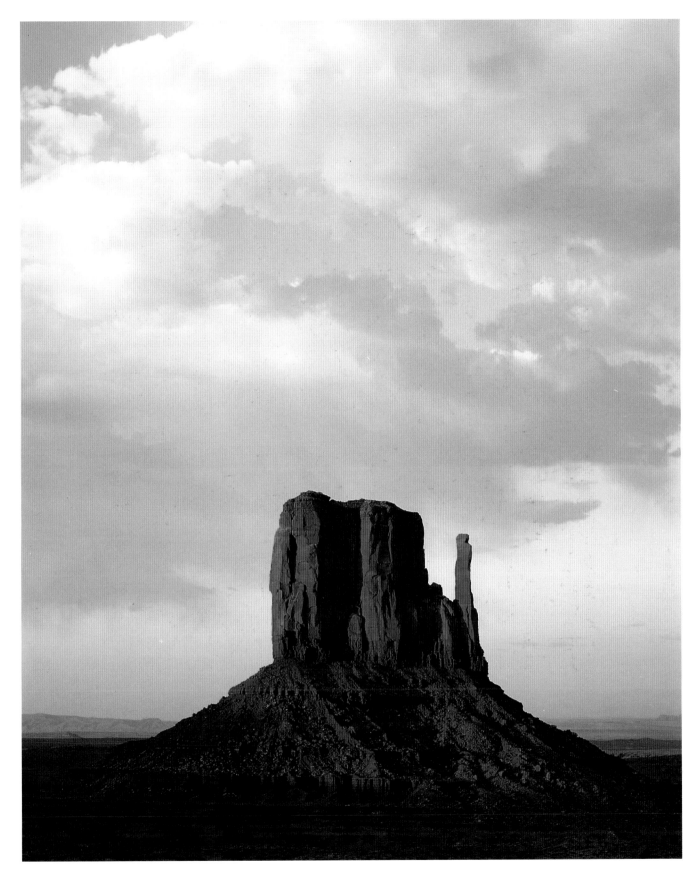

Late afternoon light on North Mitten, Monument Valley Navajo Tribal Park

Arizona/Utah border

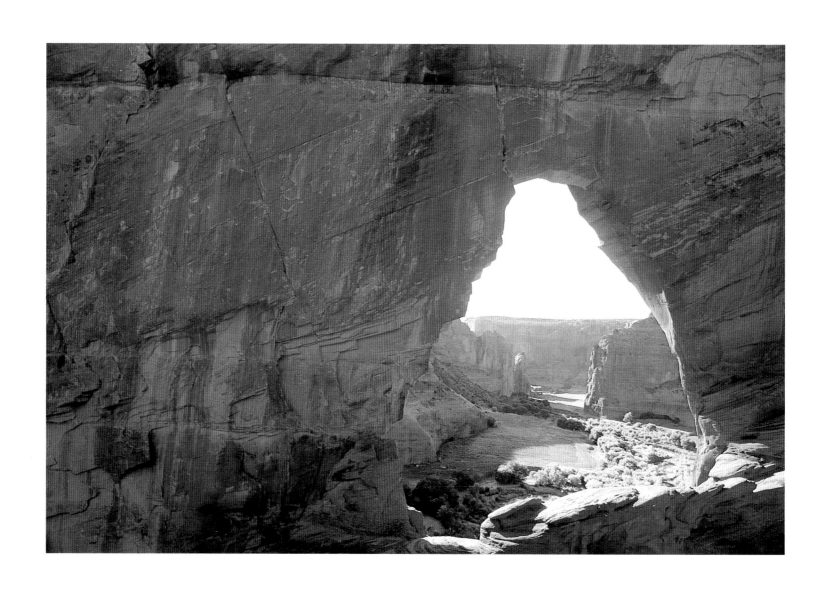

The Window

Canyon de Chelly National Monument, Arizona

Office of Broadcast Services media specialist Dewayne Johnson

Monument Valley Navajo Tribal Park, Arizona/Utah border

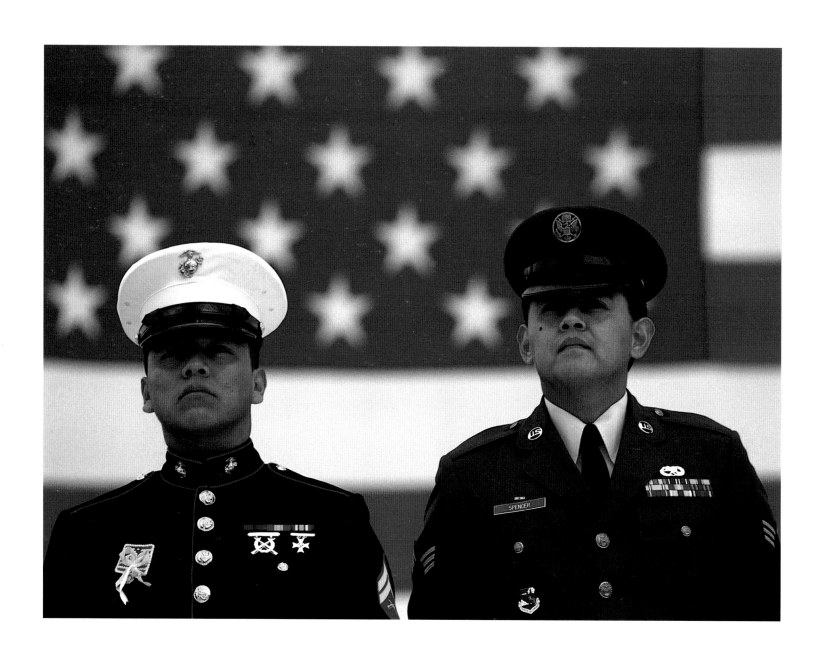

"Salute to the Warriors" ceremony welcoming returning Desert Storm servicemen Spencer, U.S. Air Force,

and Reddy Yellowman, U.S. Marine Corps, June 1, 1991

Window Rock, Arizona

Pesh ashike ni shli—yi-na, / Pesh ashike ni shli—ya-e

Lo, the flint youth, he am I, / The flint youth.

Nayenezrani shi ni shli—kola / Pesh ashike ni shli— / E-na

Nayenezrani, Lo, behold me, he am I, / Lo, the flint youth, he am I, / The flint youth.

Pesh tilyilch-iye shi ke—kola, / Pesh ashike ni shli— / E-na

Moccasins of black flint have I; / Lo, the flint youth, he am I, / The flint youth.

Pesh tilyilch-iye siskle-kola, / Pesh ashike ni shli— / E-na

Leggings of black flint have I; / Lo, the flint youth, he am I, / The flint youth.

Pesh tilyilch-iye shi e—kola, / Pesh ashike ni shli— / E-na

Tunic of black flint have I; / Lo, the flint youth, he am I, / The flint youth.

Pesh tilyilch-iye shi tsha—kola, / Pesh ashike ni shli— / E-na

Bonnet of black flint have I; / Lo, the flint youth, he am I, / The flint youth.

Nolienni tshina shi-ye

Clearest, purest flint the heart

Shi yiki holon-e—kola, / Pesh ashike ni shli— / E-na

Living strong within me—heart of flint; / Lo, the flint youth, he am I, / The flint youth.

Ka'itsiniklizhi-ye / Din-ikwo

Now the zig-zag lightnings four / From me flash.

Sitzan nahatilch—kola, / Din-ikwo / Pesh ashike ni shli— / E-na

Striking and returning, / From me flash; / Lo, the flint youth, he am I, / The flint youth.

Tsini nahatilch ki la

There where'er the lightnings strike,

Nihoka hastoyo-la

Into the ground they hurl the foe—

Whe-e-yoni-sin-iye

Ancient folk with evil charms,

Yoya aiyinilch—kola, / Pesh ashike ni shli— / E-na

One upon another, dashed to earth; / Lo, the flint youth, he am I, / The flint youth.

Ka'sa-a narai,

Living evermore,

Ka'binihotsitti shi ni shli—kola / Pesh ashike ni shli— / E-na

Feared of all evermore, / Lo, the flint youth, he am I, / The flint youth.

Pesh ashike ni shli—kola / Pesh ashike ni shli—ya-e.

Lo, the flint youth, he am I, / The flint youth.

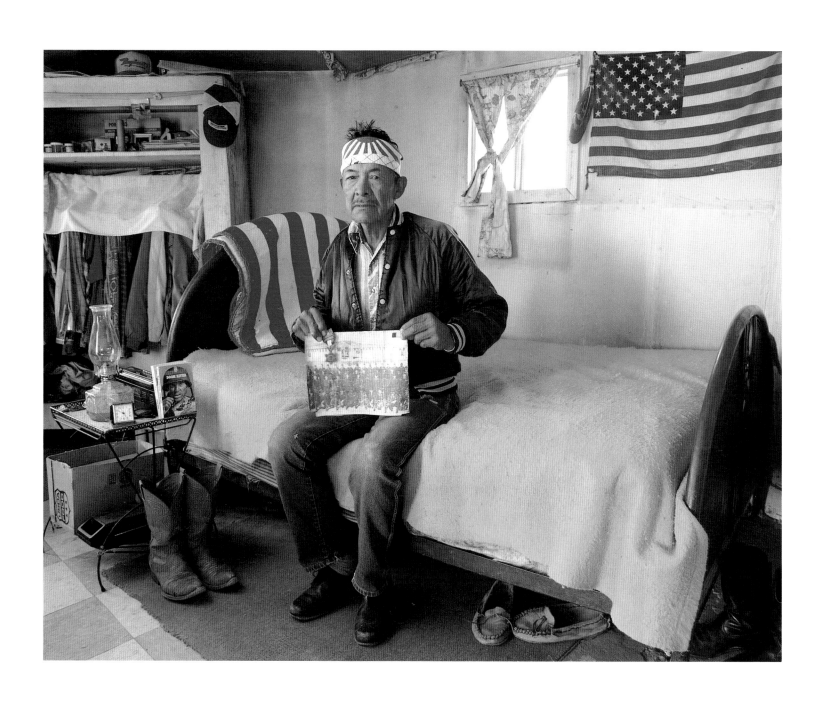

Sergeant Jimmy E. Dickson, World War II veteran

Tuba City, Arizona

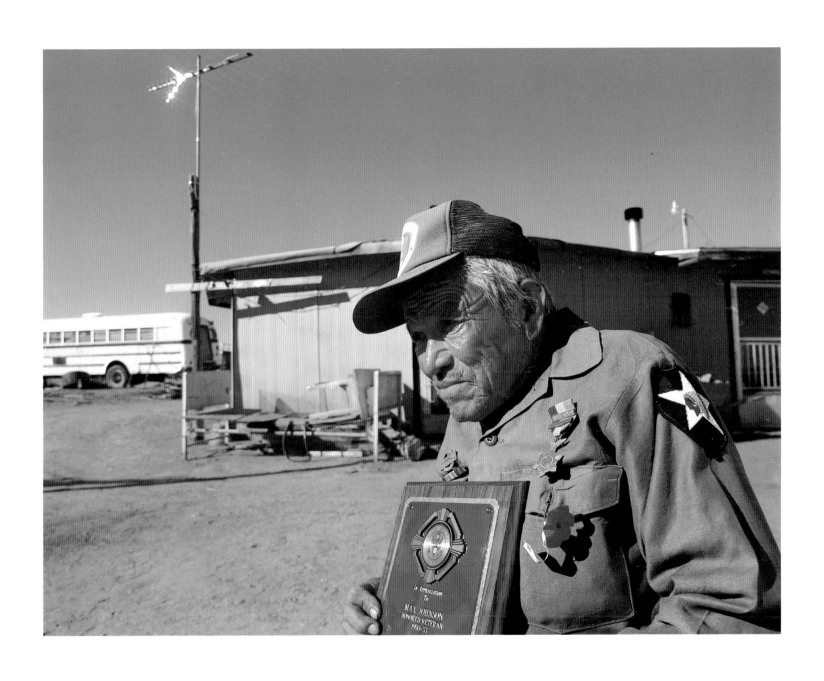

Sergeant Max F. Johnson, Korean War veteran

Page, Arizona

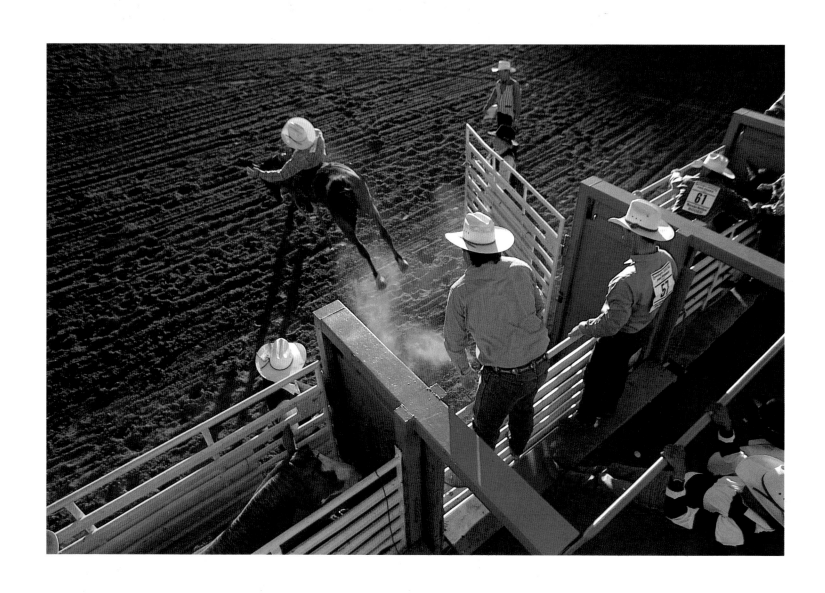

Bronc riding at Fourth of July Fair

Window Rock, Arizona

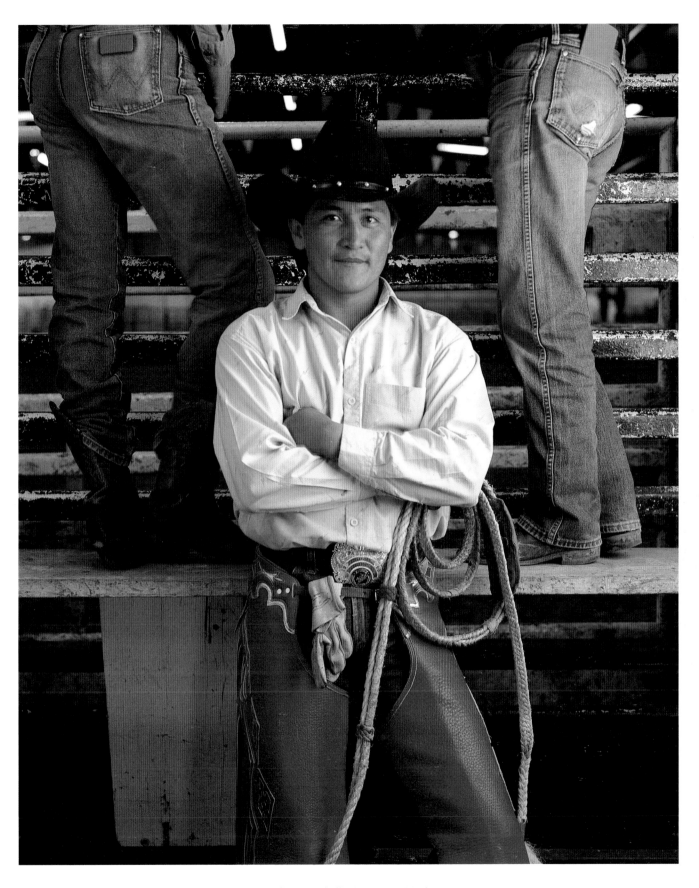

Champion bull rider J.P. Paddock

Winslow, Arizona

Calf roping at rodeo, Fourth of July Fair

Window Rock, Arizona

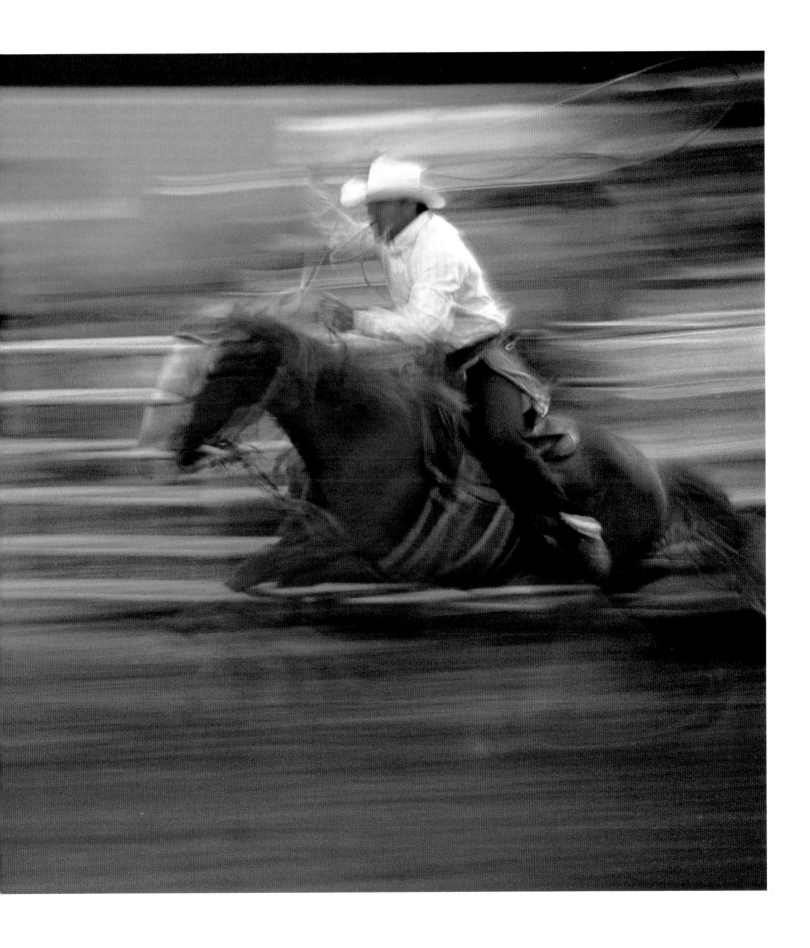

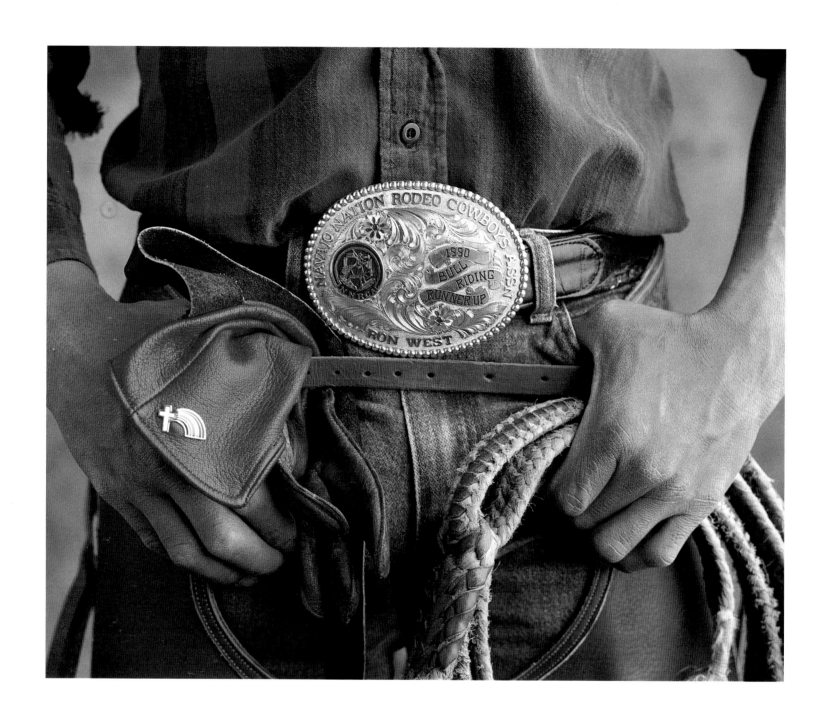

Champion bull rider Ron West's buckle

Window Rock, Arizona

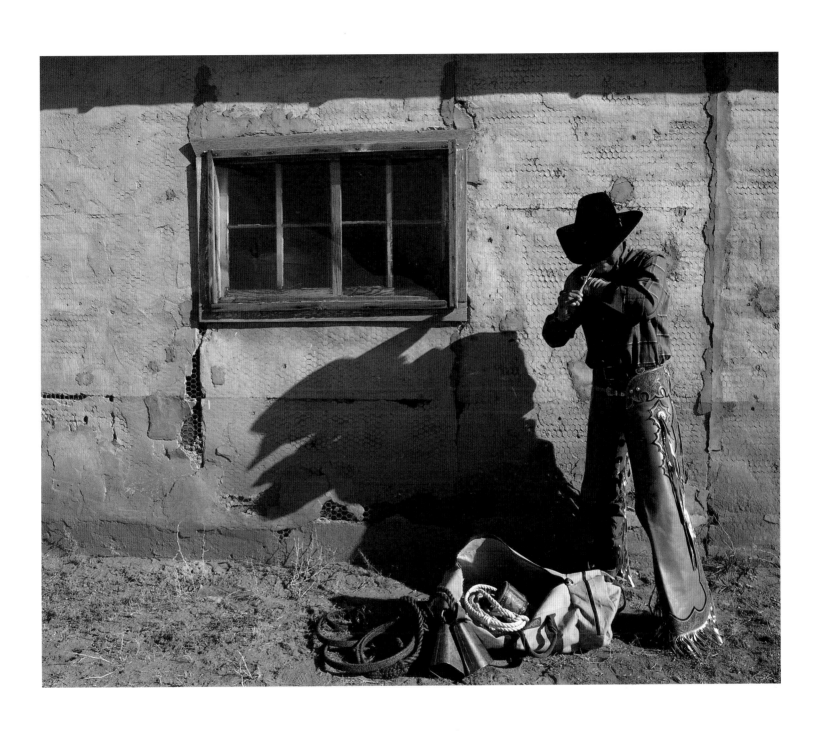

Bull rider Chee Secody, Jr.

Kaibito, Arizona

Native American Church tepees at annual intertribal fair

Red Rock State Park, New Mexico

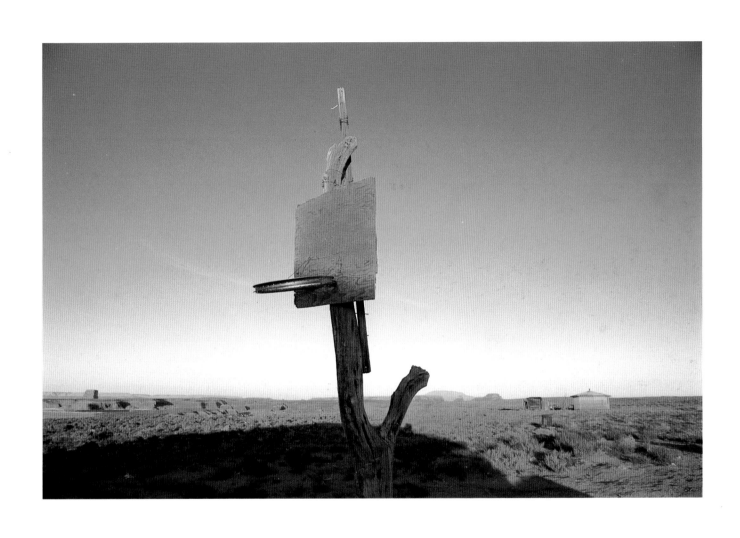

Basketball hoop crafted from hubcap

near Page, Arizona

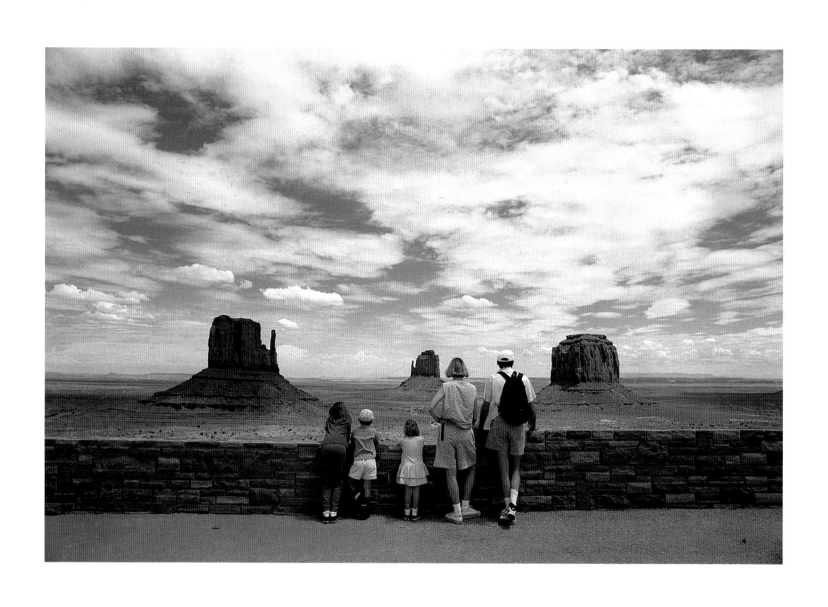

Tourist family overlooking Mitten Buttes

Monument Valley Navajo Tribal Park, Arizona/Utah border

Powwow participants in full regalia, Fourth of July Fair

Window Rock, Arizona

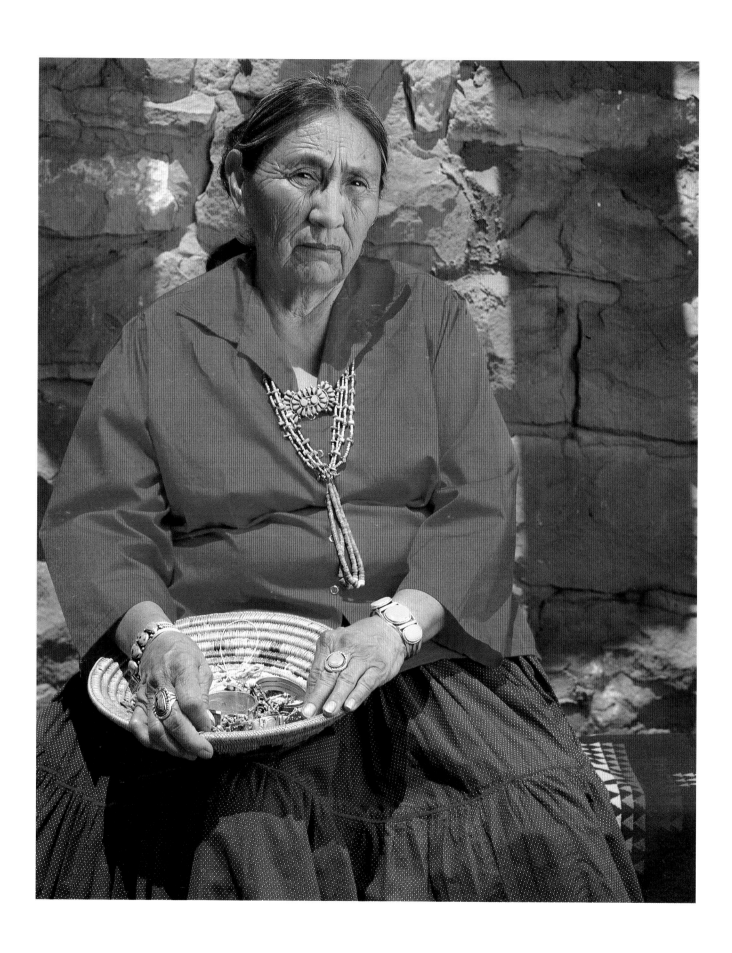

One place where all of the Navajo belief systems converge is at the Navajo fairs. Many of the larger communities hold fairs during late summer and early fall. The Northern Navajo Fair in Shiprock is the oldest.

Amid the hustle and bustle at the Shiprock fair, Eugene "Baatasolanii" Joe, 41, autographs a poster of a Yeibichei, a ceremonial figure from the Nightway Chant.

Elders say the roots of the local fair started as a time for people to gather at harvest. A few years later the gathering was held in conjunction with the Nightway Chant. Each year it grew into a larger fair, now sporting a rodeo and a modern-day carnival.

Navajo fairs are also a time for selling the year's most prized work. Families bring their best recipe of corn stew or roast mutton to a small, ramshackle restaurant for sale during the fair. In the back of a pickup, another family sells riding gear, quilts or even a fat sheep.

For Navajo artists, fairs provide opportunities to show and sell artwork. In booths and pickup trucks, fairs are full of crafts ranging from pottery to silver and turquoise jewelry.

Baatasolanii Joe promotes his creative sand art or sand painting at the Shiprock fair. Although the elders shun sacred symbols in commercial sand paintings and other artwork, Joe's trade encompasses a mission. That mission records traditional beliefs on paper and particle board. He fears the Navajo sand paintings and symbols used in traditional ceremonies will diminish as Navajo continue to adapt to change, whether it be beliefs or lifestyles.

Silversmith Thomas Kaye
Ganado, Arizona

Opposite: Bead maker
Grandma Louis Brown
Crystal, New Mexico

"As a professional artist, I try to find new ideas that will combine answers for a lot of upcoming young Navajo artists," Joe says. "I use my caliber [of work] to express my feelings from art—to show there is beauty in what your hand does, and not just words, but you can express beauty, unity and survival with your art."

Another artist—Roger Deal—moved back to the reservation from Kentucky. When Deal and his family drove up in a Winnebago motor home to his grandparents' house near Cudeii, New Mexico, the 23-year-old Navajo was taken aback by what he thought were Navajo who "looked scary" like "real mean Indians."

But Deal found his grandparents to be loving people who took the time to teach him the Navajo language and offered him a plot of land to farm. Deal married outside the tribe to a lovely woman who was attracted to him because he looked like actor Lou Diamond Phillips. With the corn the Deals grew on the farm, their grandparents taught them how to make steamed corn and kneel-down bread laced with green chile.

Deal refuses to use religious symbols in his sand paintings, preferring to use rug designs in his work. "I'm a Navajo artist," he says. "I respect a lot of what the culture has to offer. I won't touch anything as far as religion."

Many elders believe that the gift to work with the hand is determined by the Holy People. Others see a skill or talent almost as another human being who determines which artist will pick up the art of "sewing" a traditional Navajo wedding basket, weaving a rug or molding a pot. "If rug weaving doesn't want you," they say, "then you won't be able to weave."

Silas and Bertha Claw are two Navajo potters who subscribe to this belief. "A long time ago, I'm told, pottery makers isolated themselves because they wanted space to coil and shape a perfect pot," Bertha says. "To make a mistake was an omen. When I mix clay, mold it into shape and fire it, nothing should go amiss. Preparation and forming a shape out of clay should be perfect. My daughters tried learning how to mix clay. They mix clay but when a pot is baked, their pots break.

"I think it's a matter of whether you are blessed with a gift handed to you by the gods. People say clay has a soul of its own. It has a song and a prayer. Maybe nothing is sacred anymore to anyone, so it's difficult for people to make pots."

The Claw family lives in Cow Springs, Arizona, near the rich coal country of Black Mesa. In front of their home, a finished but not yet dry pot hangs from the branch of a cottonwood tree. Next to the tree is the homemade brick structure of an open fireplace where the Claws fire their pots.

Though the two elders worked with clay previously, for a while they didn't sell any products. In the late 1970s, however, the two discovered a market for pots. Both rely on the past for inspiration for their designs.

When the Claws were growing up in the 1920s, pots were used as cooking vessels, bowls and water bottles. Today, Bertha makes a variety, ranging from cooking pots to wedding vases with two spouts or ladles. She recalls the days when women buried pots containing food beneath the ground, started an open fire over the pots, and roasted a leg of mutton while the food beneath the fire baked.

In the past, Navajo life revolved around ceremonies as the seasons changed. People traveled to the Enemy Way ceremonies in the summer and the Nightway Chants in the winter. The Enemy Way Chant required a water drum or a cooking pot. Bertha, whose mother was a potter, would receive orders from people who held Enemy Way ceremonies. Sometimes medicine men asked for ladles to carry herb water when performing curing ceremonies.

"In an Enemy Way sing, a ceremonial pot containing water is usually dressed with a buckskin wrapped tightly around its neck," Bertha explains. "These drums are used during round dances where the drum is the sole instrument used among a group of singers. At the end of the ceremony, the drum is 'undressed.'"

For the most part, Navajo pots don't serve their original purposes, the Claws observe. While customers are interested in purchasing cooking utensils like the ones used by earlier generations of Navajos, many of these pots are used to decorate homes, while others become award-winning museum pieces.

"Most pots, I'd say, are for people to see and enjoy rather than use," Bertha says. "I feel my role as a potter is connecting today's youth with their past. A pot is just like a person. You'll note that on Navajo pottery, you'll see a loop around the neck of the pot. That is a pot's necklace as well as the doorway."

Bertha's husband doesn't make pots. As a child attending ceremonies or charged with tending to his mother's flock of sheep on top of Black Mesa, Silas, now 78, observed the small details of Navajo life. These details included Navajo attire, ceremonial gods, cornfields and animals such as dogs, coyotes and horny toads.

After marrying Bertha, Silas transformed his craft of molding animals into adornments for her pots. Silas also molds Navajo dolls and ceremonial

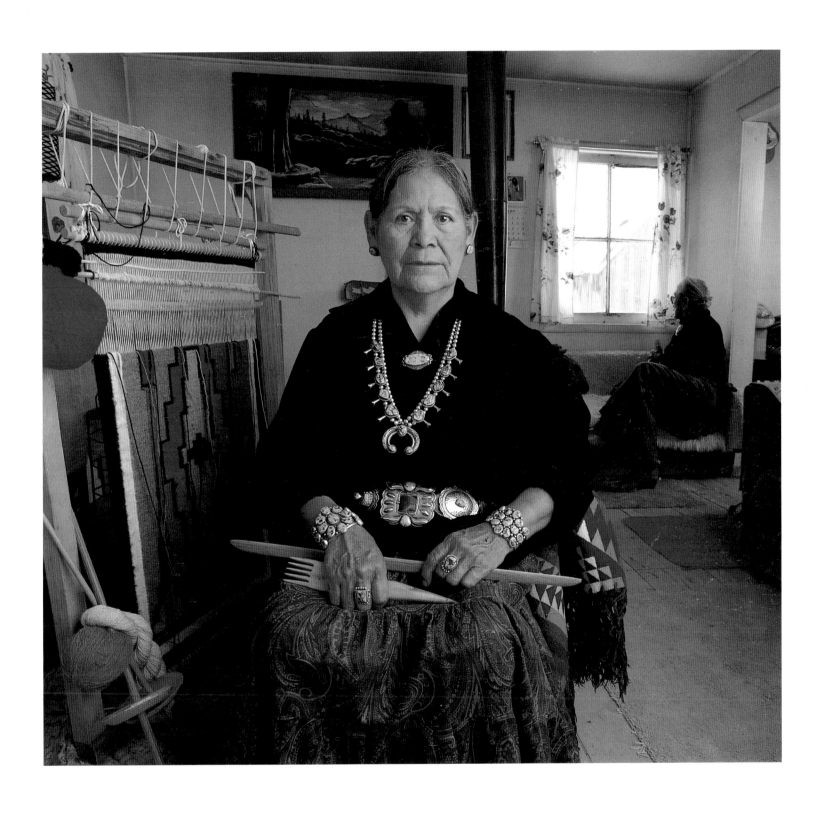

Rug weaver Ella Mae Kaye

Ganado, Arizona

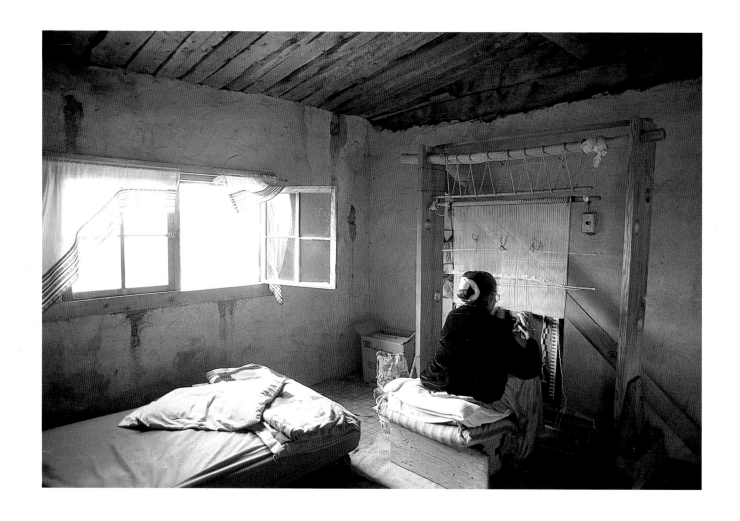

Weaver Rose Tracy

Ganado, Arizona

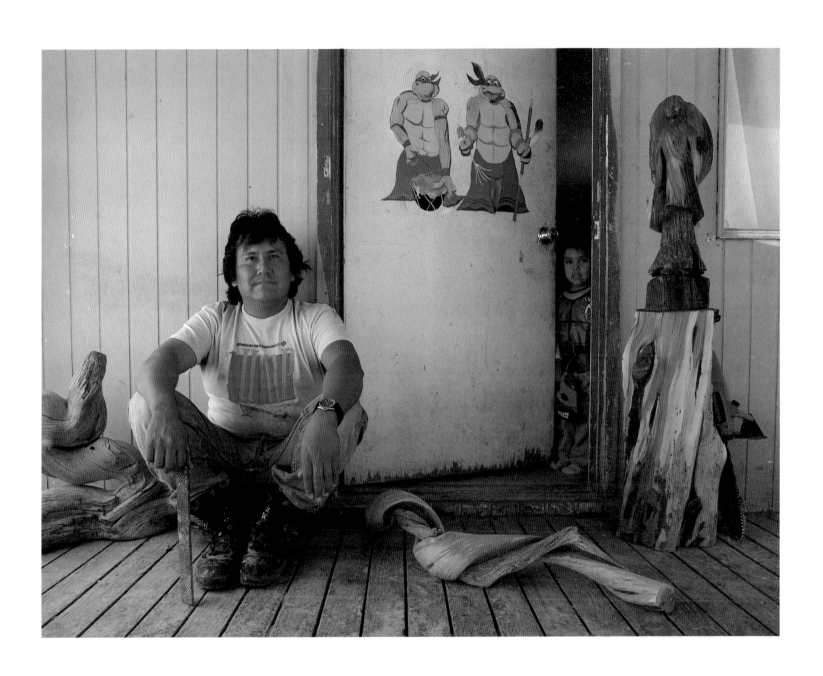

Wood sculptor Bernie Tohdacheeny

Kayenta, Arizona

gods such as Yeibicheis. Navajo people enjoy miniature versions of themselves, Silas believes. His first figurines included a complete set of tiny Yeibicheis, all standing in a row with Talking God, who was leading a dance while Water Sprinkler clowned around at the end. He has also molded such animals as a hungry coyote chasing a sheep, a sheep in a pen, a donkey, a horse and a cow—all to be used to decorate tobacco pipes.

Silas's specialty is designing horny toads for his wife's pots. Navajo address horny toads as their grandfather. That relationship formed during the Navajo emergence from the pit of the earth. Silas tells a story of how, at one time, the people-eating Yeis ruled the earth and found little Navajo children particularly appetizing. One such Yei captured a little boy for lunch. He ordered the boy to gather wood, for he planned to grill the child over an open fire.

While Yei napped beneath an arbor, tears flowed down the little boy's cheeks. Resting nearby on a rock in the sun, Horny Toad heard sniffles. "My child, why are you sad and crying?" grandfather Horny Toad asked four times. The little boy told him of Yei's plans.

"Yei is afraid of me," Horny Toad said. "I'll help you." Horny Toad gave his hat to the little boy, then instructed him to put it on and approach Yei when his back was toward the canyon.

The child returned to Yei's camp. Before the fire was started, Yei stood on the edge of the canyon, stretching from his nap. The little boy quickly put the hat on. "Take that hat off! I'm scared of that hat! Take it off!" Yei hollered as he started backing away from the child. Yei fell into the canyon.

"You see, a horny toad represents a shield for most Navajos," says Silas. "People say it has an armor on its back. Its sharp back is, I'm told, made out of arrowheads. Arrowheads are protection. When Navajo see a horny toad, they pick it up, place it over their hearts, and greet it affectionately, 'Shii cheii, shii cheii,' meaning 'My grandfather, my grandfather.' The gesture is a way of asking for safety and happiness."

Rug weavers, too, have a story about the origin of their art. White Shell Woman, a deity, came upon a dark hole in the ground. The hole was the home of Spider Woman, who was busy creating designs. Spider Woman invited White Shell Woman in and taught her how to weave a Navajo rug dress.

Traders and historians, however, are quick to point out that Navajo adopted the art of weaving from the neighboring Pueblos. Navajo improved and perfected the textiles, creating some 14 styles of rugs. The same process was used by Navajo artisans when they adapted Hispanic silversmithing into designs that are uniquely Navajo.

By day, Celesly Shabi, 13, rides the yellow bus 20 miles to junior high school in Sanders, Arizona, to learn about modern culture. By night, the Navajo teenager travels back to a time five generations ago when women sat at their looms. She weaves intricate, solid lines bordering a series of sawtooth squares, the popular design of the Wide Ruins rug.

Near Wide Ruins, Blue Metal Road crosses two mesas and leads to a lonely three-bedroom modern house—with no electricity—which sits in a clearing next to a hill. To the west in a similar dwelling lives famous Wide Ruins-style rug weaver Marjorie Spencer, grandmother to Shabi, who belongs to the Towering House clan.

As a child, Shabi spent many hours watching and studying Grandmother Spencer as she wove designs of soft pastel earth tones with yarns dyed from plants. "To me, you shouldn't be embarrassed of who you are. You should be proud and show who you are. I'm proud of who I am," Shabi says. "As a weaver, that makes me Navajo. That loom, that yarn in a rug, that design in a rug, all that is carried over from my great-grandmother, grandmothers, my mother, my aunt. If you want to call it keeping a tradition, I guess you could say that. To me, a rug is me, my culture and my heritage."

While many teenagers enjoy wandering the malls in large cities on weekends, Shabi goes to Gallup, New Mexico, only once a month when her mother pays bills. A finished rug sold by her mother

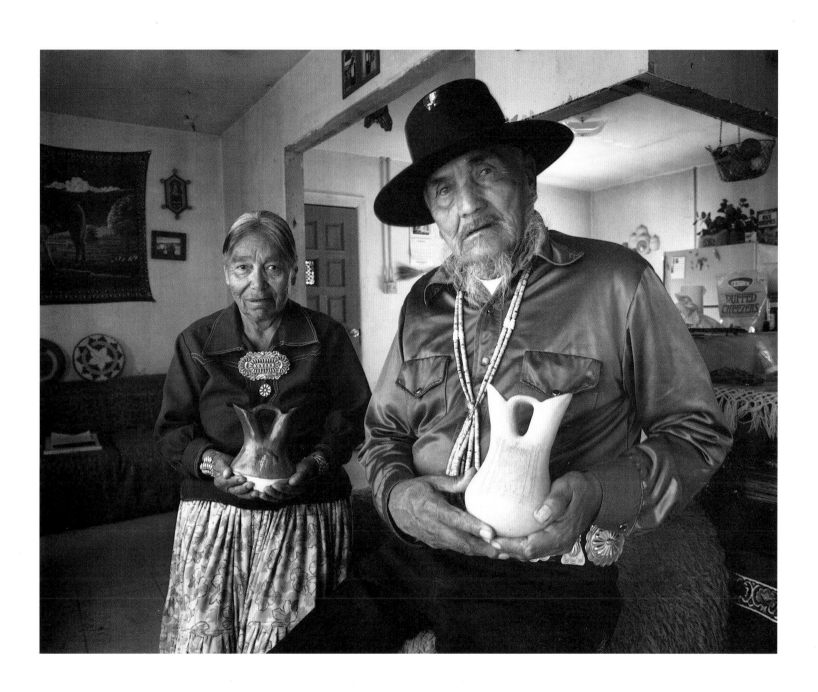

Potters Silas and Bertha Claw

Cow Springs, Arizona

means dinner at Earl's Restaurant or a new pair of shoes for a child.

Rug styles change as Navajo change their lifestyles. In Grandmother Spencer's day, rug weaving was a long-drawn-out task of shearing sheep and washing wool, followed by carding, spinning, dyeing and setting up a loom. Today, the trader at Burnham Trading Post has a business where women card, spin and dye wool. Plant-dyed wool and thin spun warp are sold at the trading post.

"I recall women wrestling a big water barrel away from their homes to an open fire ignited for boiling and cleaning wool," Spencer says. "Washing wool was a dirty chore and the stench was unbearable. When I was growing up, my grandmother used to say, 'Weave, weave, weave, you might marry a councilman one day.' I didn't marry a councilman, but it was hard raising children as a single mother." At age 35, Spencer, a jobless homemaker, found herself with five children to raise. Her husband had walked out on the family.

"I said, 'I'll show you,' and I picked up skills I learned as a child from watching my grandmother weave," Spencer says. "My children were tiny when their father left, and I had to provide for them. By weaving, we built a home for ourselves and bought a truck."

Spencer's award-winning rugs are now displayed in museums and homes.

Though elderly Navajo pass their skills down to their children, Spencer's children learned at their own pace. She didn't force them to learn how to weave.

"I say, 'Weave, weave, weave, you might marry a councilman' in jest to them, but their interest in weaving probably started by watching me," Spencer says. "During their summer vacations, if they had nothing else to do, I'd often make a remark about weaving. I'd say, 'If your rug sells for ten dollars, it would be great because it'll buy you a pair of shoes.' They understood that in order to have money, you either get a job or you weave rugs."

To young granddaughter Genevie Shabi, now 34, Spencer's mother applied pressure through phrases. "Grandmother would tell me, 'If you are a woman, you have to know a skill. It's bad if a woman doesn't know a skill. It's like having a ball of fist rather than fingers that work,'" recalls Shabi. "Or she'd apply a slight pressure on us by saying, 'So and So's daughter can weave. She can make frybread, and here, you know nothing. Your husband or children might starve if you don't have a skill.' When I was growing up, Navajo children took such remarks seriously."

Rug weaving now pays her bills.

Patience is the art to rug weaving, Shabi explains. "Keeping a straight edge is difficult. If I pull too tight on the yarn, the edge of a rug becomes indented. You have to be gentle, and a weaver can't speed weave. My children call rugs that are pulled in on the sides 'a diaper rug' because of its shape."

Weavers have their share of difficulties, not the least of which is fluctuating prices. "Weavers get frustrated, especially when a trader or buyer insists on a lower price than you expect," Shabi says. "When I was younger, I remember telling a trader at Hubbell Trading Post, 'I'm going to quit weaving.' The trader told me, 'You're not as well known as your mother is. Keep weaving, you'll get there.'"

Bessie Jackson, 54, of Navajo Mountain, knows another type of weaving. She used to rely on the Navajo Mountain Trading Post to buy her baskets. Today she has expanded.

An order sometimes arrives in the mail for a *ts'aa*, a shallow bowl made from sumac in shades of beige sand, russet red and black. People know it as the traditional wedding basket. After the recent closure of the Navajo Mountain Trading Post, Jackson now drives 60 miles to the Thriftway store in Tonalea, Arizona, for mail. The letter is postmarked Window Rock, Arizona. A family wants a wedding basket for a Male Shooting Way ceremony. They plan to drive 162 miles to Tuba City to pick up the

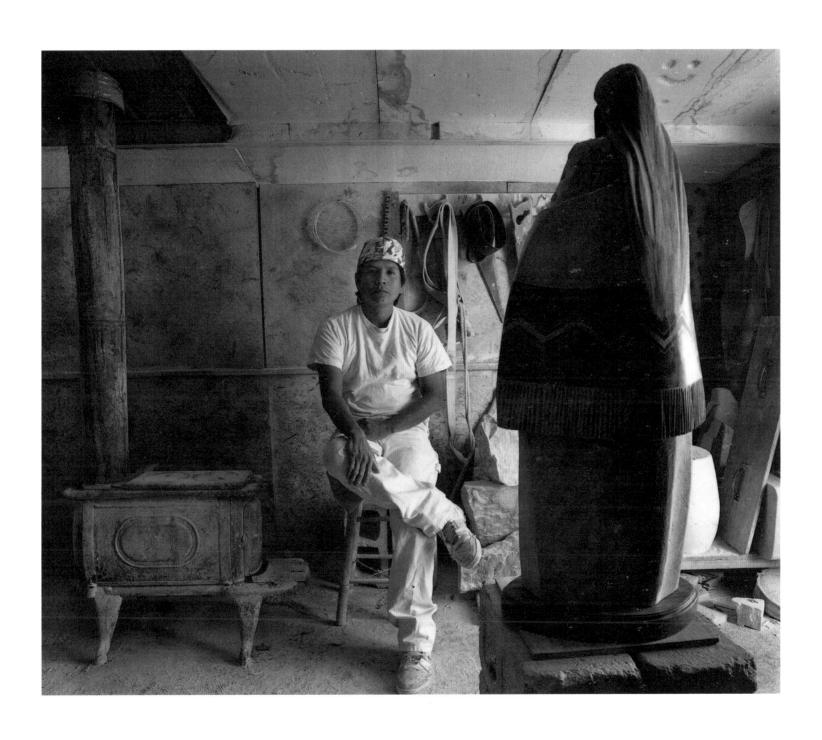

Stone sculptor Oreland Joe in his studio

Shiprock, New Mexico

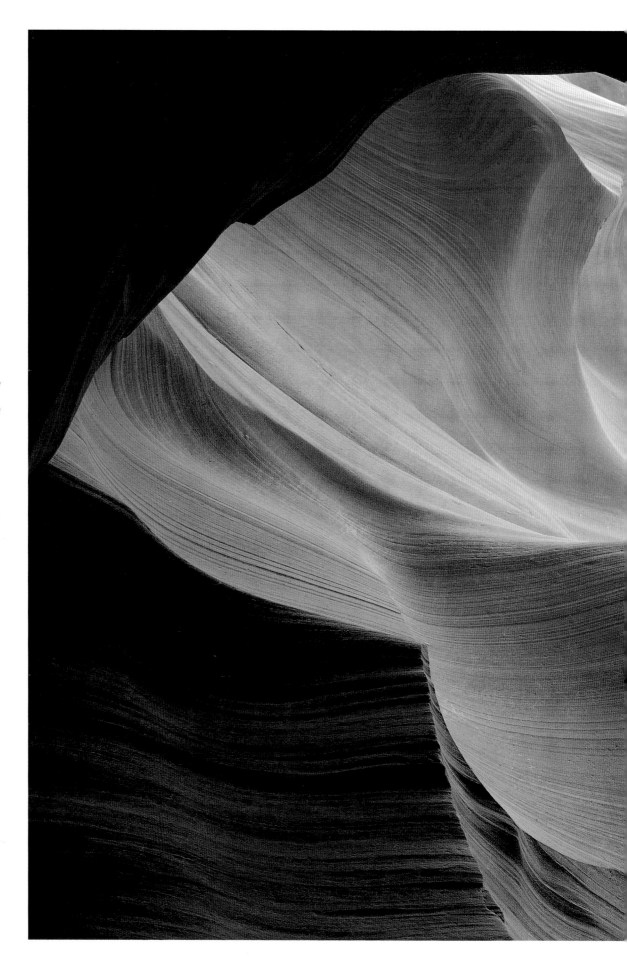

Sandstone formations in Antelope Canyon

near Page, Arizona

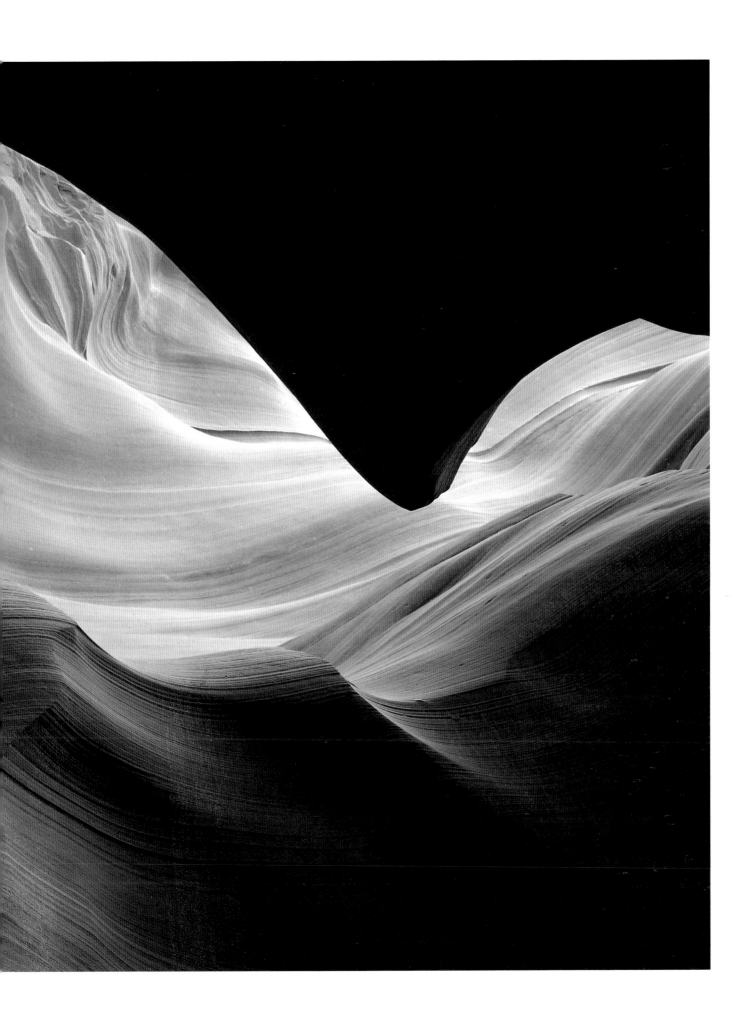

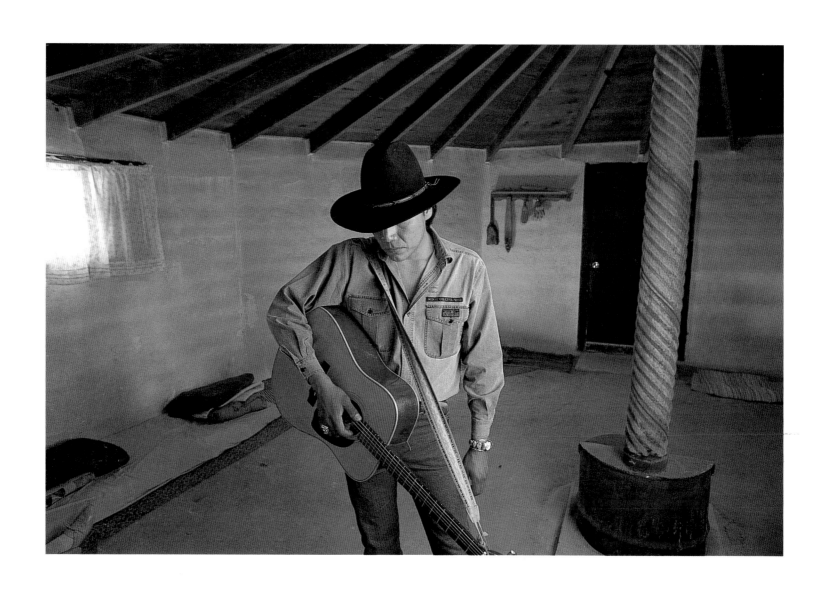

Musician Dewayne Johnson

Teec Nos Pos, Arizona

basket at the Bashas Shopping Center parking lot at 9 a.m. on a Saturday.

Jackson and her husband, Raymond, drive home in their lime green 1982 Chevy pickup over 40 miles of washboard road framed by rugged sandstone canyons. The notorious dirt road is often a challenge for motorists, but locals are familiar with each rut and pothole and expertly drive their *chidees* to minimize bouncing. The unpaved road serves as the primary access to this isolated community that borders the northern edge of the Navajo reservation east of Lake Powell. Not a stop sign exists in Navajo Mountain, where, one resident says, the elders still believe "John F. Kennedy is president."

Jackson and her family live beside a plateau among juniper trees with a view of Bear Ears mountain. A sheep corral and a homemade basketball hoop stand in front of their small one-bedroom house. Electricity and running water are nonexistent.

Between caring for her livestock and sewing baskets, Jackson devotes much of her time to the Christian church. She doesn't work on her baskets on Sundays.

Jackson's supply of sumac is low. With the time allowed, a drive to Shiprock for sumac gathering is out of the question, so she resorts to buying a bundle of already spliced sumac from another basket maker who lives near Paiute Canyon. Jackson dyes a bundle of the sumac with mahogany root, along with charcoal and juniper sap to produce the black and russet red colors for the ts'aa.

After checking on her flock of sheep, Jackson begins the task of "sewing" the basket. One strand of sumac sewn tightly around a sumac warp forms a pit. Jackson's baskets are a tight weave, and the black and russet red designs are perfectly centered.

As her hands work the sumac around the warp, Jackson recalls, "I learned by watching and studying my mother and grandmother's hands. As a child, you learn how to spell your name, memorize the ABCs. A similar application is made in teaching your hands to splice sumac or sew with sumac." Basket sewing is similar to having a job, she says.

"Outsiders probably think all we do is stay home and wait for welfare checks. Many Navajo people don't. With today's prices on food and gas, raising sheep doesn't bring the income needed for a family," she says, using her front tooth to cut an extra piece of sumac. A dentist at Tuba City told her to use scissors to splice sumac. Years of splicing have caused a space to develop between her front teeth.

Jackson has passed her talent to a daughter, who sews beautiful baskets. Teaching a grandchild may be more difficult, for the elderly basket weaver doesn't speak English. "A lot of Navajo children today, including some of my grandchildren, don't speak Navajo. If I'm to teach a child, they must understand the Navajo language. Communication is crucial because it involves telling a person where a design should start in a basket," Jackson says. "It's tough for elders to teach the young if they don't understand the other's language. I tell my daughters and sons, 'Teach your children the Navajo language so I can teach them how to sew baskets.'"

Absorbed in her work, the basket maker silently thanks God for placing sumac on earth. Each element of a basket carries a significant meaning of the Navajo relationship to Mother Earth. The pit of the basket is the emergence from the underworld; the first layer of beige sand color is the earth; the black inverted boxes represent the mountains or night; the red represents multi-colored sunrays; the second set of black boxes signifies the Holy People; and the remaining beige sand color represents the Navajo Nation. The opening in the ts'aa symbolizes dawn.

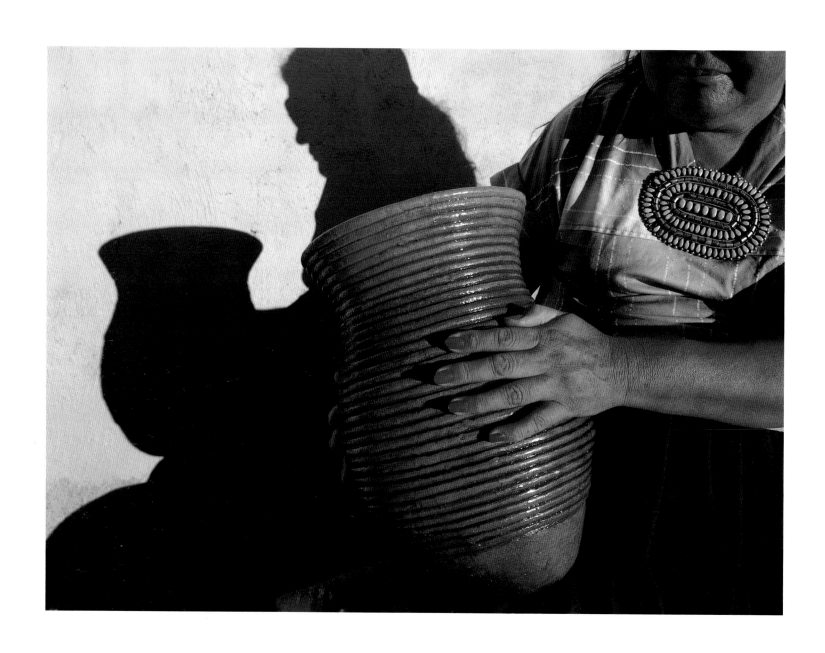

Potter Louise R. Goodman

Tonalea, Arizona

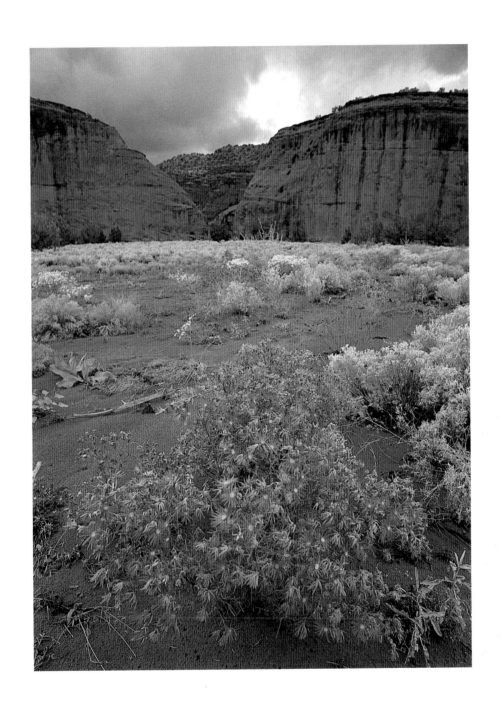

Sticky asters and rabbitbrush wildflowers, Checkerboard Area east of

Navajo Indian Reservation, New Mexico

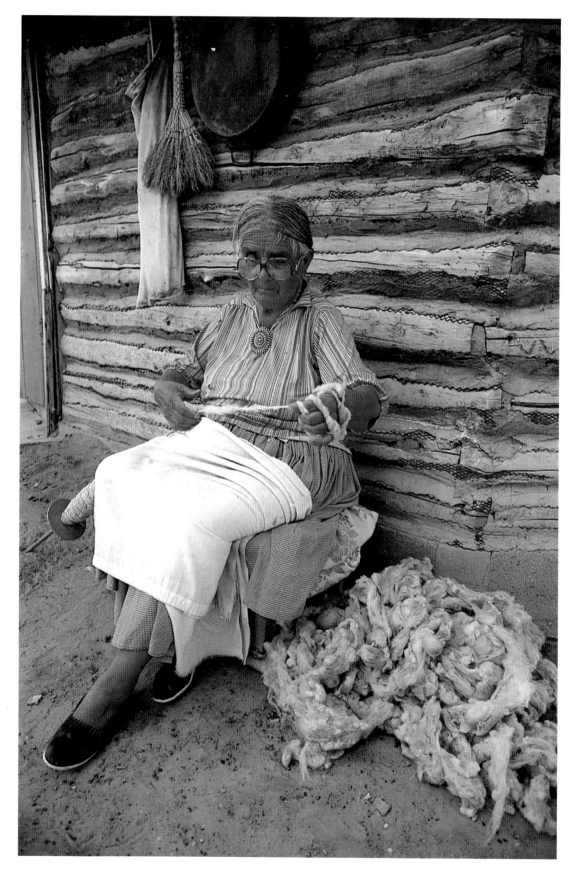

Spinner Alice B. Johnson

Yatahey, New Mexico

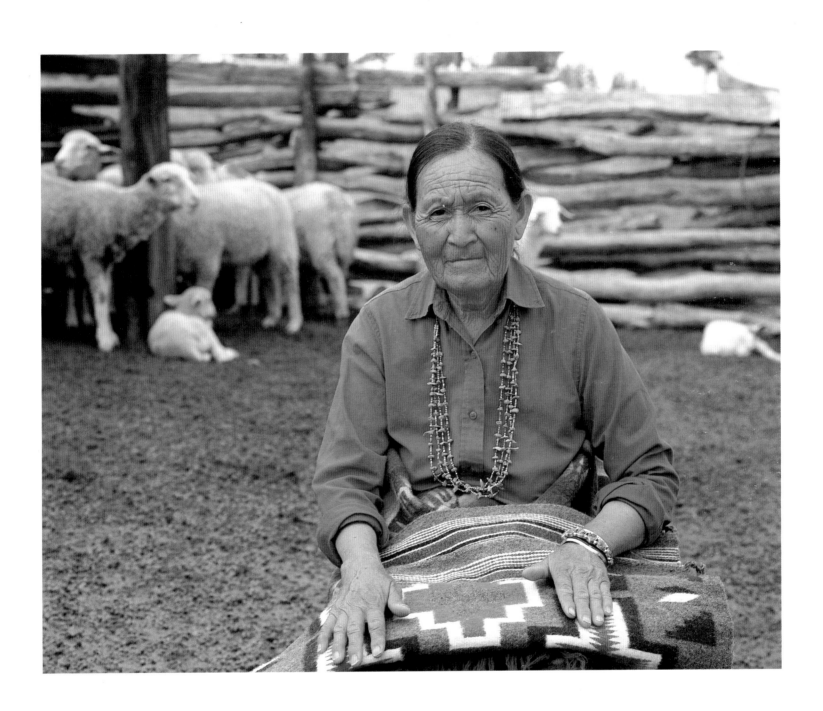

Rug weaver Antoinette Westley

Wide Ruins, Arizona

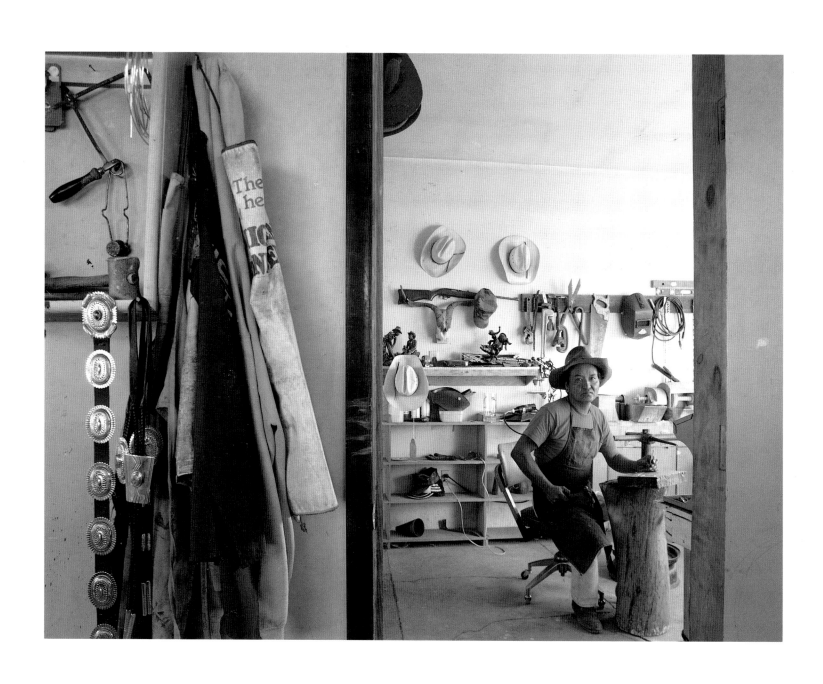

Silversmith David K. Lister in his studio

Indian Wells, Arizona

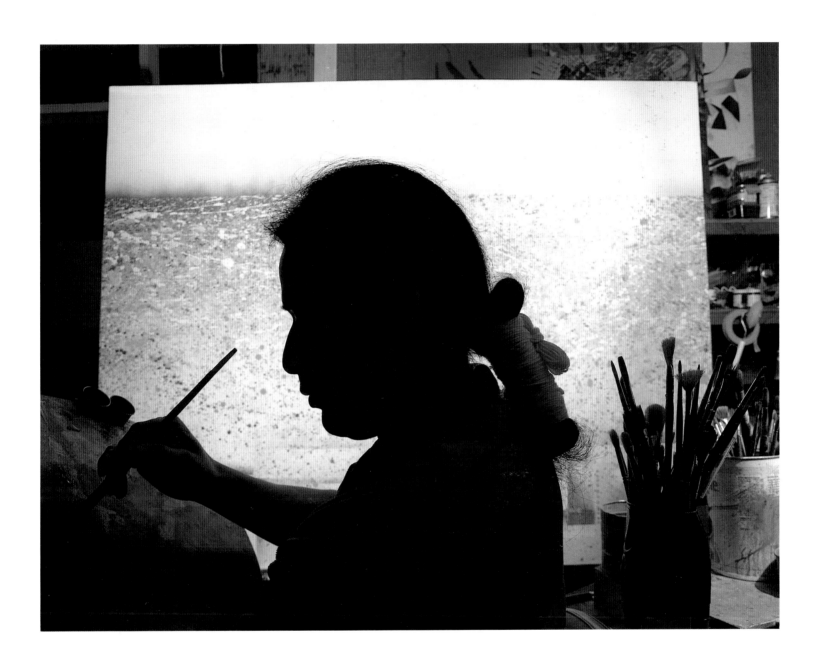

Painter/actor Redwing Ted Nez

Tuba City, Arizona

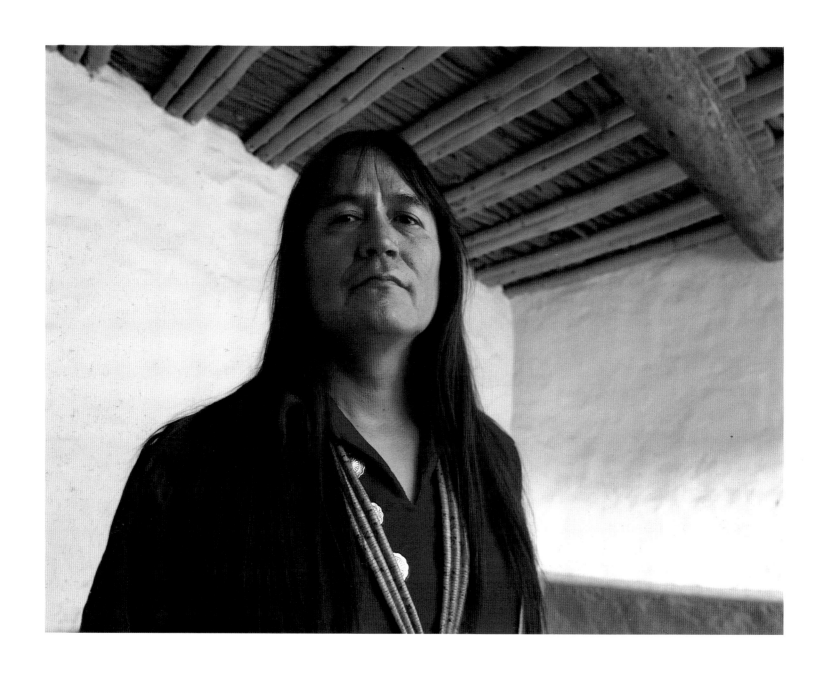

Sand painter Eugene "Baatasolanii" Joe

Shiprock, New Mexico

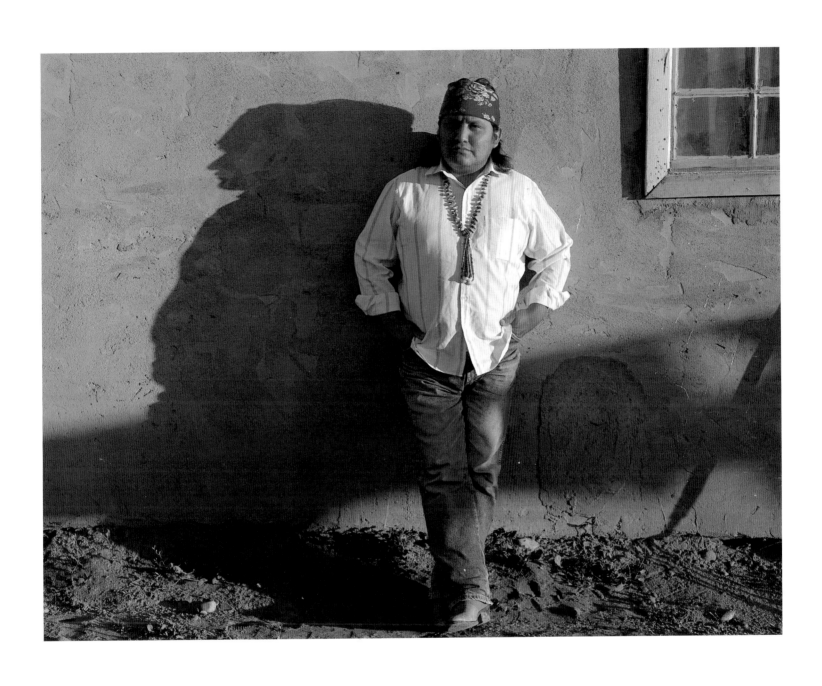

Sand painter Hosteen Etsitty

Shiprock, New Mexico

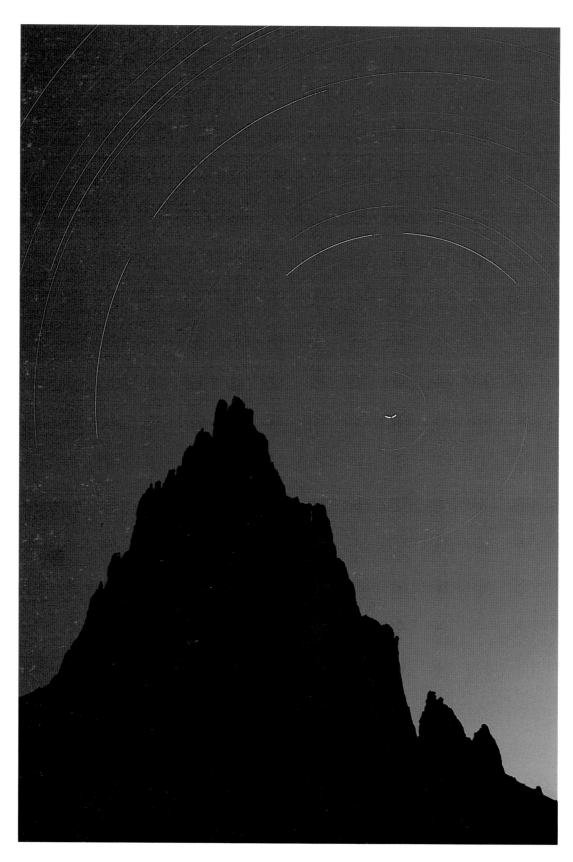

Winter star tracks in northern skies

above Shiprock, New Mexico

Baiyajiltriyish,

Thereof he telleth.

Tsilchke digini, / Baiyajiltriyish,

Now of the Holy Youth, /Thereof he telleth.

Ke-pa-nashjini, / Baiyajiltriyish,

Moccasins decked with black, / Thereof he telleth.

Kla-pa-naskan-a, / Baiyajiltriyish,

And richly broidered dress, / Thereof he telleth.

Ka'ka pa-stran-a, / Baiyajiltriyish,

Arm-bands of eagle feathers, / Thereof he telleth.

Niltsan atsoz-i, / Baiyajiltriyish,

And now the rain-plumes, / Thereof he telleth.

Niltsan-bekan-a, / Baiyajiltriyish,

Now of the Male-Rain, / Thereof he telleth.

Ka'bi datro-e, / Baiyajiltriyish,

Now of the rain-drops fallen, / Thereof he telleth.

Sa-a naraï / Baiyajiltriyish,

Now of the Unending Life, / Thereof he telleth.

Bike hozhoni, / Baiyajiltriyish,

Now of Unchanging Joy, / Thereof he telleth.

Baiyajiltriyish.

Thereof he telleth.

DSCHLYIDJE HATAL
Song From the Mountain Chant

Roadside vendors outside Bitter Springs, Arizona

Navajo wares at Yellowhorse Trading Post, near Lupton, Arizona

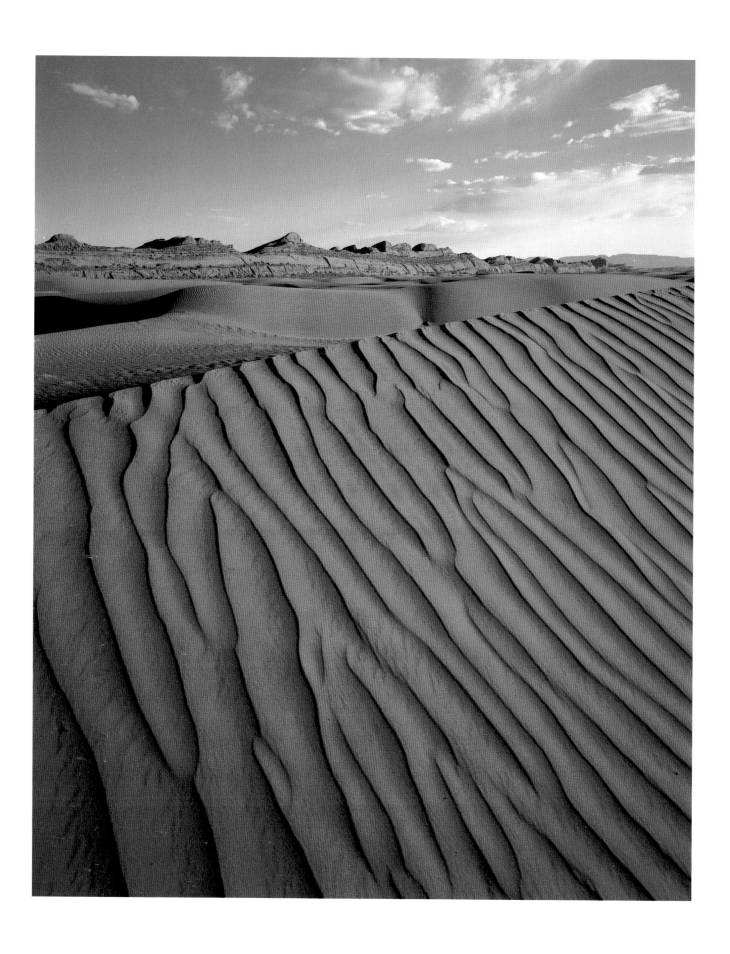

*I*n the beginning, Navajo medicine men say, there was darkness, black mist and water. June Bug formed the earth by gathering mud.

Navajo legends say the Diné, the People, emerged through a reed from four colorful underworlds and found themselves between the Four Sacred Mountains.

For Navajo, the land is the source of sanctuaries where prayers are recited to the Holy People. Although the Holy People are never physically seen, Navajo believe the gods personify themselves in the form of wind, rain, thunder, lightning and snow.

Navajo identify their relationship to the land through their relationship with the earth itself. Many grow food, gather wood for shelter and fire, gather herbs and raise livestock on the land. The earth is the mother, often addressed in prayers.

"As humans, we are a part of Mother Earth," says Benny Silversmith, a 44-year-old Navajo medicine man and herbologist from Pine Springs, Arizona. "Animals and insects emerged through four worlds from the pit of the earth. The Holy People created First Man and First Woman, who gave flesh to the Navajo people. We are told our legs are made from earth, our midsection from water, our lungs from air and our head is made out of heat and is placed close to the Father Sun. We are known as the On-Earth-Holy-People. For that reason, our skin is brown like the earth. A child has certain similarities to a mother. Likewise, Navajos are brown like Mother Earth." After a life cycle, people return to the earth, the mother, Silversmith adds.

During the week, the Pine Springs man works for the Navajo tribe. On weekends, he can be found at a chant helping, learning a chant. Or he may be gathering herbs from sacred areas on and near the reservation to cure people of diseases ranging from arthritis to cancer. Occasionally, he'll officiate a Navajo wedding ceremony.

Wilson Aronilth, 59, an instructor at Navajo Community College in Tsaile, Arizona, teaches Diné Philosophy of Learning. The message to students and sometimes to oil companies is to respect Mother Earth just as they respect themselves. In Aronilth's view, people are created from elements found in the universe. "Our body is made out of earth, water, air, light and pollen," he says. "In the Black World, the first priority was to keep those elements clean."

Today, that priority no longer exists. "Who understands the natural cosmic order?" Aronilth asks. "We forget the natural order of life. We have different priorities. We get addicted to things like cigarettes, colas, sugar, alcohol. We don't try to keep our body pure anymore. The same applies to the earth. We cut trees for no reason, without knowing they are manifested gods. We've forgotten that any time we take from Mother Earth, we give her a prayer. When we say, 'I want to keep my mind, body and soul clean,' we mean our bodies and forget Mother Earth. We name our Mother Earth in a prayer, but at the same time we are polluting our air and water and all elements she gives us."

El Capitan, north of Kayenta, Arizona

Opposite: Late afternoon light on sand dunes in Laguna Wash, Monument Valley Navajo Tribal Park Arizona/Utah border

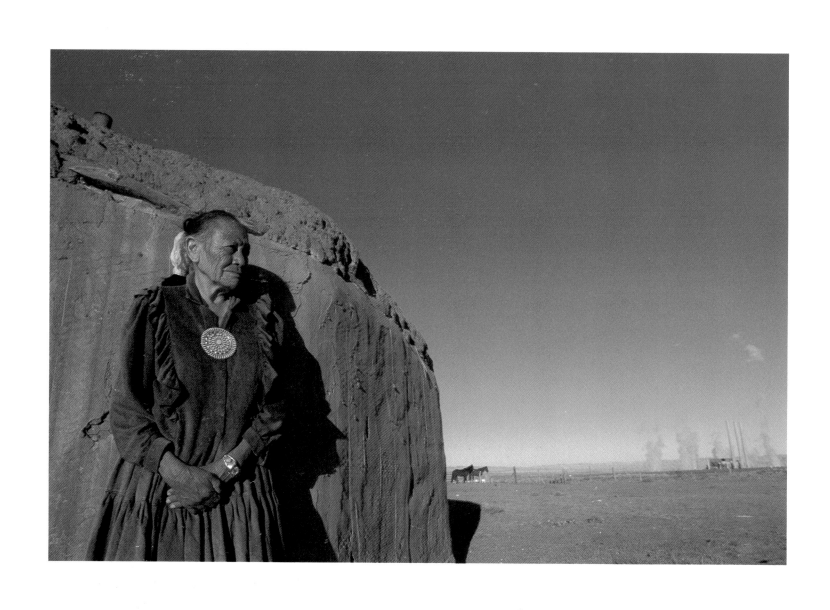

Betty Norris and Navajo Power Plant, near Page, Arizona

Aronilth blames cultural changes on the "civilized mind," which he describes as "scientific, competitive thought organized like a computer." Navajo aren't excluded from this type of thinking. "We throw trash. Animals eat the trash and spread disease. It's not the fault of animals, it's us humans. We say we want to walk in beauty, all around me from within my soul and spirit, then we still pollute our environment. We pollute our path with trash."

Revenues gained from tribal resources—such as oil, gas and coal—finance a large Navajo government. Jobs are provided, but people need to understand that nation building is being done at the environment's expense, Aronilth believes.

"It looked good to build our economy, to develop socially, but we are caught in a different stage," he says. "The outside civilization came in, and there was that money. It gave us the stimulation to reach out to these coal and uranium companies. They never told us about the hazards. Maybe they didn't know about it." Trained scientific minds should come up with answers when developing substances that are dangerous to people and Mother Earth, Aronilth says.

"Here we are as humans; we are supposed to be intelligent. I say, the four-legged animals are more intelligent than we are. They still respect the natural order of things. There is an expression, 'If you can create a destructive force, you must find a remedy to calm, or balance, that strength.'"

Most Navajo believe they are literally connected with Mother Earth at birth. "My umbilical cord is buried in the sandy earth here at Canyon del Muerto," says Canyon de Chelly farmer Woody Ben. "My mother buried my cord at birth. It links me to the earth, forming a mother-child relationship. I call the earth my earth mother."

When he isn't hunting for a job in Chinle, 51-year-old Ben raises crops of corn, melon and fruit using dry desert farming methods, with water drawn in buckets from the meandering stream on the floor of Canyon del Muerto. He lives on the rim of the canyon during the winter.

In May, the month Navajo call *Taatsoh*, the Growth of Plant Life, Ben begins his hikes on Twin Trails 100 feet down to the canyon bottom. Farther up the canyon, at Swinging Ladder, he has a plot of land passed on by his great-grandfather Curly Mustache Begay, whose ancestors were forced to march to Fort Sumner, New Mexico, in 1864 by the U.S. Cavalry. Navajo call this the Long Walk or *Hwelte*.

By July, there will be ripe apricots drying on the red sandstones. By the time the later crops mature in *Bini'ant'aatsoh*, or September, the Bens will have corn to store, to sell and to use for the Navajo delicacies of steamed corn and kneel-down bread.

One day in May, Ben and his dog Simon take the annual journey to the Swinging Ladder area. A man-made wooden ladder and cables provide access down the sheer-walled canyon to Ben's farmland in a grove of cottonwood trees facing Sheep Point Rock. Toward the end of their lives, wild mountain sheep return to die on this spot on the rim.

Beneath the cottonwoods is a one-bedroom house and a ramshackle arbor. Ben grabs a pail and a hoe, walks down to the river, draws water, walks to a fruit tree, forms a round earthen dam around the tree and pours water, quenching the dry earth's thirst. Leaning on the hoe, he affectionately gazes at his fields.

Ben often writes poems about the beauty of Canyon del Muerto, with its desert varnish walls. The canyon is also home to many late ancestors. Hosteen Curly Mustache, the late crystal gazer and singer of many Navajo chants, is very much alive in his grandson's thoughts today as Ben tills the fields. One day Grandfather told Ben a dream. Ben translated the dream from the Navajo language into an American poem called the "Dedicated Warrior."

"I rode down on a horse at the place where the Spaniards entered Canyon de Chelly. I heard cries of women and children somewhere on the canyon walls. I heard the wailing of the dead Navajos. I tried looking at one spot. Nothing. Silence. Not a shadow moved. They've been murdered and slaughtered

forever to make what Canyon del Muerto is today, a canyon of the dead.

"I rode back in the footprints of time. I slew all the Mexicans and cavalry of Kit Carson with a shield made out of turquoise stone and a silver sword. Then I woke up. It was only a dream. All of the people came to bless me for my ride as a dedicated warrior."

Ben interprets the dream as being about battles Navajo fought in order to hold on to their land between the Four Sacred Mountains. "Del Muerto is my home, my land, my mother. It nourishes me by giving me corn, fruit and water. To my livestock, she gives vegetation. Even the shade walls offer me shelter from the blazing sun. She is with me when I wander far away from home. No matter how far I roam, I'll always return to Canyon del Muerto."

Perhaps it's that strong connection to the land that prevents some Navajo from leaving the land they grew up on, even though the U.S. Congress issued them a July 6, 1986, deadline to relocate from land it awarded to the Hopi tribe.

West of Canyon de Chelly, past Cottonwood, past Pinon and Hardrock, live 59-year-old Jesse Biakeddy and his family. A hogan and a tent are erected by a sheep corral next to a juniper-studded ridge on Hopi-partitioned lands. To the east of the clearing lies Biakeddy's cornfield, next to the dry arroyo just south of Big Mountain.

Biakeddy believes that the earth and the Holy People are alive when he goes out into his cornfield and digs a hole. "I kneel down, hold my ear to the earth, hear humming inside," he says. "I understand that as a conversation taking place among the Holy People, or you can hear the movement of the earth."

As Biakeddy's family of eight waits for their flock of sheep to return on a summer Sunday afternoon, purple thunderclouds threaten to send rain on top of a butte to the north. The members of Biakeddy's family reflect the history of this traditional community's fight with the federal government and the Hopi government over a tract of land known as the Former Joint Use Area. Both tribes believe the land has always been theirs.

Congress and the federal courts agreed with the smaller Hopi tribe and ordered the land split between Navajos and Hopis. Thousands of Navajo families relocated under the federal orders. But many families, including the Biakeddys, continue to resist relocation.

"A lot of us aren't happy about the land dispute. It makes us weep because we have no doubt this is our land, but other people say this isn't our land," Biakeddy says. "Our ancestors were born here. It's unorthodox of the Navajos to abandon their land. The government tells us to relocate; we see it as abandonment of Mother Earth."

For some, no shades of gray exist when understanding the written congressional law. Biakkedy's world and thinking, however, don't function in that manner. He and Mother Earth have a symbiotic relationship. One can't do without the other.

"To the federal government, there is the written law. Everything revolves around that law. For centuries, to us, the law is what is out here. It is the law of Mother Earth. The Holy People placed us here as a people and we abide by their instructions. Most of the people here don't read English. They don't understand the laws written down by the government, but they understand the laws of nature."

The laws of nature require the Navajo people to conduct themselves in a manner pleasing to the Holy People. Some of these include living "as good, hardworking, peaceful, productive people who offer pollen or prayers to the gods," Biakeddy says. "They gave us this earth to live on. That is *hozhoni*, or beauty, which the Diné are required to live by. When something goes wrong in our life, the effort to achieve beauty is destroyed. We find a medicine man or have an Enemy Way ceremony to make things right again. Many of our ceremonies contain prayers and songs naming Mother Earth, the supernatural forces such as lightning, rain and the wind."

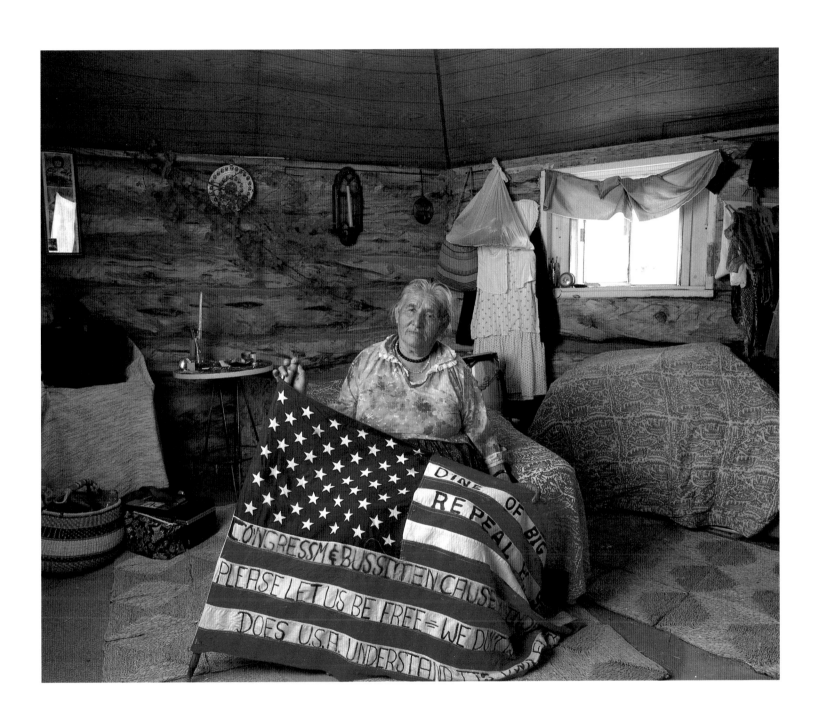

Political activist and relocation resister Katherine A. Smith

Big Mountain, Arizona

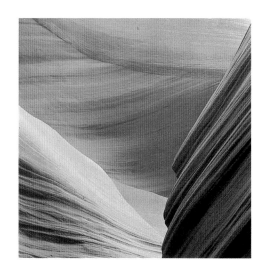

Clouds, Rock, Water, Land

Navajo Indian Reservation, New Mexico

Living with the land dispute for decades, Biakeddy understands a discord arose between man and land. "When you live in harmony with the land, no one fights, no one argues and everyone is happy. That is hozhoni. The Rain People shower us with plenty of moisture and bless us with much vegetation. Our sheep grow fat and the cornstalks grow taller than I am," he says. "But when people begin to argue and fight, the Wind People report to the Holy People of our discontent. That's when rain is withheld. The wind kicks up as the land begins to dry out, and sadness overcomes us. I think Mother Earth hears about this dispute and doesn't appreciate it. We don't get as much rain as we once did."

Biakeddy carries on a very spiritual relationship with Mother Earth. "Before I go out into my field, I sing a song. People say each living thing has a song, a prayer. My cornfield has a prayer," he says. "One of the most important things she gives me is the pollen I use for my prayers. I offer corn pollen to Mother Earth, and when I pray at dawn and dusk, I use corn pollen to communicate with the Holy People. She gives me dried cornhusk so people can smoke tobacco at ceremonies or just to put the mind at ease. I also grow corn so my family eats roasted corn, kneel-down bread or mutton stew with corn.

"Your cornfield reflects your thoughts. If you are happy, healthy corn grows. If your mind is preoccupied with worries or bad thoughts, you get a bad harvest. Lately, the rains don't come each year. My cornfield has diminished. I think the land dispute does affect the growth of my corn."

This same thinking applies to livestock. Traditional Navajo belief counters modern methods when it comes to raising sheep in a dry area. Spaniards introduced sheep to the Navajo in the 1820s, the books say. Traditional Navajo, however, say the Holy People gave them livestock to care for. To Navajo, the land, the people and livestock are all meshed into one, forming "a Navajo ecosystem operating in beauty."

Indian Commissioner John Collier unsuccessfully tried to explain erosion and overgrazing to Navajo livestock owners in the 1930s. Even today, many Navajo cannot be convinced that their sheep or goats are overgrazing the land. They believe that when the number of sheep is reduced, the rains and vegetation diminish.

Where-The-Mesas-Meet, west of U.S. Highway 89 in Arizona, is near a dry wash that connects to a narrow canyon water hole that people call The-Place-Where-Horses-Walk-In-Reverse or The-Place-Where-The-Red-Buttes-Stand. Here live the children of the late Edith Reed, a Bitter Water clan woman. A portable canvas camping tent with an arbor covered with cardboard boxes serves as shade and home for elders Lutie Wilson, Jeanette Lewis and Dorothy Reed. Wilson and Lewis are sisters and Reed is a sister-in-law from the *Tsi'naajinni* or Black Streak Wood People clan.

"We are told our sheep was placed here on earth by the Holy People," explains Lewis. "The earth provides vegetation for the sheep. Sheep gives us food, wool to weave rugs, money for its meat."

The elderly Reed, short for LongReed, inherited a flock of sheep from her mother. Her children sometimes worked toward earning a sheep or a goat by raising pets or sheepherding. Lifetime ownership was formed when a herder sliced a piece of ear off an animal for a daughter or a granddaughter.

In the 1940s and 1950s, Reed's flock numbered 600, which garnered her much status. Raising sheep is a laborious task, especially when lambing season arrives in the winter months. Winter lambs, Reed believes, are much tougher than those raised in the spring. Years ago, while a winter blizzard raged outside, it was common for her large extended family of children and grandchildren to sleep in a tight, packed circle under warm blankets while a mother sheep and newborn lamb stood by the doorway of the hogan.

In late spring, the lambs would grow strong and could follow the herd. That called for a time to shear

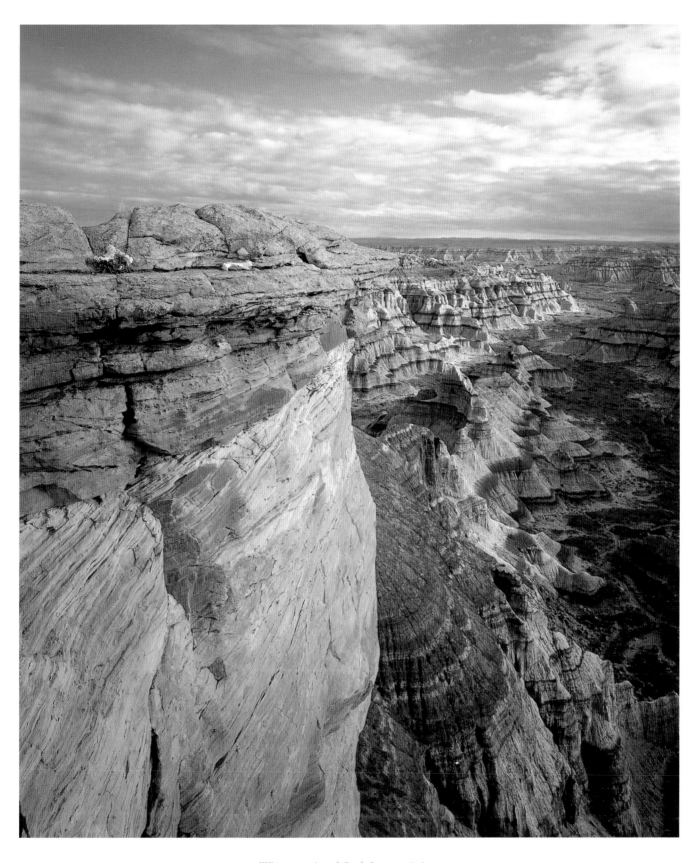

Winter on rim of Coal Canyon, Arizona

wool and sell it at the Tuba City Trading Post, Cedar Ridge Trading Post or Gap Trading Post. In addition to buying the normal staples of flour, baking soda, salt, sugar, coffee and potatoes, Reed often paid off her credit with the traders.

In August, when schools started for her grandchildren, Reed was ready to sell her male lambs. Again, the trip to the trading post was made and clothes for grandchildren were bought.

These days, when people come to visit Reed, they often remark that her sheep all look the same. "To me they don't," she says, inspecting her flock. "Each sheep or goat has its own personality. One might lead the herd on the grazing pasture, another trails behind, another is friendly. Or one sheep might be remembered as a gift given to me by a sister from her flock of sheep. A nick on the ear means the sheep belongs to my daughter. Three slits into the ear shows my granddaughter owns the sheep or goat."

Past the Wilson, Lewis and Reed home, Mary Ann Nockiadeneh lives next to The-Place-Where-The-Road-Goes-Up-A-Mesa. As do many Navajo herders, Nockiadeneh cares for goats as well as sheep. "My sheep comes from Grandmother, who one day gave two goats by slicing tiny pieces of their ears," she recalls. "'In the future,' she told me, 'you'll increase your herd from the two goats. You'll sustain a life from the herd.' That's what I've done.

"As I walk after my sheep, I think positive thoughts of how my flock will grow in health, how they will produce more lambs," Nockiadeneh says. "And I think of the season. I pray that we'll get rain and that Mother Earth gives us plenty of vegetation for my livestock."

Jeanette Lewis also believes that Mother Earth feeds her sheep. A certain hill, a young pine tree, a water spring, "a hole where wind lives," a mountain—all are sacred on the land. Whenever Lewis discovers such a site, she digs in her pocket, finds her corn pollen and says a prayer for her livestock and her family and asks that her rug will bring money.

At night at sheep camp in the cardboard arbor, 60-year-old Lewis sits at her loom by the light of a Coleman lantern. She divides the warp evenly by a quick glide of the right hand across the warp, creating a swishing sound. She lifts the heddle rod, thrusts a batten through the warp to hold it open, inserts a strand of red yarn, then beats the wool down on the warp with a boomp, boomp, boomp.

Traders identify Lewis's creations as storm pattern rugs. The textile is characterized by four heavy, stepped lines that radiate out of a central rectangle with blocks in each of the four corners, which traders call hogans. These rugs are primarily in red, black, gray and white.

"The Holy People gave me rug weaving skills," Lewis says. "I sing the rug song as I weave. Some weavers forget these songs, and winning prizes for a rug become more important. Weavers of my generation were taught to give some things back to the Holy People. That is why I carry a song."

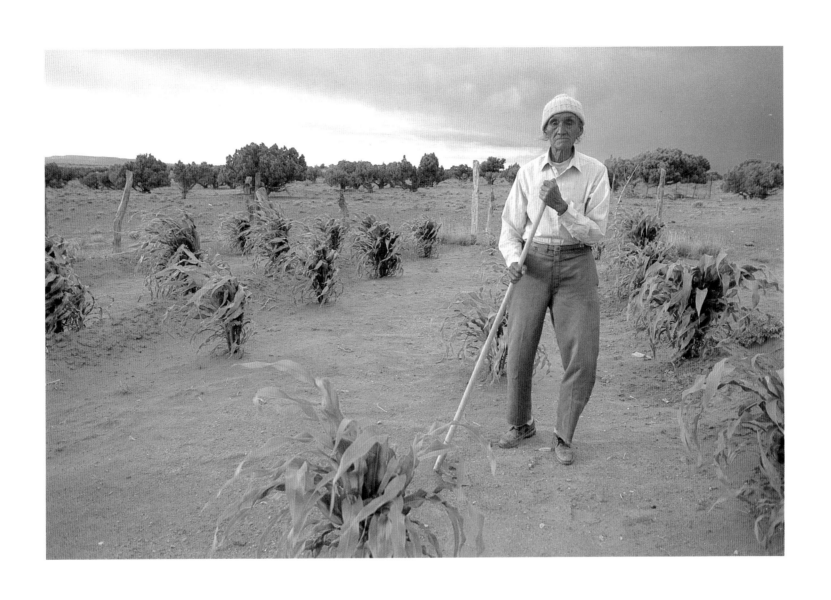

Farmer Hosteen B. Begay

Big Mountain, Arizona

Sand patterns in early morning light

Monument Valley Navajo Tribal Park, Arizona/Utah border

Farmland in Canyon del Muerto

Canyon de Chelly National Monument, Arizona

Nizho'ko ani-hiye! / Ka' Johano-ai dotlizhi be lin-iye

How joyous his neigh! / Lo, the Turquoise Horse of Johano-ai,

Nizho'ko ani-hiye, / Yotti bahostieli tsi bakaï yiki

How joyous his neigh, / There on precious hides outspread standeth he;

Nizho'ko ani-hiye, / Tshilatra hozhoni be jinichltan laki

How joyous his neigh, / There on tips of fair fresh flowers feedeth he;

HLIN BIYIN
Song of the Horse

▲

Nizho'ko ani-hiye, / Tro-tlanastshini-ye be jinichltan laki

How joyous his neigh, / There on mingled waters holy drinketh he;

Nizho'ko ani-hiye, / Ka' pitistshi-ye pilch tashokishko,

How joyous his neigh, / There he spurneth dust of glittering grains;

Nizho'ko ani-hiye, / Ka' ba tradetin-iye yan-a toitinyeko,

How joyous his neigh, / There in mist of sacred pollen hidden, all hidden he;

Nizho'ko ani-hiye, / K'ean natelzhishko k'at tonidineshko,

How joyous his neigh, / There his offspring many grow and thrive forevermore;

Nizho'ko ani-hiye!

How joyous his neigh!

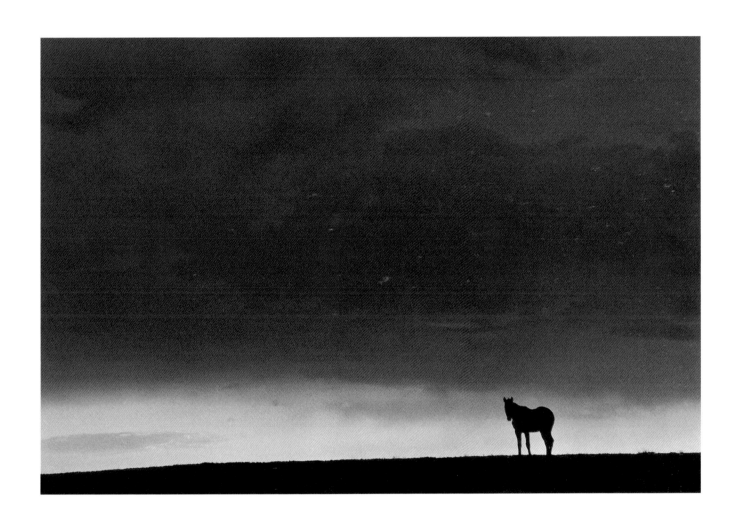

Colt grazing near Bodaway, Arizona

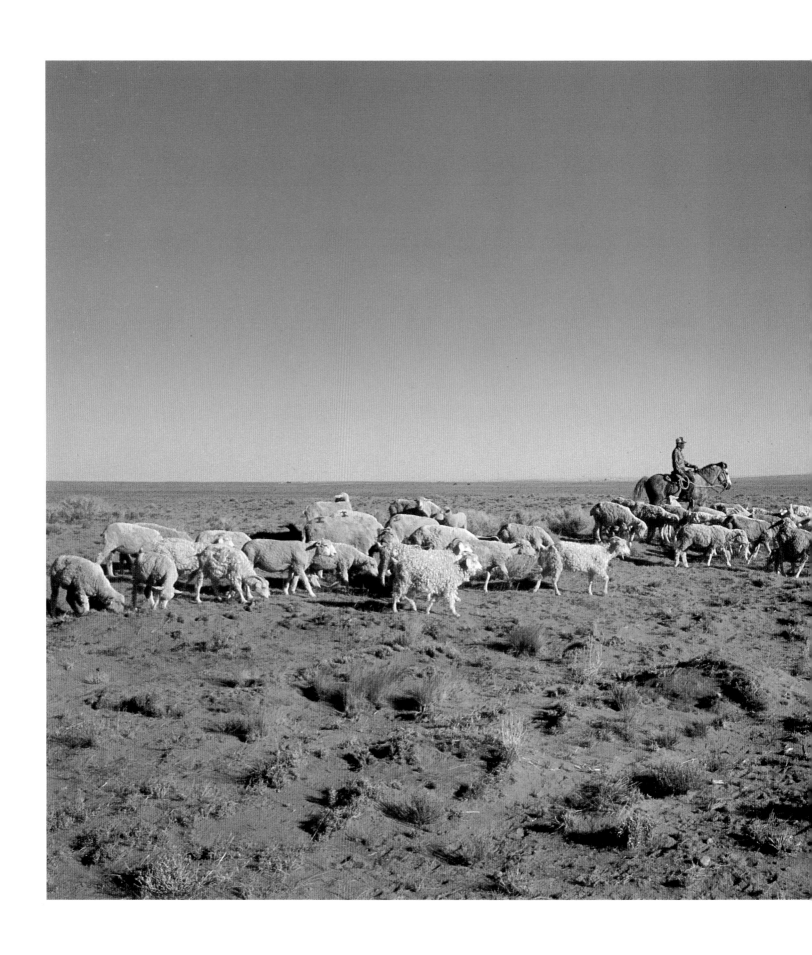

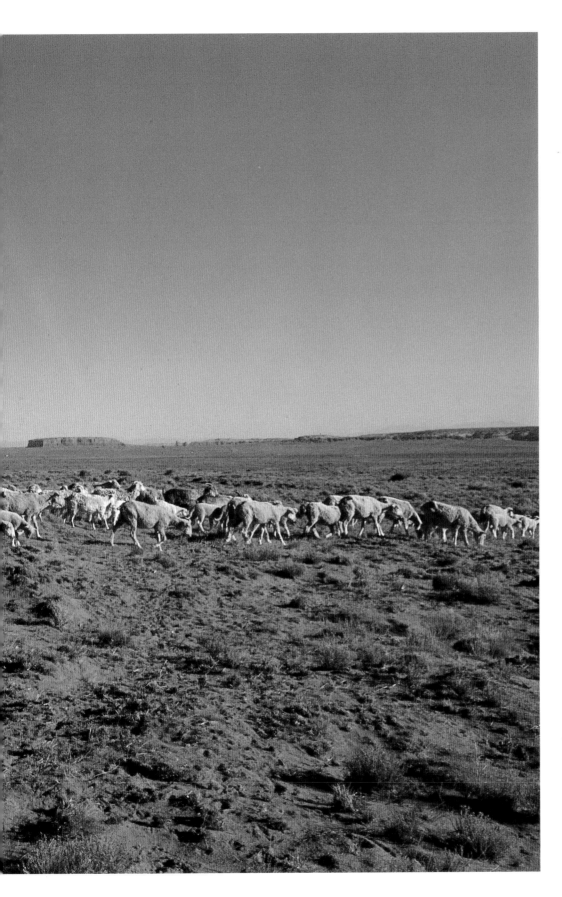

John White herding sheep

Red Mesa, Arizona

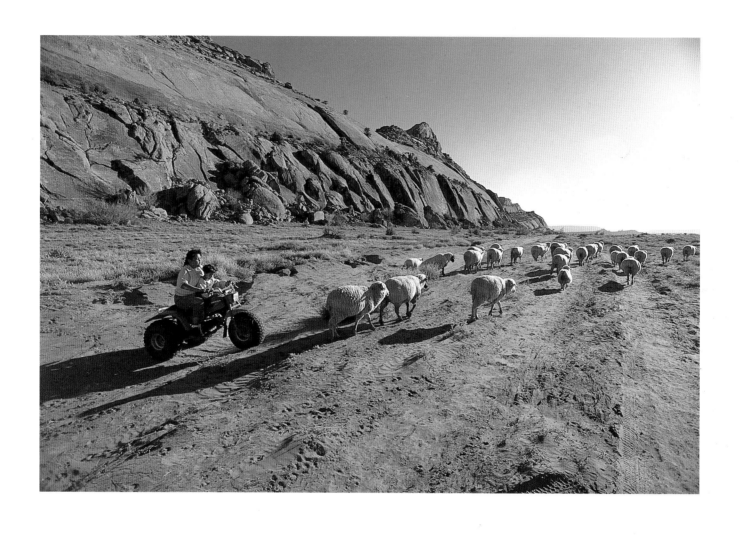

Young girl herding sheep

near Monument Valley Navajo Tribal Park, Arizona/Utah border

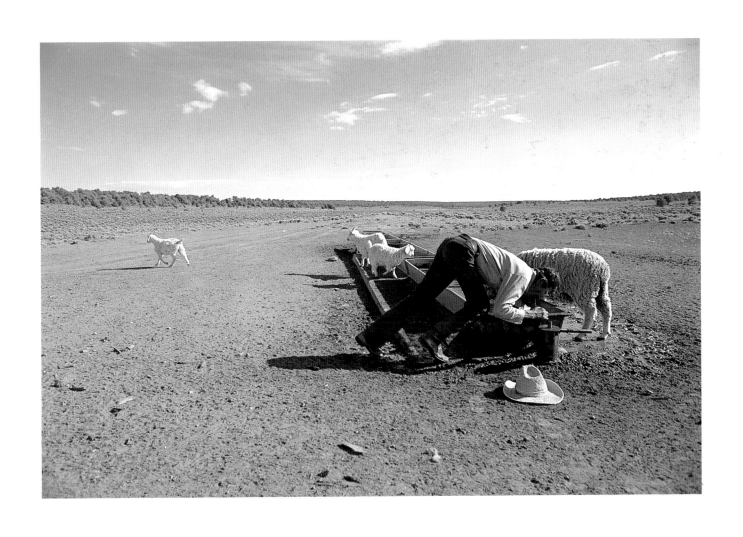

Sheepherder Jimmy Curley slaking thirst

near Ganado, Arizona

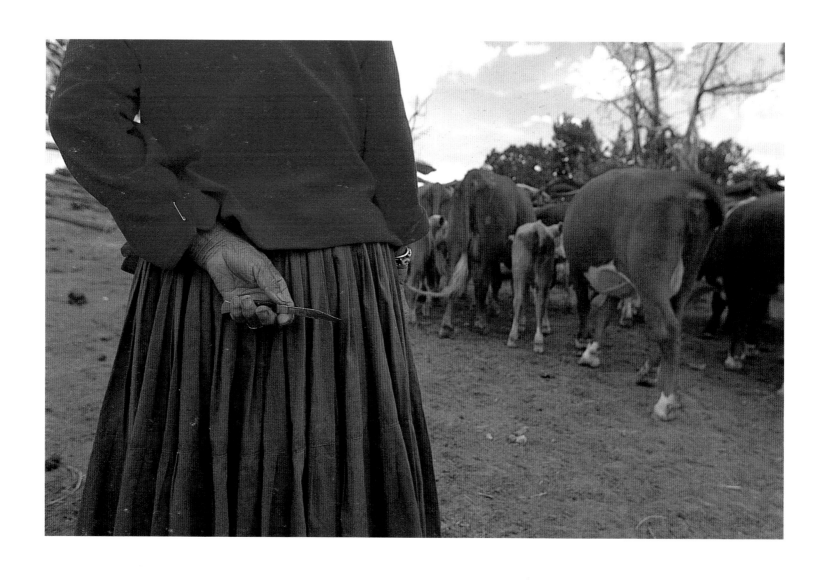

Castrating bull calves

Big Mountain, Arizona

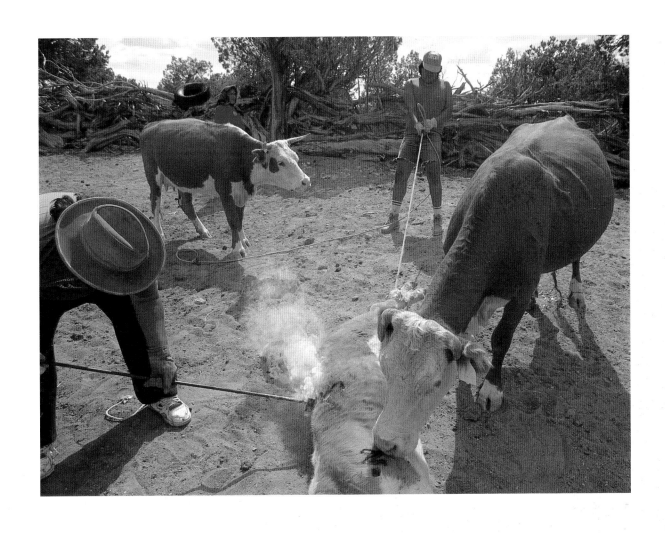

Branding

Big Mountain, Arizona

Lightning over irrigated fields belonging to

Navajo Agricultural Products Industry, near Farmington, New Mexico

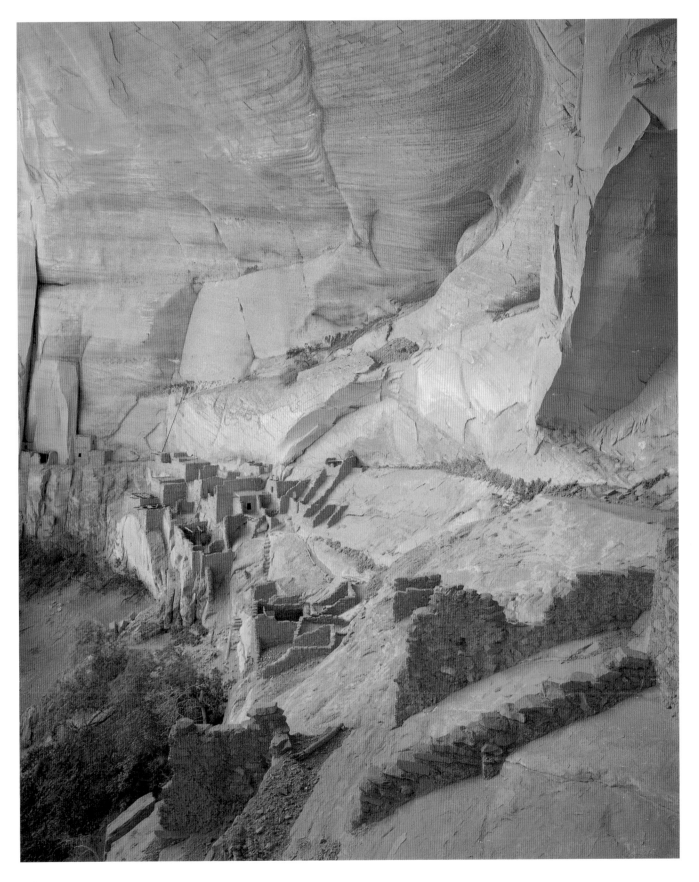

Betatakin Anasazi ruins

Navajo National Monument, Arizona

After the rain

rim of Canyon de Chelly National Monument, Arizona

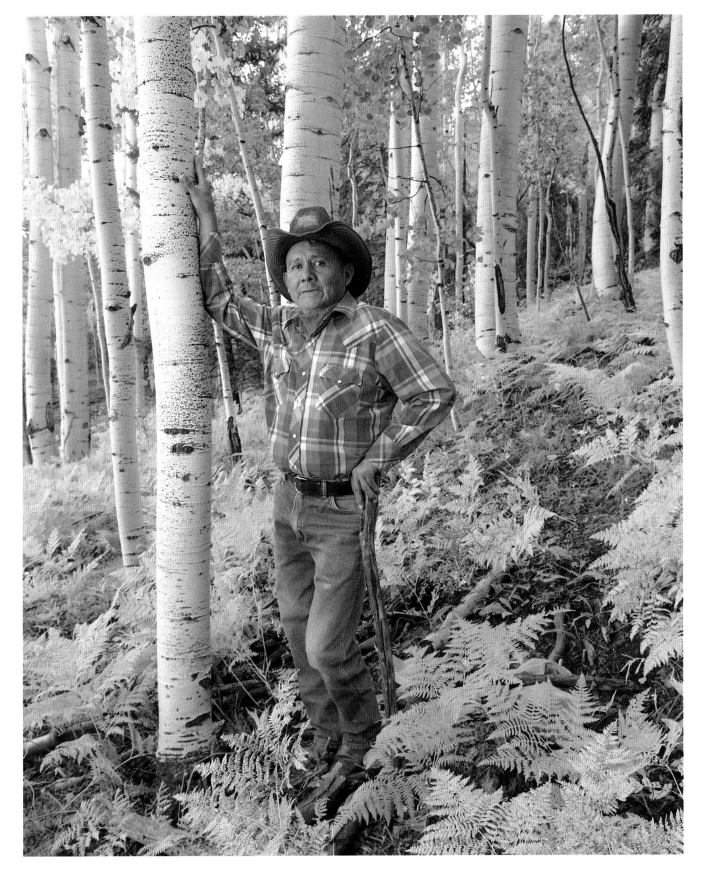

Rancher Alvin Begay

Crystal, New Mexico

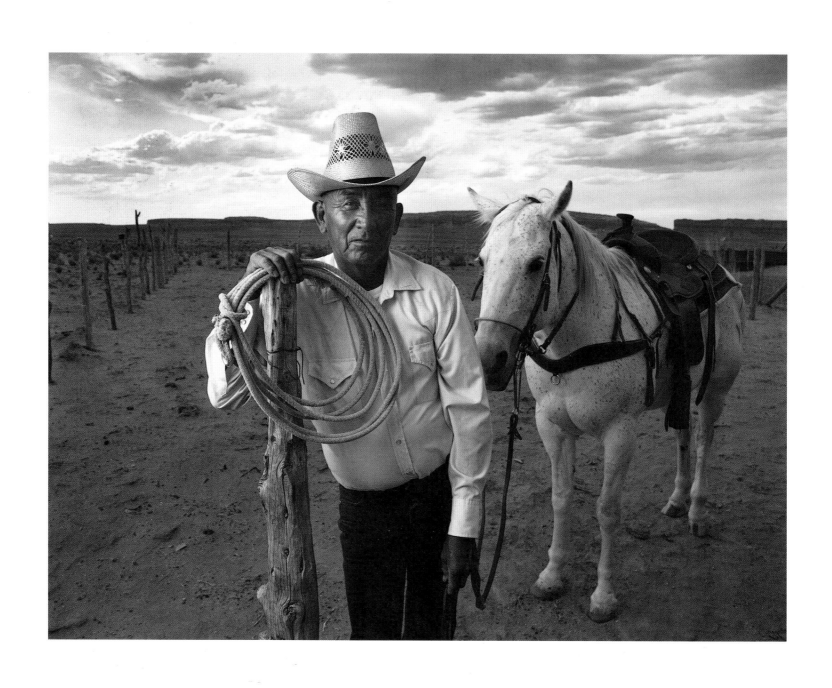

Rancher Casey Todecheeney

Red Mesa, Arizona

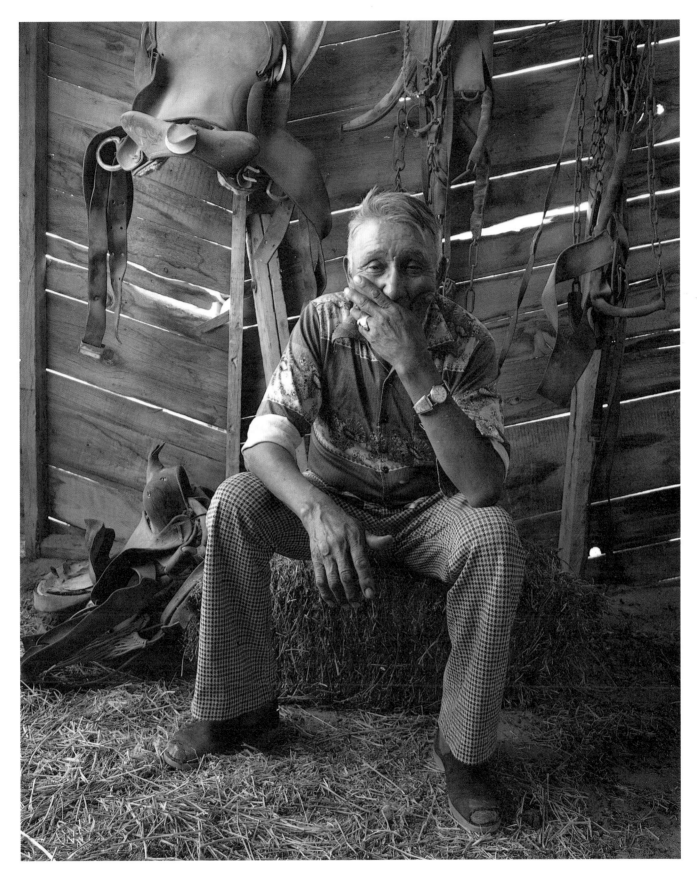

Medicine man Chee Willie

Sweetwater, Arizona

Niye tinishten / Shichl tsha huiyish tin'shta—a-ye-na

Far as man can see, / Comes the rain, / Comes the rain with me.

Niltsan Dsichl-iye / Biya ra-ashte, / Shichl tsha huiyish tin'shta—a-ye-na.

TRO HATAL
Song of the Rain-Chant

From the Rain-Mount, / Rain-Mount far away, / Comes the rain, / Comes the rain with me.

Tshi-natan a-tso-hiye / Betra-ko, / Shichl tsha huiyish tin'shta—a-ye-na.

O'er the corn, / O'er the corn, tall corn, / Comes the rain, / Comes the rain with me.

Betra-ko / Ka' itsiniklizh-iye / Ka' itahazla-ko / Shichl tsha huiyish tin' shta—a-ye-na.

'Mid the lightnings, / 'Mid the lightning zigzag, / Chirping glad together, / Comes the rain, / Comes the rain with me.

Betra-ko / Tradetin-iye / Banga-toyishtini-ko, / Shichl tsha huiyish tin' shta—a-ye-na.

Through the pollen, / Through the pollen blest, / All in pollen hidden, / Comes the rain, / Comes the rain with me.

Niye tinishten / Shichl tsha huiyish tin' shta—a-ye-na.

Far as man can see, / Comes the rain, / Comes the rain with me.

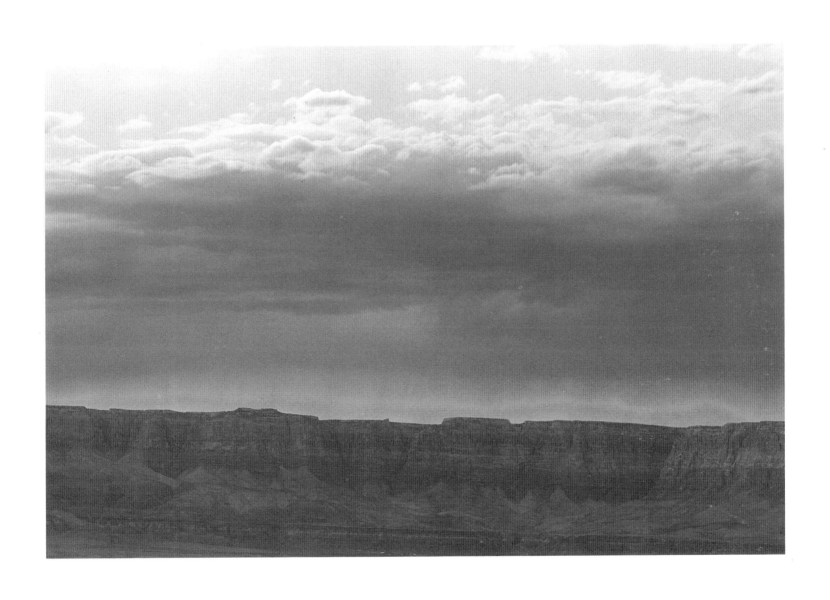

Rain clouds over Marble Canyon, Arizona

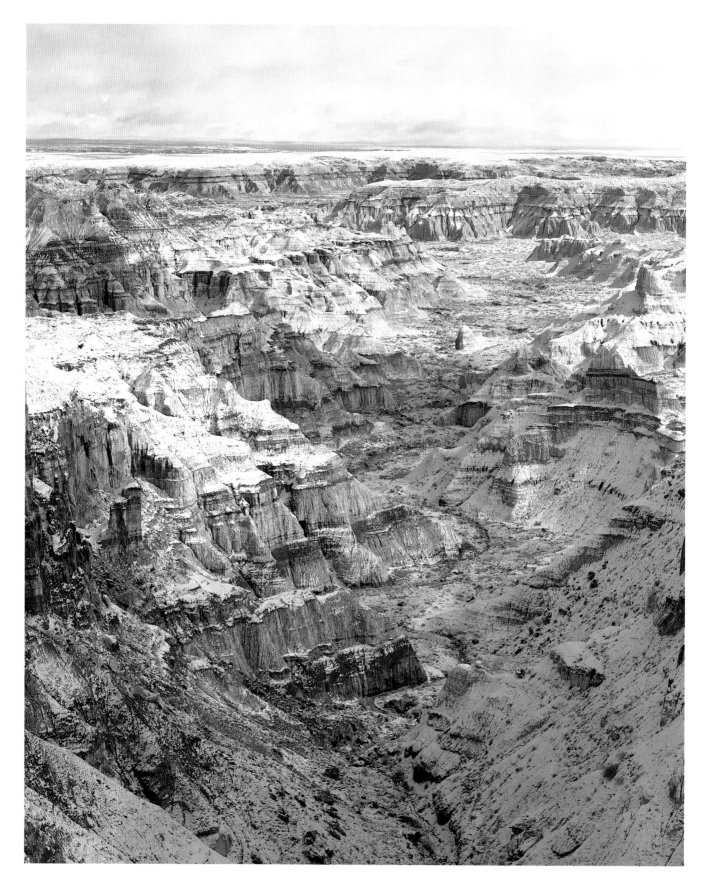

Snow at Coal Canyon, Arizona

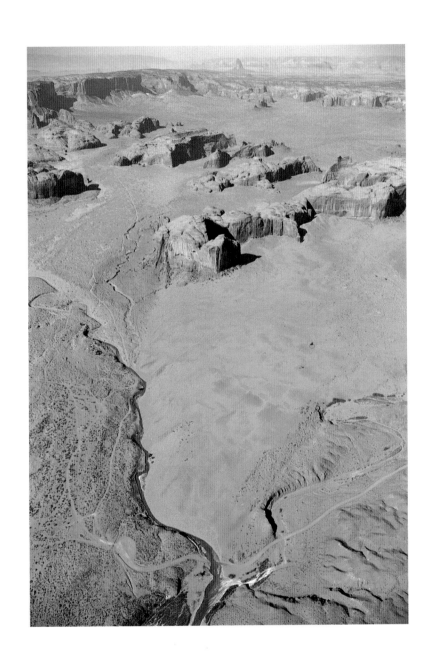

Monument Valley Navajo Tribal Park, Arizona/Utah border

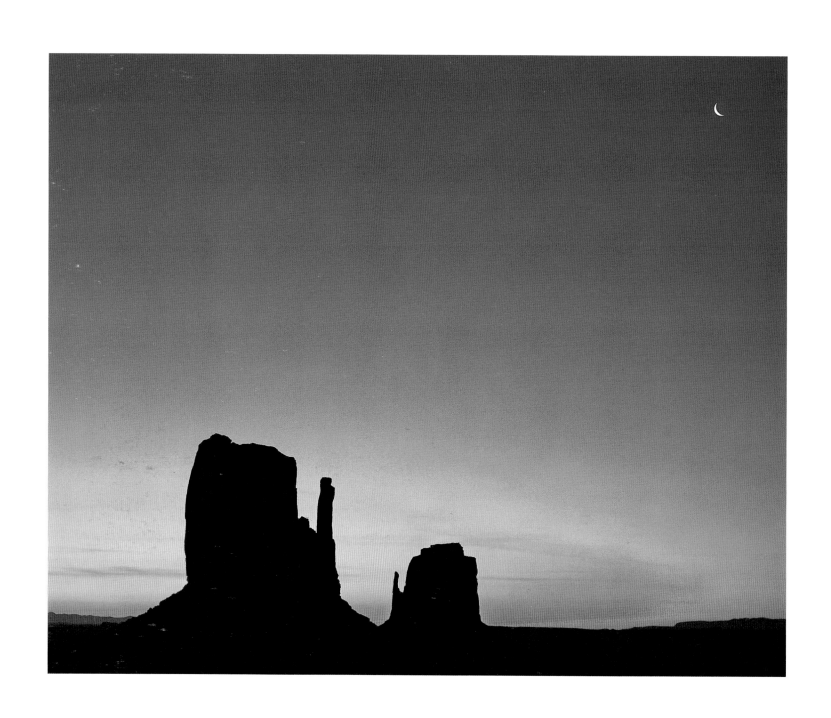

Moonset over Mitten Buttes

Monument Valley Navajo Tribal Park, Arizona/Utah border

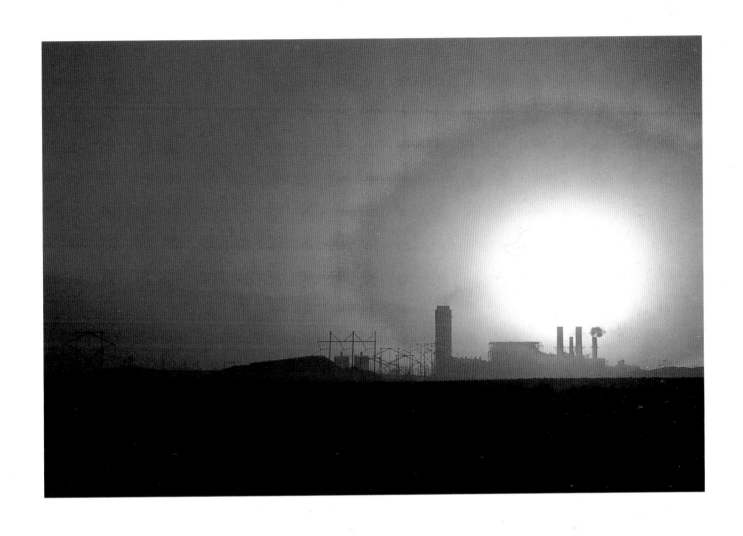

Four Corners Power Plant

between Shiprock and Farmington, New Mexico

The younger generation of Reeds left their sheepcamp home for an education or a job elsewhere. Many are coal miners, welders, construction workers, teachers, artists and students.

The elders say in amusement, "When our children tire of steak, chicken and crave real meat, they'll return home to eat mutton." On a more serious note, they say, "When they miss the land, they'll come home."

For 13-year-old Engenia Salt, Black Mesa is home. During the week, the Navajo teenager attends Shonto Boarding School. On weekends, she travels home to her parents.

Behind the Salt house stands a thick, sturdy electrical pole holding a slightly crooked basketball hoop. Navajo youth are athletes. The interest in basketball is nearly universal on the reservation.

"There is a lot to do out here. I play basketball; we go visit my grandparents," Salt says. "Once in a while, we get a treat from my parents by taking a trip to Flagstaff or Farmington. We go to the malls, and my mom shops for groceries."

Salt dreams of living in New York. "New York City would be different from Black Mesa, Tuba City or Kayenta," she says. "Yeah, I'd like to get off the reservation. But not for long, though. I'd miss this place. There is open space here with a lot of land. The land is sacred, and it means a lot to preserving who I am."

"J.R.," 19, from Greasewood, Arizona, leads a restless life. He grew up in this lonely outpost, where a boarding school, a trading post and a chapter house (community center) are located by Indian Highway 15. Born into a family that raises livestock such as cattle and horses, it was only natural that J.R.'s interest turned to rodeos. His dream is to one day grab the championship bareback rider title at the Window Rock Navajo Nation Fair.

On weekends, J.R. tosses his chaps, rigging gear and a clean straw hat into the back of his truck and heads for a rodeo. KTNN is his favorite station, Garth Brooks his favorite country artist.

"I love to ride bulls," says the young Navajo cowboy. "They are a challenge. The best rodeos are places where you get an opportunity to compete with Navajo big names. My big dream is to one day beat one of the big names."

J.R. doesn't think of moving off the reservation. "I think realistically. I see people moving fast to somewhere. I don't think of being somewhere. I am here at Greasewood," he says. "I'm a reservation person. My family is here. I like working with my hands. I'm interested in engines, rodeos and pacifying a mean ass bull one day."

Some elders love to attend rodeos. But even cowboys are changing, they say. "People call today's Navajo cowboys, 'cowboys,'" says Raymond Jackson, 64, from Navajo Mountain. "I think the genuine Navajo cowboys are a part of the past. They could tame a wild bronc without a holding chute. They'd grab the ears of a horse,

Cattle auction observers

Tuba City, Arizona

Opposite: Reggienell Guy dressed

for traditional dances

Window Rock, Arizona

bite it and bring the creature down to earth, climb on, and the horse exploded out into an open area. I believe that shows the emotional and physical strength of the past Navajo people."

A lack of opportunities on the reservation often take Navajo away. Like the Reeds, many leave the reservation for an education or a job. They have no problems hopscotching between two worlds — the modern and the traditional.

The goal of the Navajo government is independence: independence from the federal government and true self-determination for the Indian people. But many, including "D.R.," a 32-year-old coal miner, remain skeptical. "The bad part about life out here is people have a mentality similar to a socialistic society. They expect things to be given to them instead of people doing it for themselves. We are dependent on welfare. I think you have to be pressured to improve a lifestyle. You have to start starving before there is a change.

"I see too much of a movement to the modern white culture. It's tough," D.R. continues. "When you look at yourself in the mirror and declare, 'I'm Indian,' the next minute you get lost in your behavior and you find yourself acting like a white person. It's all pretty silly after a while when you think too deeply about who you really are. But I'm Navajo."

Delores Wilson balances the two worlds differently. A 26-year-old artist and student at the University of New Mexico in Albuquerque, she left the reservation at 14 in a Greyhound bus headed for Salt Lake City. Wilson lived with a sister for a couple of years before enrolling at South Sevier High School near Richfield, Utah.

"In the modern world, you live on switches. For instance, switching a light on. As a Navajo living in two worlds, I do the same," Wilson says. "I switch from the non-Navajo world to the traditional. It's easy for me to go back and forth. When I go home to sheep camp in the boonies, I can talk to anyone in Navajo, and when I return to Albuquerque, I speak English."

As a teenager who wanted a change, Wilson didn't wish to be a Navajo. One day she cut her long hair, an act her grandmother discouraged because of a Navajo belief that hair represents thought. "One day I thought, 'Man, I really lost it,'" recalls Wilson. "That is one way to describe almost losing yourself in the city."

As she matured, Wilson realized she had a special heritage. "I wanted to change into someone else. When I went to the big city, it was like hitting a wall. I realized that I couldn't change the color of my skin. I took cultural anthropology to help me understand what I was all about. Just knowing the language and the customs of Navajo while living in the city helps. It gives you strength and a strong identity."

Wilson returns home on holidays and for special occasions, such as the Western Navajo Fair in October. "When I do go home, it feels great, especially if I go home to sheep camp," she says. "But I don't think I can go back to my traditional world and live there permanently. It's just in my head and heart where I want to keep records of who I am. I have grown used to the city. A part of me is here. I find it hard to move into one world and declare, 'I'll live here.' Who knows? I might live in a car between here and the reservation one day. What does that make me? A Navajo in a city or a Navajo in the traditional world? One thing I know, I can speak Navajo and I am Navajo."

Another young woman who has lived both on and off the reservation says she has returned home for good. "A lot of my friends say they are Navajo, but they don't know a thing about being Navajo," says Susan Baldwin, 29, from Dilkon, who works for the tribe after graduating from Arizona State University in Tempe.

"My parents are traditional, and I grew up with ceremonies and chants. I'd speak Navajo in front of a lot of my friends at school, and they referred to us as 'sheep-camp girls.' What stays with me is a saying, 'Don't ever be afraid of having an accent. It just means you are worth two people.' Sometimes they

Terriline and Fernando Stash dressed for traditional dances at Fourth of July Fair

Window Rock, Arizona

made fun of me because I wear a lot of silver and turquoise jewelry. I go, like, 'Hey, I'd rather wear this than your 99-cent earrings from K-Mart or some expensive item from Dillards or from some Santa Fe store."

Shiprock photographer Jonas John lived away from the reservation for a decade. He praises the slower pace of life on the reservation. The city, he says, often leads a Navajo to live a life without a religion or family. "In my mind, I think I'm more adapted to the modern world. Mentally living in two worlds is like trying to walk a fine line half of the time. You spend time trying to adapt to a different culture while retaining your identity. If you can juggle the two, it works out. It can also create mental stress. Maybe that is why you have a lot of college-age Navajo people into drugs or alcohol.

"The future scares me," John admits. "I don't know where it's going—the religion and language aren't retained. In the year 2050, will there still be Yeibichei dances? Or the Enemy Way ceremonies?"

The trick to juggling two cultures is to take the best of both worlds and use it to one's advantage, says William LongReed, 36, a chemistry and biology teacher at Tuba City High School. His parents live in Bodaway.

"You have to take some good from both the Navajo and modern. Science is a very good field. I always think of the Navajo medicine people. They use the herbs and use different colored rocks in ceremonies," LongReed says. "That helped me a lot in learning about science. If you understand your culture and the modern world, it's easier. If you have

problems with one side, perhaps an identity, I think that will cause problems. For me, I understand the depth and meaning of both worlds. In Navajo, you have to understand what harmony is. In Western thought, it's more a linear thought of cause and effect."

Not many Navajo are in the science field. It's a chore teaching and getting Navajo interested in it, LongReed admits. "Everybody thinks science and math are hard. I used to have a lot of problems in math and science. They have a lot to do with symbolism, right? The way I got around the difficulty was thinking of Navajo sand paintings. There is a lot of symbolism there. That made studying math and science a lot easier to learn."

One day, LongReed would like to see bilingual science taught in the schools. The way of the future, the way of the Diné: Where do the paths cross? Where do they diverge into different directions?

Dwight Witherspoon, 26, a student at Arizona State University, plans to return home after college and teach young Navajo. "Navajo youth are having to pave a path for themselves in taking the best ideas from other cultures and making it their own," he says. "That is becoming more pluralistic, so long as they keep their traditional values.

"The best example is Navajo weaving. Navajos learned weaving from other tribes and became the best weavers. I don't think they changed because they've had new ideas, such as learning to weave new designs. It's just the value that's different. We have to get society to recognize and respect our value system."

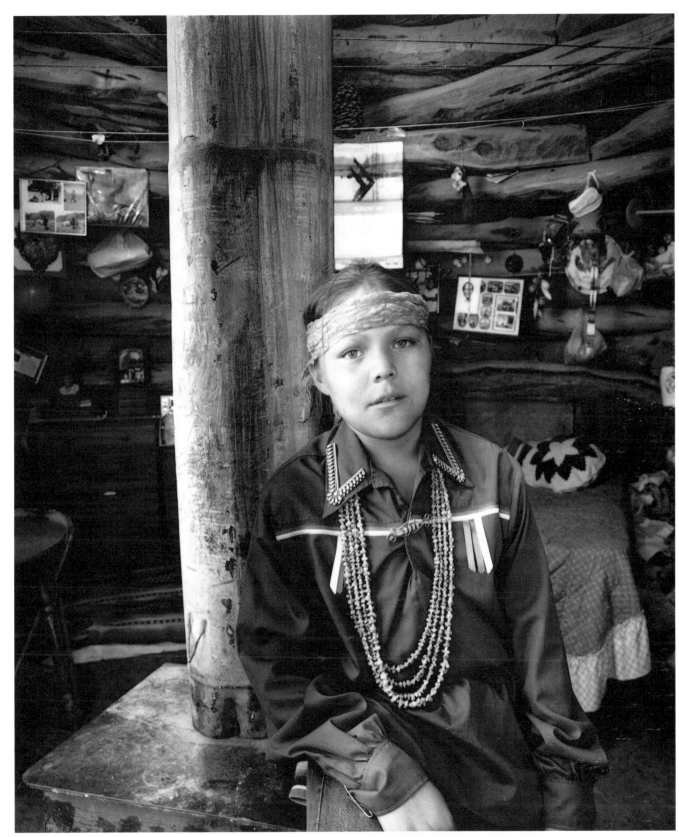

Orville Felix Butler

Monument Valley Navajo Tribal Park, Arizona/Utah border

Kerry Begay

Big Mountain, Arizona

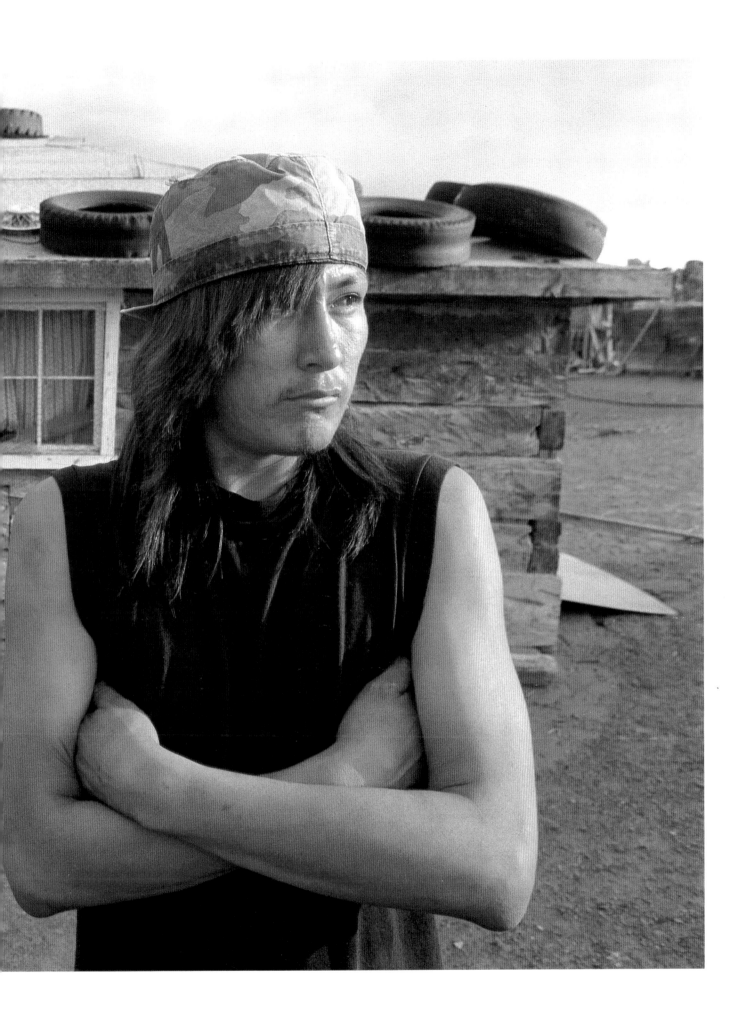

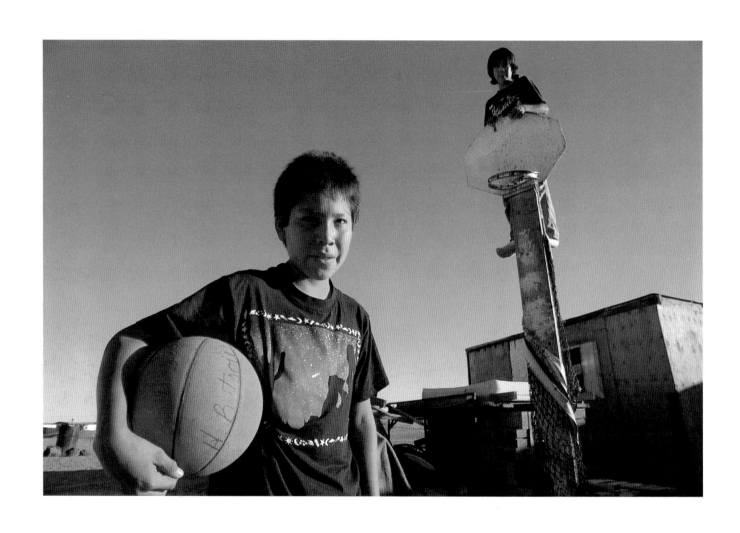

Leon (with basketball) and Everett Bitsosie

Kaibito, Arizona

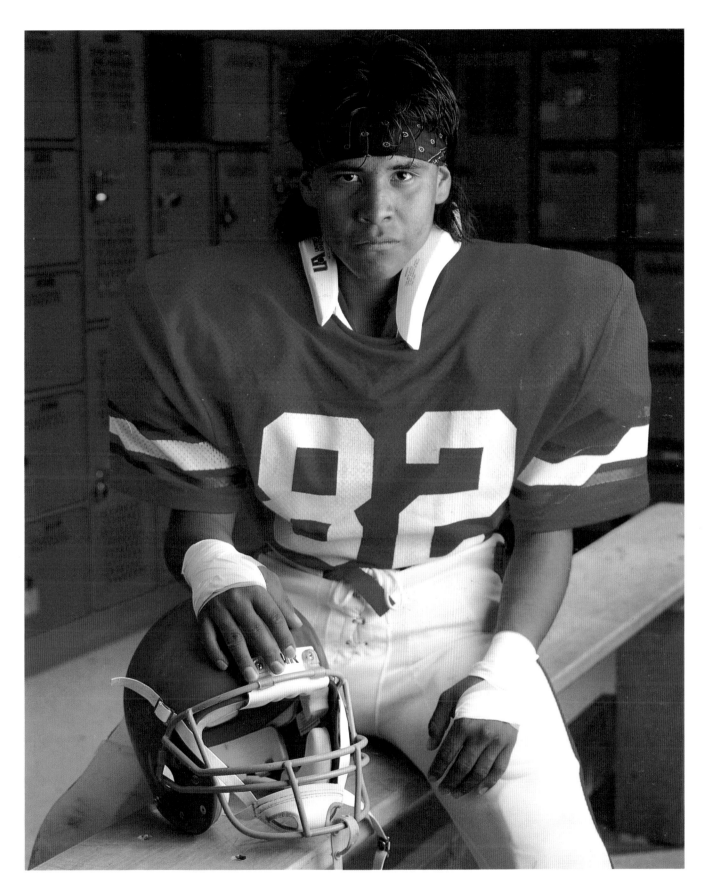

Tight End Jeremy Hale, Red Mesa High School

Red Mesa, Arizona

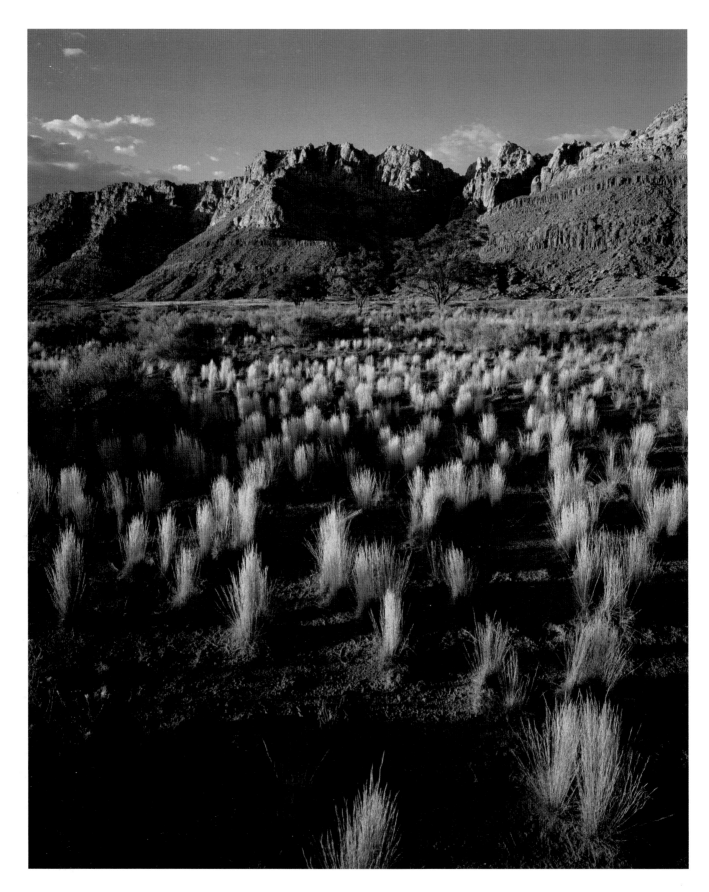

Echo Cliffs from grassland

near Cedar Ridge, Arizona

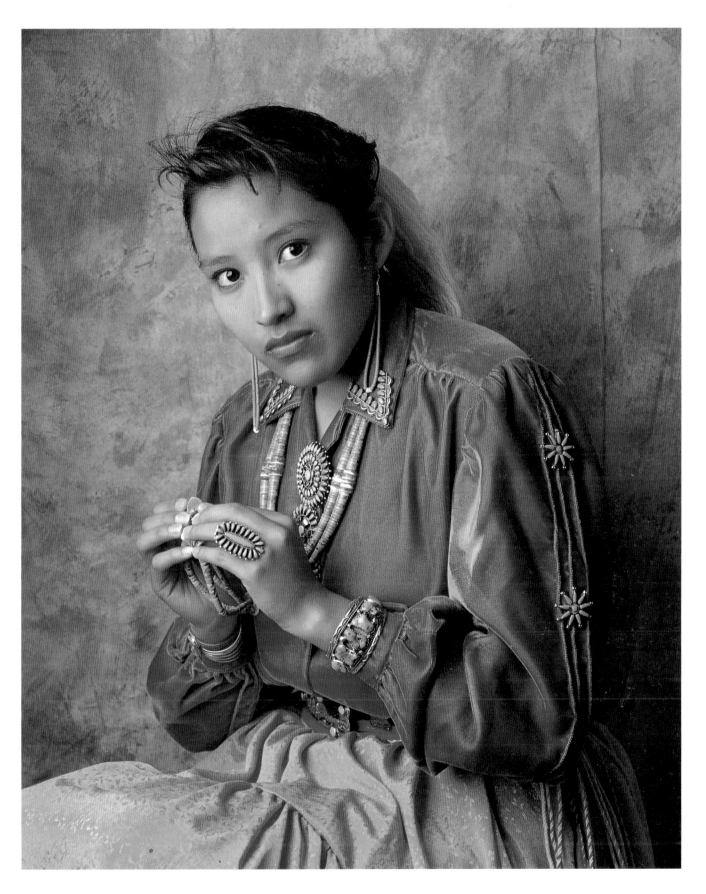

Traditional dancer Charmaine Store at Fourth of July Fair

Window Rock, Arizona

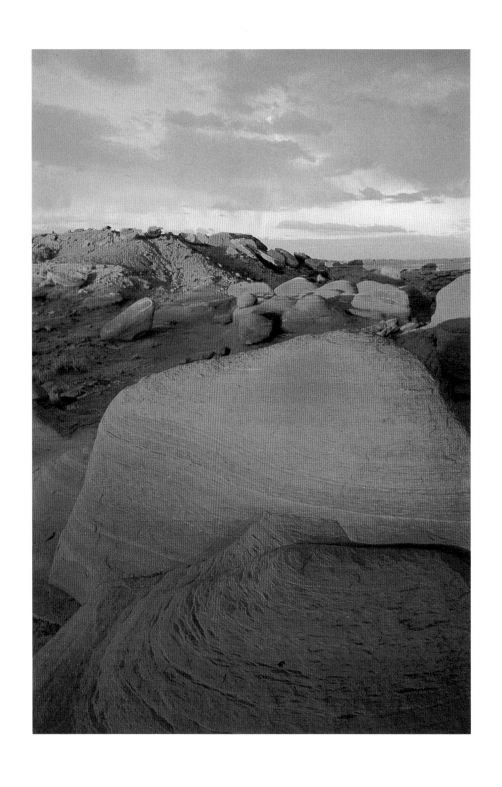

Sandstone rocks and clearing storm in late afternoon

near Tuba City, Arizona

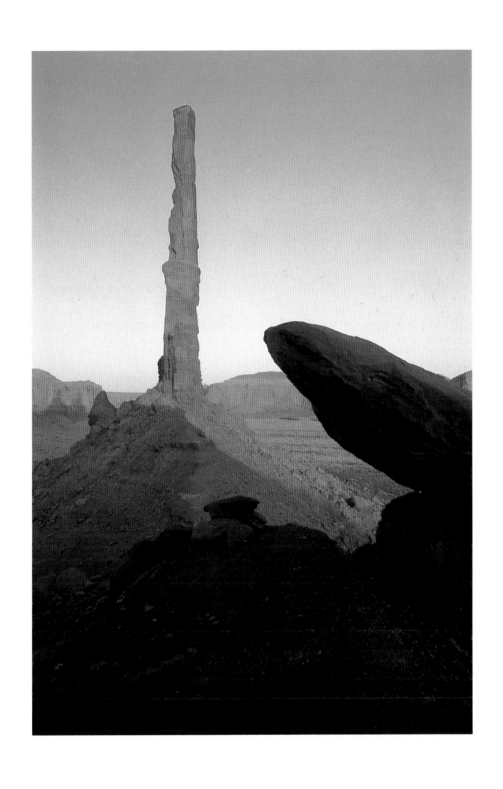

Totem Pole at sunrise

Monument Valley Navajo Tribal Park, Arizona/Utah border

College students home for summer employment

Window Rock Civic Center, Window Rock, Arizona

Navajo youth at Hubbell Trading Post

Ganado, Arizona

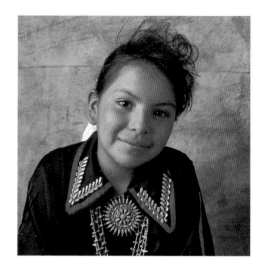

Hershal Yazzie

Darlena Stash

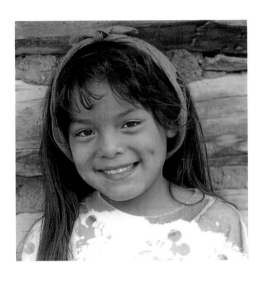

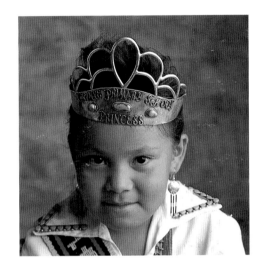

Sissy Tracy

Philina Begay

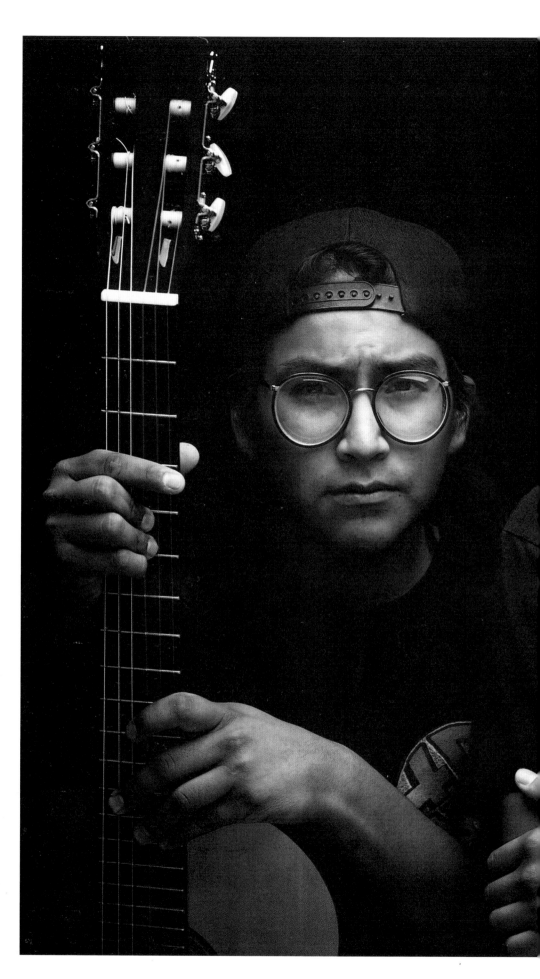

High school guitarist Darren Tuchawena

and drummer Marvin Begay

Tuba City, Arizona

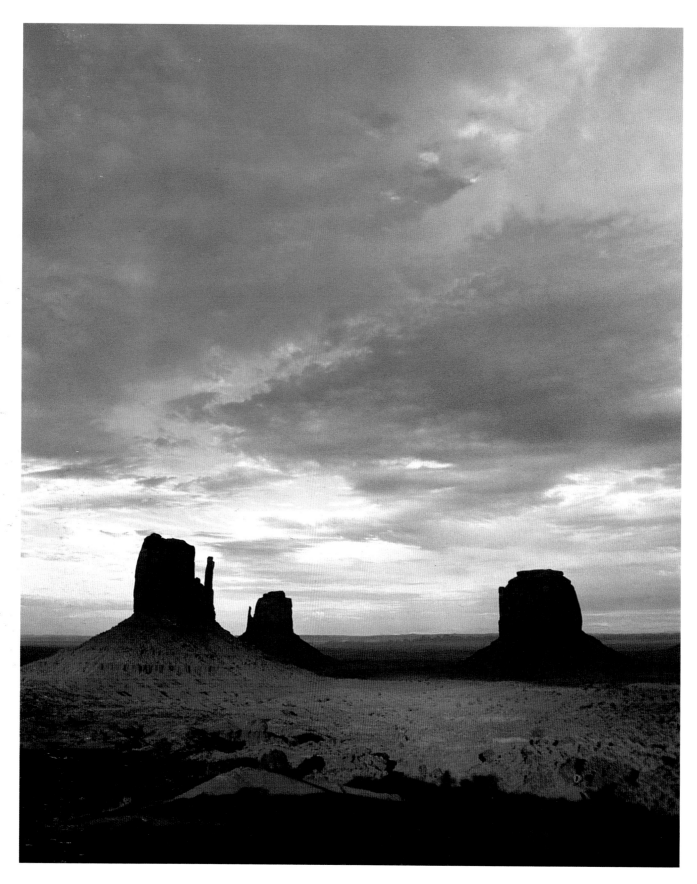

Mitten Buttes in autumn sunset

Monument Valley Navajo Tribal Park, Arizona/Utah border

Traditional dancer Fernando Stash at Fourth of July Fair

Window Rock, Arizona

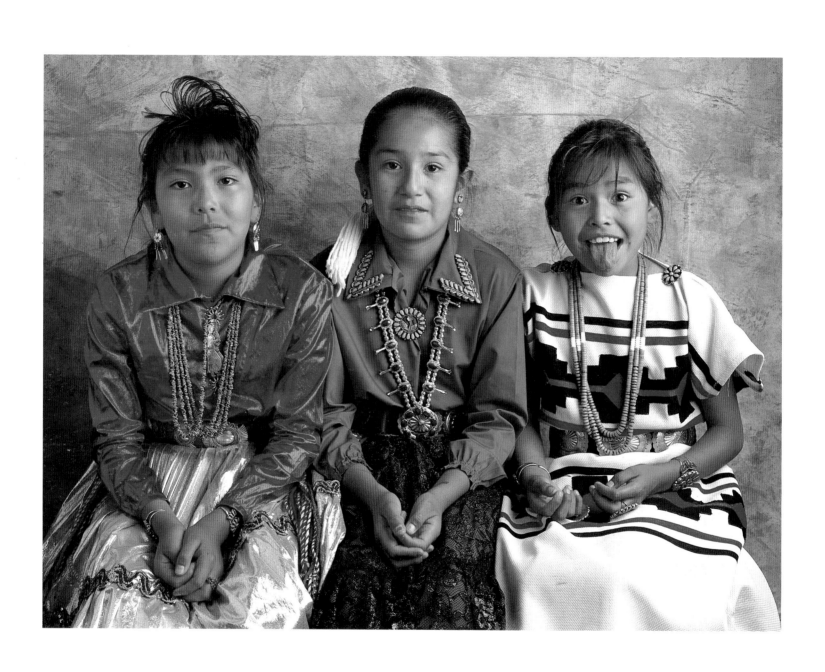

Traditional dancers Melissa, Alexander and Renita Begay

Fourth of July Fair, Window Rock, Arizona

Bita Hochee Trading Post at Bidahochi

near Indian Wells, Arizona

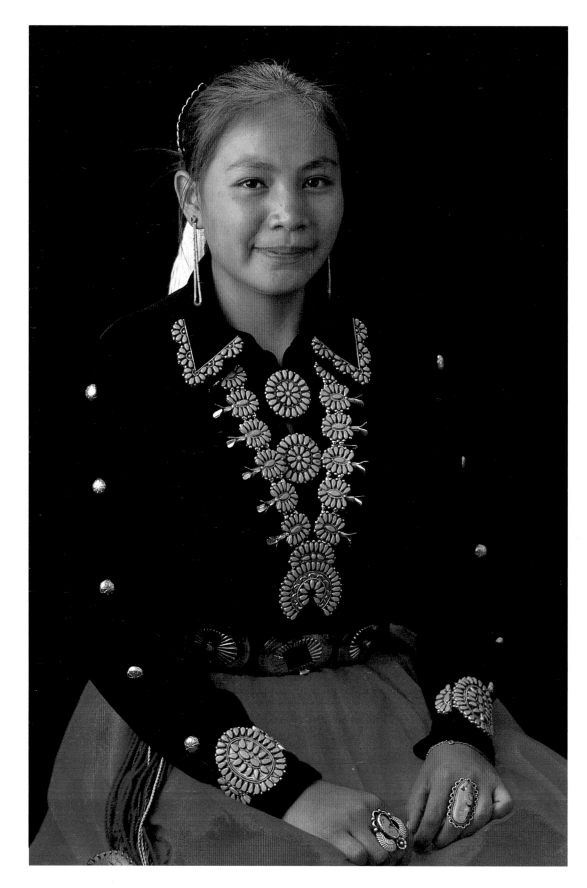

Traditional dancer Sunshine Dechilly at Fourth of July Fair

Window Rock, Arizona

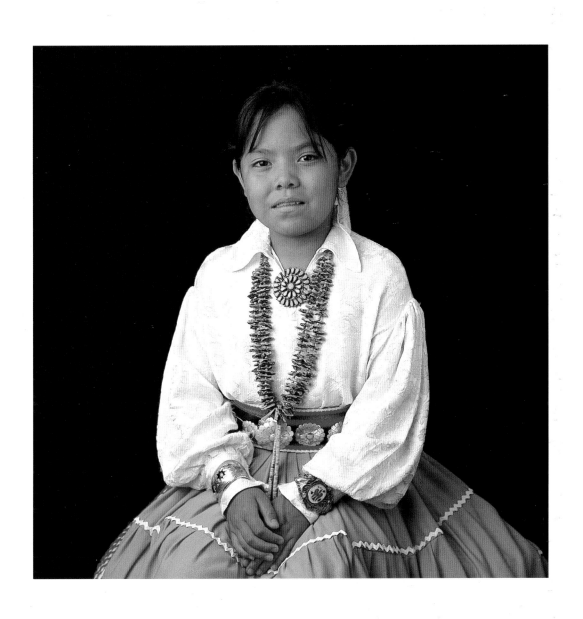

Traditional dancer Diana Garcia at Fourth of July Fair

Window Rock, Arizona

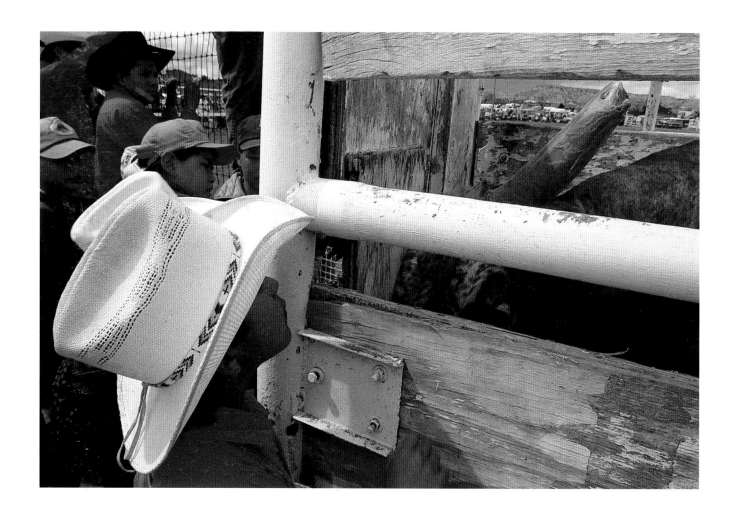

Navajo boy and rodeo bull

Ganado, Arizona

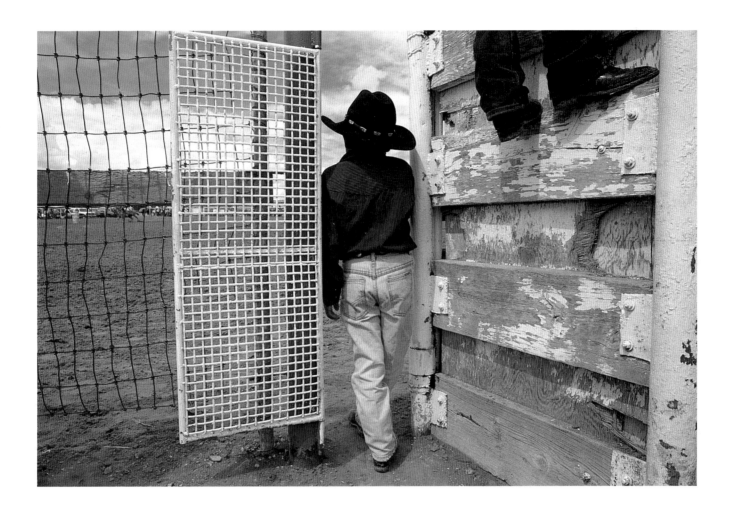

Navajo boy at arena's edge

Ganado, Arizona

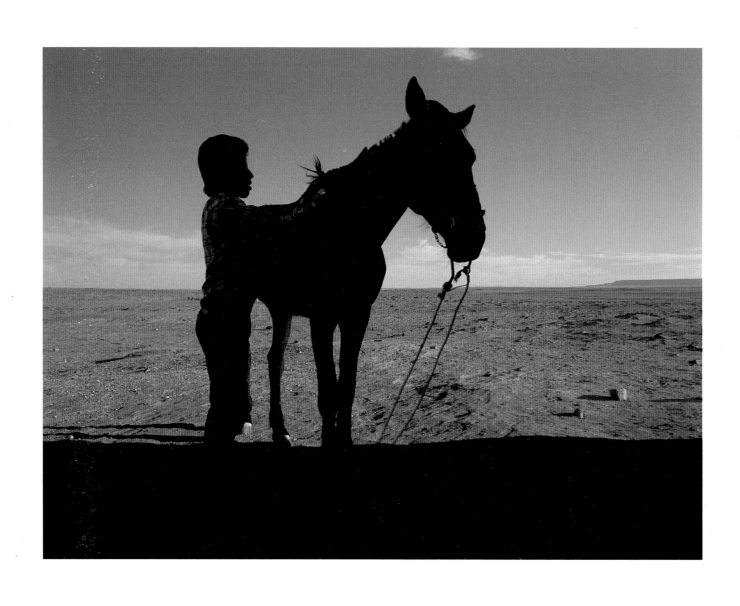

Sheepherder Roland Tayah outside Chinle, Arizona

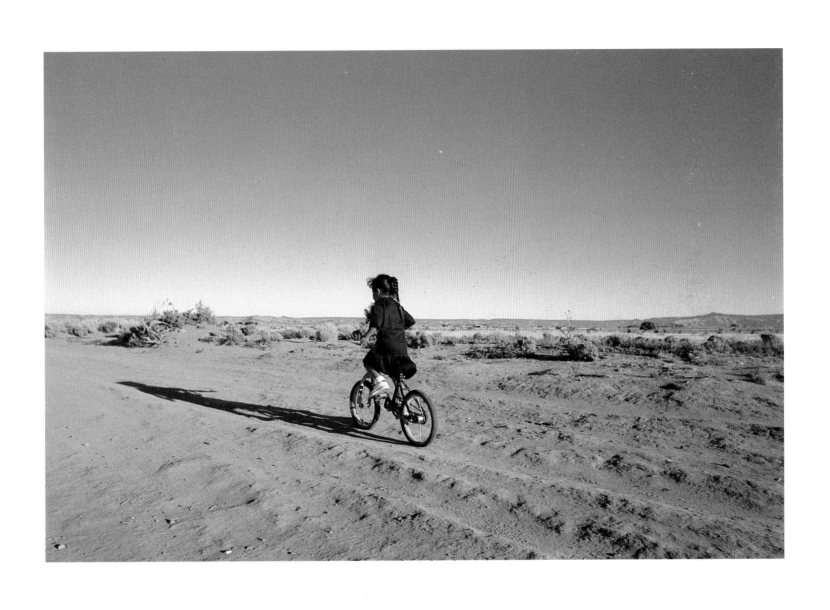

Taryn Alexandra Betsoi outside Twin Lakes, New Mexico

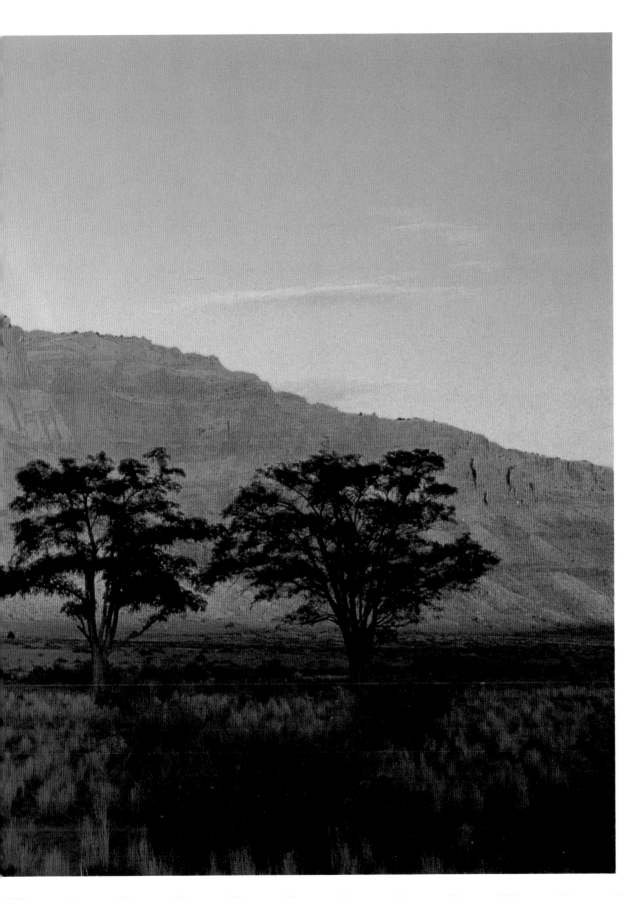

Trees silhouetted against distant Echo Cliffs near Cedar Ridge, Arizona

Sheepherder Roland Tayah with nephew

near Chinle, Arizona

Sunset from Monument Valley Navajo Tribal Park

Arizona/Utah border

This negativity surrounding my people must cease.

Alcohol abuse must decrease.

Now let me express my peace by saying our nation will increase

If we release that bottle of beer that is in our hand.

Nothing like that can be back by popular demand.

A mind is a terrible thing to waste.

Now all you dope heads don't fade the race or you will come face to face with the real enemy.

Like I said this is reality in the first degree.

As you look on the streets you see trash.

How we suppose to walk in beauty when our land is trashed?

When I'm not with my posse educating people, I roll solo.

I'm brown and proud yet I'm not a cholo but a native.

Busting out with a rhyme that is very creative.

The American Indian of today needs to rise and shine as one people and with that in mind we will be lethal.

My roots come from this vast land called the reservation.

I'm glad to be free from emancipation.

So why shouldn't I be proud to speak on behalf of the Navajo Nation?

Let's put our heads together and think of a master plan.

Written by
Harmon J. Mason
"Bass Bandit"

Rap artist Harmon Mason

Window Rock, Arizona

Blowing sands

near Canyon de Chelly National Monument, Arizona

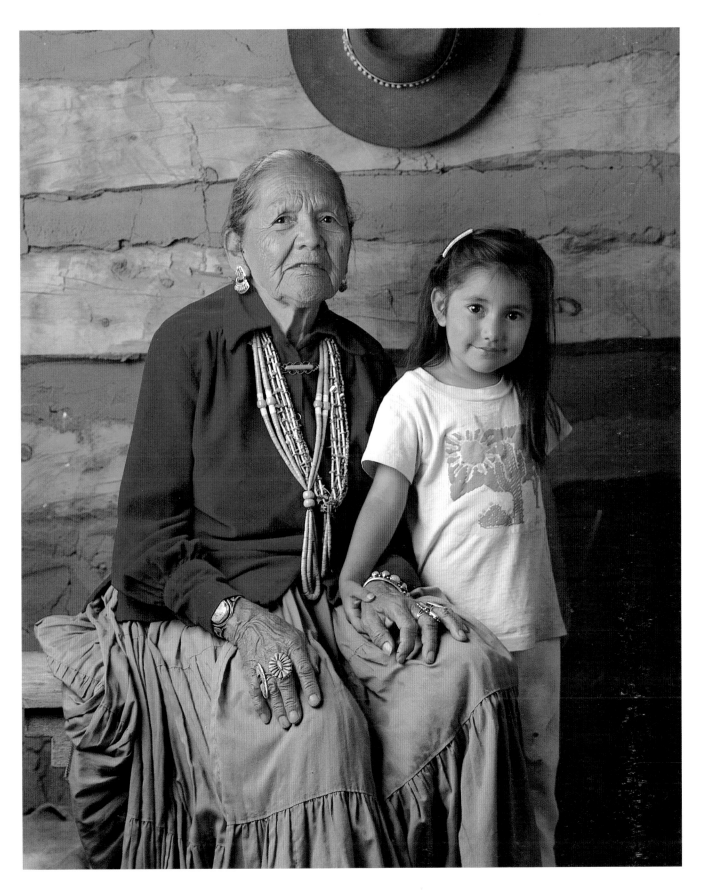

Rose Tracy and great-granddaughter Amanda

Ganado, Arizona

A sense of urgency overtakes me as my van weaves down the desolate dirt road toward Big Mountain. Downshifting, I accelerate through another deep mud puddle. This is a harsh land filled with beauty—home to the Diné, the Navajo People.

Beside me sits Navajo political activist Tom Bedonie. More than just a guide, Tom is my ambassador to the Navajo relocation resisters of Big Mountain. His task is a difficult one: convincing his people to allow me to take their portraits. To a Navajo, this is no small request. For more than a century there have been those who have carried a camera of disrespect. Before Tom agreed to help me, he asked a great number of questions, then gave me guidelines to follow. No matter how genuine I may seem, to the Navajo I am a *Belagaana*, a White Man.

Today's journey takes us to the home of Fannie Goy and her 12-year-old son, Jonathan. Choosing his words carefully, Tom explains my intentions to Fannie. He assures her that she will be compensated for her participation. Fannie agrees—in return for a 25-pound bag of Bluebird flour, a sack of potatoes and $10 cash. Bluebird flour is a valued commodity among the more traditional Navajo, and indicates I have some understanding of what is important.

Once permission is granted, I begin sorting through possible options for a strong photograph. I ask if I may look inside the house. The Goys do not live in a traditional hogan, yet their one-room brick house lacks any conveniences of the modern world.

I decide to seat Fannie and her son on a bed next to the kitchen. I begin unloading and setting up my equipment. Every move I make is watched and evaluated. Near the front door just to the left of the bed, I set up a Chimera soft bank to diffuse the light from my two 400-watt strobes. This will allow me to blend artificial light with existing light to create the atmosphere of a natural environment.

About four feet to the right of where the Goys are sitting, I set up a three-foot-square fill card to bounce light back into the scene. As I place my 6x7

camera in position, I begin to sense the elements that will work together to create a delicate photograph. Tacked to the wall behind the bed is an American flag with an eagle printed across the stars and stripes. I position the camera to include it.

To allow me to study the room's lighting, assess composition and determine proper exposure, I attach a Polaroid back to my camera. Setting the lens aperture at f/11 and the shutter at one second, I shoot a Polaroid. After allowing 40 seconds for the print to process, I quickly analyze it, make adjustments and shoot another Polaroid. I then exchange the Polaroid camera back for a roll film cassette loaded with Kodak EPP 100 color film and start shooting.

To gain a more emotional feel, I ask Jonathan if he would feel comfortable placing his head on his mother's shoulder. He does. After shooting 10 exposures of color film, I run a roll of Kodak T-Max 100 black and white film. The result? See page 23.

My devotion and personal vision for two years was dedicated to the photography of the Navajo people. During the nearly 400 days I spent in the field (three times the original estimate), I traveled 90,000 miles and exposed close to 45,000 frames of film. I endured what seemed to be an eternity of blowing sand and dust and an endless number of rejections from people I approached for portraits. I sacrificed precious time away from my greatest friends—my wife and two sons. In the end, the expense involved exceeded my original estimate by a factor of four. Yet the project was kept alive by the commitment my wife and I had to preserving our original project goal and vision. The concept of this book is not profoundly new or ingenious. However, the logistics of such a project proved to be most difficult, testing my committment and perserverance.

Notably absent from this collection are images of Navajo religious ceremonies, despite my vigorous campaign to seek permission to photograph these events. To this end, I met with all sorts of individuals and organizations, including the Medicine Men

Association, cultural and educational leaders, tribal government officials, family sponsors, participating patients and, most importantly, medicine men themselves. At times I would drive 12 hours to attend a ceremony or spend a few days assisting in preparations for an event. At last I would get permission to photograph, yet in every case I was asked to leave before any pictures were taken. In the Navajo culture, if one prominent family member feels uncomfortable with a Belagaana, the white man is escorted from the premises.

It took more than a dozen rejections before I realized there was a good reason for my lack of success. The Navajo people have lost much to the invasion of Anglo-American society. To pursue photography of their religious ceremonies would be just one more injustice heaped upon them. If one goal of this book is to assist in the preservation of the Navajo culture, surely exposure of their sacred rites could only negate such an aim.

This project does not attempt to illustrate every aspect of the Navajo. To do so would require coverage of social and political problems that have received ample press attention in recent years. My intention is not to present a false reality, but to portray the Navajo people in a sensitive manner, allowing all of us to see who they really are—a proud and beautiful people.

—J.G.

Acknowledgements

There are many people to whom I am deeply indebted, without whose assistance this book would not have been possible. My thanks go: To John Fielder and Westcliffe Publishers for taking the risk of publishing this book, and to Dianne Howie for her logistical assistance over the past two years. To Rosetta Tracy for helping establish my first true working relationship with the Navajo people.

Thanks also are due to all the guides who went beyond their duties: Ernie Lister, Arnold Chee, Oscar Detsoi, and Tom Bedonie. Also, to all the staff at the Office of Broadcast Services, with special thanks to Dewayne Johnson.

To all those who provided moral support, opened their home, loaned their darkroom or a desperately needed piece of equipment, I am very thankful: Denny and Gina Collins, Kerrick James and Theresa Bell, Doug Sensenig and Jenny Bell, Brad and Lynn Morari, Dave and Kate Wooddell, Jeff Noble, Betty Reid, Dorothy Baldwin and Paul Begay, Ruth and Minielle Tracy, Mike and Shirley Voita, McKee Platero, Steve and Elizabeth Sammons, Oliver and Marcia Urbigkeit, Bob Fuller, Jim Kelso, Rob and Karen Johnson, David Brown, Edward Chamberlin, Rich Clarkson, Joe and Bob Romeo, Mary Jo Lawrence, Michael Collier and Tom Brock.

Thanks also to those who arranged clearance for photographing industrial workplaces: Alan Balok at the Pittsburg & Midway Coal Mine, Marvin H. Shurley and Ray Martin at the Navajo Forest Products Industries sawmill and Ferdinand Notah with the Navajo Agricultural Products Industry.

Special thanks to Rich Weidman who, on occasion, assisted me in the field, Chris Harrell who contributed greatly at the onset of the project, Nancy Rice who worked so hard in the designing of this book, and Ann Moscicki at Kodak for the generous contribution of film: I thank you all.

—J.G.

Joel Grimes received a bachelor of fine arts degree in photography from the University of Arizona in 1984. Since then he has made a national reputation in the commercial advertising and corporate photography fields.

Grimes lives in Denver, Colorado with his wife Amy, and sons, Benjamin and Aaron. _Navajo Portrait of a Nation_ is his first book.

Betty Reid, Black Streak Wood People clan and Bitter Water clan, is a journalist who has written about the Navajo people for nearly a decade. She left Bodaway, Arizona, to attend college at the University of Colorado at Boulder. Reid is a reporter for the _Gallup (New Mexico) Independent._ She lives in Fort Defiance, Arizona, where she is raising her daughter, Jaylene.

Stewart Udall grew up in the tiny town of Saint Johns, Arizona, just south of the Navajo Indian Reservation. The four-term congressman and secretary of the Interior under presidents Kennedy and Johnson now makes his home in Santa Fe, New Mexico.

For the past 14 years, Udall has worked assiduously for passage of a bill to compensate hundreds of Navajo uranium miners for their work-related disabilities. That bill was passed by Congress in 1991.

The elder statesman continues to devote his time to working as an author, speaker, historian and naturalist.

Garrick Bailey is a professor of anthropology at the University of Tulsa. An Oklahoma native, he holds a bachelor's degree in history from the University of Oklahoma and master's and doctoral degrees in anthropology from the University of Oregon. His wife, Roberta Glenn Bailey, is a native of Phoenix, Arizona. She holds a bachelor's degree in history from Arizona State University and a master's degree in history from the University of Oregon.

Since meeting while working as park rangers at Bandelier National Monument in New Mexico, the Baileys have conducted extensive field work and authored numerous publications about the Navajo, most notably their book _A History of the Navajo: The Reservation Years_ (School of American Research Press, 1986). The Baileys have also served as consultants to the Navajo Nation.